how
to love
wine

how
to love
wine

a memoir and manifesto

eric asimov

wm

WILLIAM MORROW
An Imprint of HarperCollins*Publishers*

HOW TO LOVE WINE. Copyright © 2012 by Eric Asimov. All rights reserved. Printed in the United States of America. No part of this book may be used or reproduced in any manner whatsoever without written permission except in the case of brief quotations embodied in critical articles and reviews. For information address HarperCollins Publishers, 10 East 53rd Street, New York, NY 10022.

HarperCollins books may be purchased for educational, business, or sales promotional use. For information please write: Special Markets Department, HarperCollins Publishers, 10 East 53rd Street, New York, NY 10022.

FIRST EDITION

Designed by Jamie Kerner

Library of Congress Cataloging-in-Publication Data

Asimov, Eric.
 How to love wine : a memoir and manifesto / by Eric Asimov.
 p. cm.
 Summary: "A beautifully written, thought-provoking combination memoir and manifesto by Eric Asimov, the acclaimed, highly respected chief wine critic for the New York Times"—Provided by publisher.
 ISBN 978-0-06-180252-2
1. Asimov, Eric. 2. Wine writers—United States—Biography. 3. Wine and wine making. I. Title.
 TP547.A85A3 2012
 641.2'2—dc23

 2012018452

12 13 14 15 16 OV/RRD 10 9 8 7 6 5 4 3 2 1

To my mother,
Ruth

And to my wife,
Deborah

Contents

Wine Anxiety

Does the world really need another book about wine? The bookshelves are already packed with volumes that tell us everything we could possibly want to know. Atlases, encyclopedias, guides to the grapes and to the vineyards. Ratings, analyses, textbooks, historical surveys, and coffee table companions. Monographs on single grapes and single estates. Many of them are wonderful tools, the kind of reference works that any serious student ought to have.

Beyond these are the primers, the essays, the how-to guides to wine-and-food pairing. Then come the prevention books—how not to embarrass yourself in front of your boss, ten surefire tricks to avoid wine gaffes, and so on.

On the other side are the books that promise to demystify wine, to make it easy for anyone to cut through even the densest jungle of vinous terminology. Of course, these books succeed only in reinforcing the mysteries that make wine seem, for so many people, as arcane as quantum physics.

Clearly, wine is a serious matter that can weigh heavily on a person. Not something to be taken lightly at all. If you doubt this, consider the hallowed ritual of examining the wine for flaws, which you can view at any decent restaurant on any given night. Notice the embarrassed-bordering-on-doomed expression of the individual targeted by the sommelier to taste. The bottle is uncorked, a thimbleful of wine is poured into the glass, and the glare of the spotlight hits full force.

The haunted look tells all, like the voiceover narration of internal dialogue in a bad film noir: *I know I'm supposed to twirl the glass. I'm not sure why, but I see it all the time, twirling, twirling, twirling! Why? Now what do I do? Drink it, I guess. Why is he standing over me? I'm supposed to nod, right? What if I don't like it? How should I know whether it's good or bad?*

Nine out of ten times it ends meekly, possibly with a game shrug to the sommelier and an embarrassed aside to one's companions. At some fancier restaurants nowadays, sommeliers have taken it upon themselves to give the wine an initial taste, with the laudable aim of weeding out any bad bottles before they make it to the table. Of course, this practice has given rise to the suspicion that, by pouring a taste for themselves, the sommeliers are somehow bilking customers by giving them less than a full bottle.

I think everybody knows how it feels to be put on the spot like this. I know when I've been charged with tasting the wine at a meal with famous collectors or wine writers I've experienced performance anxiety, too. This fear of being mistaken, of being wrong, or of simply not understanding what's going on, pervades the world of wine, where

such a premium is placed on knowing everything and always being right.

Most people are resigned to enduring their wine fears. Some make halfhearted efforts to learn, but really, they just want to enjoy a glass of wine, not immerse themselves in a college-level course.

A select few are determined to overcome the obstacles. They head for the books, the classes, the glossy periodicals. They try CDs, DVDs, podcasts, and online educational devices. They learn to sniff out the myriad aromas in the glass and to talk in tasting notes, the global lingua franca of wine connoisseurs. They determine that 1945, '47, and '61 were great years in Bordeaux, but that '77, '84, and '97 were not so good. They can recite the number of 100-point wines they've tasted, and they know the difference between a Sassicaia, Solaia, and Ornellaia.

But is becoming what society considers a connoisseur really the best way to learn to love and understand what's in the glass? What is connoisseurship, anyway? And why is it that we assume the path to finding pleasure in wine begins with the accumulation of expertise?

The United States has become the largest single consumer of wine on the planet, yet what's missing in many people's experience of wine is a simple sense of ease. Instead, choosing a wine becomes an exercise in anxiety. Many people have come to believe that they cannot enjoy wine unless they are already knowledgeable, and so deny themselves the pleasurable experiences that would allow them to gain confidence. Instead of a joy, for many people wine has become a burden.

A friend once called me up because he didn't know what wine he should drink with pizza, of all things. Well, why shouldn't he be stumped? He's read articles that break down wine choices depending on the toppings—pinot noir with a mushroom pizza, primitivo with pepperoni, Chianti if it's topped with prosciutto and arugula, that sort of thing.

But what if it's a prosciutto pizza with no arugula, or it's topped with roasted peppers? Maybe you don't like primitivo, or don't have any around the house. If, like me, you live in Manhattan, 75 percent of the pizza you eat is delivered to your apartment. You know that the sturdy mushroom pizza from down the block is completely different from the more delicate mushroom pizza from the place three blocks away. The variables are endless, and relatively few are considered in such articles that purport to be helpful. Frankly, nothing should be simpler than choosing a wine to drink with a pizza, regardless of the topping. Pizza goes with so many different types of wine that it's hard to be wrong. Yet for many people this sort of overly specific discussion fosters a sense of doubt and an unfortunate dependency on experts.

It saddens me to imagine the pleasurable task of acquiring wines perceived instead as a chore. As you might expect, I'm devoted to wine shops. I never tire of exploring the shelves in a thoughtful shop, examining the labels on the bottles, turning them over in my hands in search of new producers or more bits of arcane information, like an importer I've never heard of who brings in wines from a region I never knew existed. Of course, it's all a preliminary, like poring

over restaurant menus. As much fun as I have in the anticipation, the real pleasure is in opening bottles and sitting down to a wonderful meal with good wine, consumed with friends and family.

Wine to me is entwined with pleasure, joy, fun, family, and friendship. It's not the sort of thing that requires book learning, academic training, or special classes, but rather an elemental pleasure that satisfies emotionally and physically. Yes, wine also has its aesthetic dimension, its rare and subtle beauty that becomes more apparent with experience. Plunging deeply into wine can be thoroughly rewarding. But it's not at all required. It all depends on what you're after. The simple contentment that comes with a glass or two at dinner is no small thing.

Years ago, back when I was coming of age in the 1970s and '80s and found myself becoming consumed with interest in wine, its world seemed awfully small. Great wines came from Bordeaux, or possibly Burgundy, but most definitely from France. In the United States, for the most part, wine was obtained from a liquor store, an apt description of the nation's drinking priorities. A few places did specialize in wine, like Sherry-Lehmann in New York City, where men in ties and aprons, the formal guise of the wine steward, might advise you on Bordeaux vintages or suggest a Champagne for a celebration.

Wine's image was stuffy, the atmosphere clubby, and its world constrained and aloof. The general public was convinced that wine lovers were essentially snobs who looked downward with an attitude of sneering pretension.

A mere thirty years later everything seems so different—

almost. No longer does wine occupy only a small corner of upper-crust society, or the hellish reverse fantasy, the down-and-out nightmare of bus stations and flophouses. Where I live in New York City, great wine shops can be found almost everywhere, from the carriage-trade posts of old to the hippest of hipster neighborhoods, where the young and the ardent chase wine with the same committed, obsessive energy that they pursue coffee, cocktails, and—this year, at least—meat cutting.

Yet one thing has barely changed. Wine still causes a sense of dread and suspicion. Nowadays, however, it is often directed inward. As the wine critic for the *New York Times*, part of my job is to talk to people from all walks of life about wine. I'm the natural recipient of their questions, and I love the give and take. They ask me for my opinions and seek recommendations, but sometimes they simply want to tell me how they feel. More than anything else, the single thought many people confess is that they don't have what it takes to enjoy wine. They feel that somehow they lack the ability or the knowledge to appreciate what passes through their lips.

"I don't know anything about wine, though I really should," they say to me apologetically. Or, "All those flavors and smells that people talk about, I just don't get them!" Or, "Can't you recommend a book or a course that will teach me what I need to know about wine?" The desire is not so much for a guide that will effortlessly transform them into knowledgeable wine consumers as a yearning for relief from wine anxiety.

This sense of obligation and anxiety, with its accompanying feeling of inadequacy, is the biggest single obstacle to

deriving pleasure from wine. Now, I don't pretend to be a psychologist. Nor do I believe I am especially sane—like any good New Yorker I take great comfort in my neuroses. But I do understand and empathize with people who experience wine anxiety.

Despite what many people would have you believe, wine is indeed a complex subject. Demystifying wine is unfortunately too often a synonym for a disingenuous form of oversimplification, which only reinforces the anxiety that people feel about wine. This book will not demystify wine for anybody, and I can live with that. In fact, as the wine importer Terry Theise has suggested, we ought to think more about remystifying wine rather than demystifying it. But more on that soon enough. What I really hope to do is to clear up the murky, intimidating business of enjoying wine, of loving it. About this, no mystery exists: If people can feel more comfortable simply taking pleasure in wine, without the distressingly sad qualification—"Of course, I really don't know anything about it!"—I think people will have overcome the greatest impediment to achieving a healthy relationship to wine.

Why is that important? Well, let's think about it for a moment.

What other field of pleasure comes saddled with the same sense of obligation as wine? Few people feel that they really ought to know something about baseball, or automobile repair, or French literature. But wine? This is what I hear all the time: "Well, I really ought to know something about wine. . . ." People do not use that same semiapologetic tone to excuse their lack of knowledge of ballet or bread baking.

Why do people feel such a sense of obligation? Why are they so anxious and intimidated? That's what I hope to explore and understand in this book. And by coming to some understanding, even an imperfect one, I hope to open the doors to less-encumbered pleasure. When the last book has been closed, the last note filed, and all that remains is what's in the glass, pleasure is, after all, the primary purpose of wine. Yet to look at wine solely as a hedonistic vehicle is to miss much of what has made wine so significant throughout history. It can convey so much more than simply pleasure, but those added elements of wonder, of history and culture, of complexity and conviviality, are most available when wine can be enjoyed with ease, in its fundamental role as a pleasurable, refreshing beverage and dining companion.

It bears repeating: The primary purpose of wine is to provide pleasure and refreshment. It can do much more than that, but should never do less. With a mission so seemingly simple, I ask again, Why is it that wine and its trappings seem so often to breed a feeling of inadequacy?

These questions seem especially pertinent now because never before has wine been in a position to offer more pleasure to greater numbers of people. Right now is the greatest time in history to be a wine drinker. Regardless of the fluctuations of the economy, we have today unparalleled access to more different sorts of excellent wines, from more places all over the world, than ever before. Wouldn't it be great if everybody who wanted to enjoy wine were able to take advantage of this fortunate time without fear and inhibition?

I've pondered this question for a long time, and I've learned that the answers are not easy or simple. Believe it or not, that's a good thing, a very good thing.

Yes, that sounds contradictory. But contradictions are essential to understanding what makes wine such an immensely fulfilling topic for so many people. In fact, some of the most confusing things about wine are the books that promise to demystify it, to make it easy and simple. Just the other day a slender volume came to me in the mail—sixty-three pages including index. It promised to teach "all you need to know to choose the right bottle every time."

I had to laugh, as nothing could be sillier or a bigger waste of its $16 cover price. Nobody, not even the world's greatest wine scholar, will ever master all they need to know to choose the right bottle every time. Not only is that impossible, the notion is dreadful. Picking the right bottle every time is a little like eating only at franchise restaurants—at least you know what you're getting, people will say—or owning a dozen sets of the same clothing—no surprises!

One of the great joys of wine is picking the wrong bottle and having it turn out even better than the right one. The surprise, the unexpected, the serendipity, the new experience—these for me are among the most euphoric moments wine can provide. But more to the point, even if choosing the right bottle every time were a goal, it takes years to gain the necessary experience to achieve even an approximation of such rote consistency. And for most people, it's not at all necessary. The single most important thing one can do if one wants good bottles with dinner is to make friends with a smart salesperson at a good wine shop. Let them help

you. Don't bother with the sixty-three-page equivalent of a get-rich-quick scheme.

Honestly, though, whether the book is 63 pages or 630 pages, the underlying notion of these sorts of manuals is that learning about wine is a prerequisite to enjoying it. Or, to put it another way, only connoisseurs are equipped to love wine.

Nothing could be farther from the truth, or more backward.

My purpose in writing this book is to try to reorder this equation, to reorient our thinking about wine so that pleasure comes first—that is, first the pleasure of enjoying the wine, then, if you are so inclined, the pleasure of learning about it. Over time I've developed a response for the many people who tell me with embarrassment that they aren't equipped to understand wine, or who feel as if they are unable to penetrate what they imagine to be an exclusive wine culture. I say to them: Nobody is obliged to like wine.

Nobody is obliged to know anything about wine. It is not a sign of a well-rounded personality, of a civilized human being, of a renaissance individual, or of anything else. Knowing something about wine ought to signify nothing beyond the fact that you can be helpful with a wine list.

Wine is a great pleasure for many people. If you are at all curious about why so many people seem to care about wine, start drinking a glass or two of wine with dinner. Experience is the best teacher.

If the experience of enjoying wine regularly makes you even more curious, that is the time to think about books and classes. But understand that, as with any vast subject worth learning about, wine can become a lifelong passion. No such

thing exists as one class or one book that will teach you everything you need to know. The first book is simply the first among many. It will most likely make you overly conscious of what you don't know. And as many great people in the wine business have said, no substitute exists for pulling corks. In other words, the more different sorts of wines you drink, the more you'll know and the easier wine will be to understand.

Last, but perhaps most important, no special physical characteristics or equipment are required to love wine. You do not need a hypersensitive nose, a palate that must be insured by Lloyds of London, a grasp of the world's most obscure fruit flavors, or a set of expensive, ungainly glasses. You simply require an open mind, a sense of curiosity, and an awareness that learning about wine is an act of volition, not of obligation. The aim is pleasure and joy, not status, not connoisseurship, and certainly not wealth.

My point is that by overemphasizing the knowledge required to appreciate wine, our culture neglects the emotion necessary to love it. We focus on what people don't know. We preach the virtues of wine education. Our wine culture tends to lecture instead of letting the wine in the glass do the talking. As a result many people end up in a tormented relationship with wine, marked by fear and resentment rather than simple pleasure, just as children end up hating school because they've had a demeaning teacher.

Having said that, writing a book runs the risk of adding to the lecture. Obviously, I don't want to end up as another

hectoring parental voice telling people to drink their wine as if it were good for them, like vegetables on a recalcitrant child's plate. Nor would I enjoy coming off as self-laudatory or, equally unattractive, defensive.

So it is with some trepidation that, in addition to analyzing some of the features that mark American wine culture, I offer up my own experience of falling in love with wine. I do this because, almost as often as people confide in me their anxiety about wine, they ask with genuine curiosity how I got into this business.

I usually tell them that I possess the single most important trait of a food and wine critic: an enormous appetite combined with a swift metabolism.

That's absolutely true, and people often laugh. But clearly it doesn't begin to answer their question. And when I think about it, my own serendipitous path to what for me is a dream job might in fact prove instructive, if only because my experiences, whether accidental or purposeful, seem rather ordinary compared with the usual stuff of the wine memoir. Ordinary, at least, in the sense that they indicate no special attributes, unusual sensory characteristics or extraordinary access to great bottles. If I fail to convince you of that, I hope my experiences will at least be entertaining.

This book, then, is part manifesto and part memoir, a gathering of impressions through experience. I don't imagine for a moment it will tear apart our entrenched wine culture. In fact, even if it did, I'm not convinced that my solutions offer the only method for reimagining it in a less threatening way. The idea is to start a discussion, and a reconsideration. I do believe I am asking the right questions, and if I can pull

a thread on the crazy-quilt of established dogma, accepted principles, and so-called facts that rule our wine culture, I will feel that I have done my job.

I fear that the various parts of this book may not always dovetail neatly. For that I apologize. But neither the world of wine nor my own inner world is particularly neat and well organized. Both are full of awkward corners, sharp angles, overlaps, and unexplained culs-de-sac that can create tension and friction if you are not comfortable living with ambiguity and contradictions. Pretending otherwise would only contribute to the problem.

Twenty-First-Century Connoisseur

The wine connoisseur of today resembles the exaggerated, cartoonlike popular culture stereotype about as much as Barack Obama does Millard Fillmore. No longer is it a portly white man in a manor house, a bon vivant with a big red nose or a Jeffersonian aesthete hobnobbing with the lords of the châteaux. Those types still exist, of course, but they are the residue of a dying era, a culture that, in the United States, at least, has largely receded.

Today, the wine connoisseur may live in a fifth-floor walk-up on the Lower East Side of Manhattan, an aspiring novelist who pays her rent teaching yoga and wonders whether the printed word will ever be relevant again. Does she drink first-growth Bordeaux and Grand Cru Burgundy, the defining wines of connoisseurs past? She'd jump at the chance! But these wines are largely fantasies to her. She's read about them and imagines savoring them, but could no more

afford them than she could a penthouse apartment on Park Avenue, complete with a wine cellar.

Yet she loves wine. It is an abiding interest and a crucial part of her life. Her cellar is the plug-in kind, which holds maybe sixty bottles, sits in her bedroom, and also serves as her nightstand. She's got some excellent Cru Beaujolais, and red wines from the most interesting producers in Sicily. She likes sherry, and German riesling, and she's socked away some Barolos and Premier Cru Burgundies for special occasions. She adores Champagnes, especially those that come from small farmers who grow their own grapes and make it themselves. She loves to cook, and she puts on great dinner parties with her friends, with whom she no doubt will discuss wines, though it's just one subject among many in the evening's lively conversation.

She's got friends who love wine as much as she does, some of whom she's never met before. Well, why not? Social media nowadays connects like-minded people without the burden of face-to-face encounters.

One of them makes a fair amount of money working in arbitrage. He's got a loft apartment in downtown Manhattan, but since he's on the West Coast quite a bit he also keeps a little place in San Francisco. The financial world is full of wine boors, and he's met his fair share—the kinds who buy expensive wines according to critics' ratings and brag about one-upping one another, as if their workplace were one giant locker room. To these people wine might as well be cars or designer clothes. It's a status statement, a show-off accessory.

Our connoisseur once engaged in these sorts of reindeer

games himself. He read the magazines, took the classes, tasted with his friends, and believed that was how wine drinkers behaved. But somewhere along the way he became more curious about what he was drinking than eager to display his exquisite taste. In typical fashion he took it upon himself to learn as much as he could about the wine, where it came from, why it tasted as it did, how it changed over time. He came to realize that the meaning and understanding of wine could not be captured in the glass itself. So he began to travel, planning trips to wine regions so that he could see the earth where the grapes grew, the cellars where it was transformed from fruit to wine, and the hands and minds that did the work and made the decisions. The more he learned, the less he knew, and so he came to understand a fundamental truth of wine: As much as we learn about it, as much as we know, it is at its heart a mystery. No, not the science of fermentation, which is now well understood, or the various chemical processes that occur along the journey from grape juice to wine. The mystery rather lies in how a great wine can be so expressive of its origins, of where the grapes are grown, and of the people who grew them and turned those grapes into wine.

This mystery cannot be unraveled simply by trying to dissect the characteristics of a wine, he realized, and it certainly can't be boiled down to ratings and scores. He understood this, and so he set about amassing a collection of bottles that conformed to nobody's notion of the world's great wines but his own: Loire reds and whites, primarily, bottles from producers and lands that he found fascinating but which his colleagues in pursuit of glamour completely

ignored. He could discourse knowledgeably about Burgundies, if he felt like it. Indeed, he loved them, though with his financial background, he did not care to invest his money in wines that he considered inflated in price.

A guy he knows out in California loved wine so much he left his lucrative job in the advertising world for the dubious prospect of opening a wine shop. But this was no typical wine shop, replete with mass-market labels touted by shelf talkers, those little marketing aids supplied by distributors that include a score and a blurb from some nationally known critic. The owner decided he was going to stock his shop only with wines that he himself loved or at least respected, which is like a chef refusing to put hamburgers, salmon, or pasta on his menu. Instead of pleasing the crowd, he just wanted to please himself, which meant offering obscure wines from the Italian Alps and from French regions that few people knew, like Arbois Pupillin, Gaillac, and Irouléguy. He even sells a few wines from California, though none that would be found along the route of the touristy Napa Wine Train.

Surprisingly, because he's broken all the rules of conventional wine shops, he's done great business. In fact, people all over the country want to visit his shop, because it speaks directly to them in a way that so few do. In a wine world full of pandering and marketing blather, it's clear to his customers that this shop speaks from the heart.

Would we even call these three wine lovers connoisseurs, with all the fatuous nonsense the term connotes? Absolutely. Why reject this perfectly useful word because of associations

that have become irrelevant? According to my dictionary, *connoisseur* means an informed, astute person with the ability to discern in the fine arts or matters of taste. I think it's a perfect word for people who've come to love wine and therefore gotten to know a lot about it.

Yet none of these three would think of calling themselves connoisseurs, perhaps because of the twentieth-century evolution of the term, and the impressive but ultimately irrelevant skills Americans have come to expect of the stereotypical wine connoisseur. These three would not choose to play the game of publicly tasting a glass of wine blind and trying to answer the question of where the grapes came from, who made it, and from what vintage. Sure, it's a useful skill for honing the palate. But the notion of doing so as a public demonstration of one's qualifications as a connoisseur can be contrived and pointless. The three would almost certainly shy away from the ritual of trying to describe wines in terms of ever-more-obscure aromas and flavors. They have not memorized the best vintages of Bordeaux in the twentieth century, nor can they recite off the tops of their heads the thirteen grapes permitted to go into Châteauneuf-du-Pape. That's what reference books and the Internet are for.

For them, connoisseurship is not a set of esoteric skills or the ability to regurgitate trivial matters of fact. It's the emotion, the love of wine, that has led them to drink widely, and to learn about what they have come to love. The distinction is crucial. Those stuck in the past still speak of "wine appreciation," as if knowing wine were simply a matter of accumulating a set of skills, like impeccable speech and proper table manners. The idea of wine appreciation reeks of bour-

geois hopes for social mobility. A goal of appreciation treats wine like an obligation, as if it were something to be mastered among the other trappings of gentility. And so wine becomes a badge, a trophy, a demonstration of one's standing, a course at finishing school.

The twenty-first-century connoisseur grasps that the key to unlocking wine is love, not appreciation. The necessary tools are a passionate curiosity, a motivating desire that demands time, energy, and money to pursue a vast field that is fascinating but, truth be told, not easy. It means first falling in love with wine, which comes from drinking, not from tasting or learning how to taste. The emotion gives rise to the passion for learning.

Each of these hypothetical twenty-first-century connoisseurs has come to terms with wine not as a subject that must be understood intellectually to be enjoyed, but as one that must be embraced emotionally to be understood intellectually. Each, in his or her own way, has broken the conventions that define which wines are great and which are not, how wine is to be analyzed and understood, how it is to be discussed, and how it is to be enjoyed. By so doing, they have discarded the rigid hierarchy that has tethered wine to a nineteenth-century worldview that has little to do with the twenty-first-century reality of many wine lovers' lives.

By leading with their emotions and instincts, they have discovered a culture of wine that does not depend on the omniscience of critics and authorities, is not prohibitively expensive, and is not rigidly hierarchical.

———

Much of what we are taught about wine today is based on the wisdom of an age that no longer exists. Until the twentieth century, fine wine was available to very few, even if more people in wine cultures drank far more wine per capita than they do today. Outside of the leading French wines (which were reserved largely for the well-to-do, or at least for the prosperous middle and upper classes), and the top German wines and fortified wines, most wine was not intended to travel far. Much of it was consumed locally and was of little consequence outside its home territory. It is reasonable to assume that some of this wine was quite good. But much of it was simple, consumed for sustenance rather than for pleasure, and a great deal of it was frankly dreadful, often spoiled or marred by flaws that resulted from an imperfect understanding of the science of winemaking.

The twentieth century saw the arrival of vast, far-reaching changes, particularly after World War II, culminating in the crazy, mixed-up world of today, where more great wine from more different places is available to more people than ever before in history. As unlikely as it might seem, given that the wines held historically in the highest esteem are largely unaffordable for most people, we are living in a golden age of wine drinking.

This happy fact is due to transformations in almost every aspect of society in the twentieth century, beginning with winemaking but also in communications, in transportation, and in the world's economy.

Advances in science and technology have deepened our understanding of how grapes are transformed into wine, and have given an arsenal of tools to winemakers so they can better manage that process. Consider the weather, for example, which has often been overlooked in the evolution of winemaking. For centuries, predicting weather was a guessing game. No doubt our agricultural forebears got pretty skilled at reading the signs, as it's a crucial factor in determining when to harvest grapes. Farmers trying to squeeze in a few more days of ripening sunshine might see a sizable percentage of their crop damaged if a heavy rain were to come instead. Conversely, farmers playing it safe in fear of rain might pick too early and lose out on a couple of sunny days. Modern-day meteorology is by no means perfect, as anybody knows who dresses according to weather reports, but it is far, far superior to the old methods in predicting weather, which helps growers make better picking decisions.

In the cellar, the technology of refrigeration, for example, has given far more control to winemakers, who can now manage the temperature during fermentation rather than leave it to chance. Winemakers also can use inert gases as a tool for protecting wine from exposure to oxygen. This has allowed winemakers in warmer regions to make the sort of fresh whites and fruity reds that would have been impossible sixty or seventy years ago.

As beneficial as science and technology have been, many producers came to realize that an overreliance on such tools creates problems. The tools available today have made possible a new category of clean, palatable mass-market wines,

but producers who hope to make something more under-stand that these tools can be detrimental to wines of char-acter and distinctiveness. Just as in the food industry, wine production today is essentially divided between those who make huge amounts of acceptable wine for cheap prices and those who make small amounts of more ambitious, more distinctive, and more expensive wines. Before World War II, the challenge facing producers was to make wine that was sound rather than tainted or somehow marred. Today, very little wine is spoiled. The challenge is to make wine that is not boring.

This revolution in winemaking largely began in the New World and trickled back in dribs and drabs to the historical wine-producing world. It took hold there in the most pros-perous and worldly places first, like Bordeaux, and spread through the most well-to-do and well-organized coun-tries, like France. Other countries were slow to catch up. The wine revolution struck northern Italy well before the south, but regions like Campania, Basilicata, and Sicily are coming on strong. Spain, burdened by decades of dictator-ship, entered the latter part of the twentieth century even further behind. One of the most fascinating trips I've taken in recent years was to Ribeira Sacra in eastern Galicia, where steep hillsides rising up from rivers were first carved into terraces and planted with grape vines two thousand years ago by the Romans. For centuries, grapes were a subsistence crop in Ribeira Sacra. Farmers tended animals, grew grain, and made wine for themselves. Many of these terraces were abandoned in the twentieth century as farmers, like agrar-ian workers all over Europe, sought to escape the rigors of

agricultural life and moved to cities in search of other jobs.

Then, a curious thing happened in Ribeira Sacra. Just as the twenty-first century arrived, young people began to return to the region, to rebuild the terraces, to plant grape vines, and, again, to make wine. This time, though, they were not making it for themselves or for the small city up the river. They were making it to be sold half a world away. Wine—their wine—was now an object of desire. Older people in Ribeira Sacra are astounded that their region's wines are now popular in New York and San Francisco. It's as if Ribeira Sacra moved directly from the nineteenth century to the twenty-first century, skipping the twentieth century entirely.

What is happening now in Ribeira Sacra has already occurred in other Spanish regions like Bierzo and Priorat, Ribera del Duero and Rueda. It's happened in small towns in the Jura in eastern France and in the Douro in Portugal. For better or worse, villages that for centuries were part of a localized wine culture have adapted to a global economy, where their distinctive produce can be consumed across oceans, thousands of miles away. To the old local wine culture, winemakers were simply farmers. To the new global wine culture they are celebrities.

The transformation is not nearly complete. Other countries with centuries-old wine cultures have yet to make their worldwide splash. But it's coming. The local wine cultures of Eastern Europe were gravely damaged by Communist dictatorships, which largely turned them into drab commercial

collectives. The fall of the Iron Curtain has given these cultures a new chance, and we've only seen the beginning of what may occur in coming decades. Among these wine-producing countries once paralyzed under communism, Slovenia has charged onto the worldwide stage, led by superstar producers like Movia, and other countries like Hungary are not far behind.

Of course, I'm only talking about the Old World here. I haven't even touched on the United States and Canada, South America and South Africa, Israel and Australia, all of which became global wine powers in the twentieth century and which have pioneered many of the new winemaking techniques and technologies. And who can say what will come from Asia this century? The geographical choices are boundless.

Now, local wine shops all over the United States are displaying bottles from every corner of the wine-producing world. Many of these wines are not only unfamiliar, they're made from a profusion of grapes that most people had never heard of twenty-five years ago. Back then most people with an interest in wine knew about cabernet sauvignon and merlot, pinot noir and chardonnay. They had heard of riesling and sauvignon blanc, syrah and zinfandel, nebbiolo, barbera, and sangiovese. But would they have recognized grapes that wine lovers now find fascinating? Albariño, verdejo, and mencía from Spain, and viura, too, if you have a taste of traditionally made white Rioja; grüner veltliner and blaufränkisch from Austria; savagnin, poulsard, and trousseau from the Jura in France; and aglianico, cornalin, frappato, fiano, ribolla gialla, and many, many more grapes from Italy. And

I haven't even mentioned assyrtiko from Greece, furmint from Hungary, or rkatsiteli from the Republic of Georgia (and the Finger Lakes of New York).

Diversity is not simply a matter of geography or grapes, it's also a question of style. Without a doubt, the globalization of wine culture has given many consumers access to a greater variety of styles than ever before. If you went to a French restaurant in the middle of the twentieth century and examined the wine list, it might appear to be missing salient facts. Back then, a bottle might be identified simply as "St.-Julien" or "Graves," without information that we consider essential now, like producer and vintage. You would nonetheless have a rough idea of what you would be getting.

Today, that's not nearly good enough. Terms like *California chardonnay* or *Barolo* or *Mosel riesling* are far too broad to have much meaning, at least as far as conveying a particular idea of what you might be drinking. Even as you probe deeply into wines from ever-smaller parcels of terroir, you can't help but notice a wealth of styles. Two chardonnays from the same part of the Sonoma coast might have some basic characteristics in common, but one might be creamy in texture and dominated by oaky flavors while the other might be lean, minerally, and vivacious. No Barolo lover would mistake a defiantly old-school bottle from Bartolo Mascarello for a stylishly modern offering from Elio Altare. Even in proverbially monochromatic regions like Napa Valley, where the wines are all too often subject to vast generalizations, you can find cabernet sauvignons as strikingly

different as Bryant Family and Mayacamas, Paul Hobbs and Cathy Corison. Think you know what Australian shiraz tastes like? Try two of the best side by side: Penfolds Grange, rich, dense, and highly sought after the world over, and Penfolds St. Henri, leaner, more angular, and far cheaper. They are both exceptional wines. Whichever one you might prefer, the point is you have a choice.

The explosion of styles, grapes, and regions would be entirely meaningless and probably would not have happened at all had a wider demand not developed for these wines. For Americans after World War II, demand grew as interest in wine and access to wine-producing regions shot upward. I was a late baby boomer, growing up in the 1960s and '70s, and my parents, Stanley and Ruth Asimov, were part of the generation that could explore the world as none but the wealthy could before. Their parents—my grandparents— were immigrants, and my parents both grew up in New York City. For my mother, travel during her childhood meant a trip to Jones Beach on Long Island, or perhaps a car trip to Lake George in upstate New York. My father never left New York City until he was a college student at New York University, and a classmate invited him to his home in Westchester County, the northern suburbs. Later in life, to illustrate how narrow his urban upbringing had been, Dad told the story of how his friend, proud of his parents' backyard vegetable garden, pulled a carrot up out of the ground and turned to display it to him. My father goggled, horrified at the apparition. "From the dirt?" he exclaimed.

So awakened to the potential of nature, he and my mother moved to the suburbs in the 1950s, believing idealistically that split-levels with yards provided a better environment for their children than apartments and asphalt. By the 1960s, my mother had her own vegetable garden, and one of her favorite television shows was *The French Chef,* with Julia Child. Through this new medium, my parents and millions of Americans like them got a close-up introduction to other cultures, not through documentaries on architecture, art, or military history, but in a way they could really understand— through food.

Television gave them an eye to what could be seen and done outside their narrow realm, and a taste of what they could eat. But it was the prosperity of the postwar economy that gave them the means to travel, and it was the increased availability of relatively inexpensive transportation that allowed them to act on their newfound desires. My parents were by no means wealthy. But my father had a good job, and eventually, in 1971, my parents took their first trip to Europe. They started with France, where they went to museums, visited Paris and Versailles and drove around the country. Perhaps most interesting of all to them, they ate in French restaurants and drank wine.

My parents loved food. They were adventurous, within the constraints of their times. So while they relied on instant coffee and frozen vegetables, my mom also learned how to make dishes like a great bouillabaisse—I didn't know any other mother in my little Long Island suburb of Roslyn Heights who was making bouillabaisse. Still, most of her highly satisfying culinary repertoire was squarely within the

Russian-Jewish canon that she had learned from her mother. But as with millions of other Americans with a small amount of disposable income, they got an inkling through television of what the rest of the world had to offer. Through the miracle of jet travel, they were able to go see for themselves.

Certainly, they were not transformed overnight into wine-and-food-obsessed citizens, making their daubes and drinking their Provençal rosé. That was for people like the food writer Richard Olney, a vital link between the France that Julia Child introduced to my mother's generation and the wider vision that Alice Waters and Kermit Lynch offered to the next. Nonetheless, the combined effect of the advances of the twentieth century was to make them and millions of other people curious and to give them access to the wider world, right about the time that the wider world was ready to receive them.

Now, well into the twenty-first century, the dialogue between wine producers and wine consumers is far more multilingual, and far more diffuse than ever before. It only makes sense that our notion of what it means to be a connoisseur evolves as well.

Twenty-first-century connoisseurs are democratic yet critical. They recognize the difference between wines that sum up generations of tradition and those in demand simply because of their prestige. They understand the difference between honest wines and luxury products, and they can identify the bottles that qualify as both.

Nowadays, honest wines come from all over the wine-

producing world, but regions with long traditions of wine production have an advantage. The centuries of experience that went into selecting the best sites for vineyards and the best grapes for those sites cannot be overlooked or underestimated. By contrast, wine production in the New World is largely a copycat enterprise, seeking to duplicate what's been done so well in the Old World. New World growers choose the grapes they plant far more on the basis of their ambitions and desires rather than on a real sense of which grapes would best bring out the distinctive qualities of a particular site. Not surprisingly, they have limited their selections to the world's most prestigious grapes, as defined in the mid-twentieth century. The hundreds of different kinds of wine that you can find in the various regions of France, Italy, and Spain are the delicious results of decisions made over the course of generations in local wine cultures. But New World wine producers narrowed their focus to what was considered the best in the world. And so the wines of the New World are repeated over and over— cabernet sauvignon and chardonnay, merlot and pinot noir, sauvignon blanc and syrah (or shiraz), and of course a handful of others. One of the most exciting stories in California right now, in fact, is to watch a new generation of growers and producers slowly enter the business. Their experience has been shaped by the wider world of the twenty-first-century connoisseur, so their palette of preferred grapes has expanded.

Do any of these New World wines have character? Sometimes, but certainly not to the extent that you find distinctive wines in traditional Old World regions, and absolutely not to the extent that New World wine marketers would have you believe.

The Blind Leading

Some years back, a brief flurry of interest blew through wine circles when the venerable, trusted *Consumer Reports* magazine announced it was going to rate wines, just as it did toasters, televisions, and cars. Here, then, would be an objective, unbiased effort to infuse the crazy, disorganized shambles of retail wine sales with a welcome blend of rationality.

Such efforts are wonderfully comforting. Who knows anything about margarine or minivans, or wine, for that matter? If the experts can set out objective criteria, and then evaluate products on their ability to meet those criteria, so much the better for consumers. *Consumer Reports* would cut through the dense thicket of snobbery and mythology surrounding wine, which makes it so forbidding to so many people.

Only one problem: Short of detecting whether a wine is spoiled (and sometimes even that is up for debate), wine does

not lend itself to dispassionate evaluation. It does not accelerate from zero to 60, or perform in any measurable, quantifiable manner. Yet we cling earnestly, maybe even desperately, to the naive belief that we can eliminate all sorts of biases and judge wines objectively, simply by evaluating the liquid in the glass. This determined belief in objectivity, in its power to reveal verifiable truths through unreflective, disinterested examination, is at the heart of American wine culture and of the wine anxiety that many people experience.

Consumer Reports' efforts to evaluate wine never took hold among knowledgeable wine consumers. Partly this is because the magazine aimed its wine coverage at people who didn't know much about wine, whose main concern was which mass-market bottle to pick out at the supermarket. This approach is certainly understandable: These people are the least interested in wine and will spend the least amount of time learning about it. They simply want to feel comfortable that they are not wasting their money. *Consumer Reports* fulfills this function admirably, even if the articles do not have much to offer to more discerning wine drinkers. Still, to a certain extent, the wine culture that envelops all American consumers is governed by the same belief in the power of objective test-driving.

The dominant American wine culture promotes outdated notions of connoisseurship over fun, while emphasizing wine at the expense of food, or even divorcing it from the table entirely. This wine culture is founded on the notion that wine can best be understood through clinical study, by

omniscient experts who freeze a wine's moment—the quick taste—into eternity with scores and tasting descriptions. This effort to capture the aromas and flavors of a wine in definitive, ironclad prose creates the illusion of certainty and reinforces the divide between those who are convinced they know and those who are convinced they don't.

But I'm getting ahead of myself. Let me say right away that I've been on both sides of this equation. I've been in groups where I simply could not understand why everybody else was finding characteristics in a wine that completely eluded me. I've wondered what was wrong with me that I couldn't sense what was apparently obvious to other people. And as a professional wine writer, I've no doubt contributed to the anxiety of others by thoughtlessly accepting and re-peating conventional wisdom, if only because I hadn't yet had the experience to find my own truths.

Here is one of the most important things I've learned: Wine experts make mistakes all the time. In a blind tasting, they might be wrong about what kind of wine is in the glass. They may be off the mark in guessing the producer or the vintage. They may be entirely misguided in estimating how long that wine will need to age before it reaches its peak or is over the hill. They are not always right. More important, it is not their job always to be right.

Really? Wine experts do not have to be right all the time?

Absolutely. The fact that we grant such power to a hand-ful of authorities is absurd. Consumers understandably want guidance. Wine is not cheap, and nobody wants to waste money in the service of exploration, at least not until you commit yourself to loving wine, in which case buying bot-

tles to satisfy curiosity is no longer a waste of money, except maybe to your spouse.

Believe me, I'm not singling out a particular writer, say Robert M. Parker Jr., or an organization like *Wine Spectator* magazine. These two are generally understood to be the most powerful wine-reviewing entities in the United States. They can sell many bottles with a high score or a few well-chosen descriptive words.

But they are not the problem. Both may be controversial, yet in the Internet age many other voices with differing points of view are now being heard. The spectrum of wine opinion covers vast ground, yet it so often comes down to the same relationship between critics and consumers: omniscient voices issuing rigid judgments that leave little room for doubt and ambiguity.

Personally, I feel that wine cannot be understood without a sense of uncertainty, of modesty and humility and respect. Yet too often the wine world offers a sad parallel to the world of religious strife, where each sect is convinced that its way is the right way, and that others are benighted, worthy only of pity or anger. Among this multitude of sects, each has its own set of facts that create comfort and easy understanding. Some people like big, powerful wines, the equivalent of blockbuster Hollywood movies. Others like more rarefied fringe bottles, the arty, independent films of the wine world. Plenty of other loosely knit groups abound, whose unofficial members constantly reinforce the brilliance of their own taste. Yet as different as each of these sects might be, they all subscribe to a similar dogma, that every bottle can be clinically assessed and hierarchically ranked, a dogma that largely

ignores the roles of emotion and context, as well as the exceedingly changeable nature of wine itself.

What unites many people in the wine world, regardless of their taste in wine, is an adherence to the seemingly objective clarity of blind tasting. In so many ways, the notion of blind tasting, in which wines are served unidentified so that tasters can judge the wine solely by what's in the glass, appeals to American notions of democracy and fair play. By tasting the wines blind, the thinking goes, nobody can be prejudiced by the status of the label or the size of the price tag. This way, every wine has an equal chance, whether it comes from a producer of great wealth and aristocratic heritage or a guy on the wrong side of the highway who planted his vines only five years ago.

And really, don't we love the idea that the $10 bottle from some producer in Washington State could be better than the $100 bottle from a haughty French family that's been making wine for generations?

I am here to tell you that it is almost never, ever that easy.

Consider the actual mechanics of a blind mass tasting. The tasters will be faced with many, many glasses of wine. For our wine panel tastings at the *New York Times,* I limit the number of wines we taste in one sitting to twenty or twenty-five. This apparently is on the extreme low end of what wine writers feel they can tolerate. I've heard other writers brag of tasting 120 wines before lunch and then another 120 wines afterward.

With each of those glasses, the ritual is virtually the same. Hold it out to the light against a white background to examine the color. Swirl the glass to aerate the wine, in order to release the aromas, then stick your nose right into the glass.

Give a series of quick, short sniffs and scribble some notes. Swirl again, sniff again, and this time swig a small mouthful. Whirl the wine around your mouth while taking in quick bursts of air, making noises that most assuredly would not please your mother. Take a few more notes. Spit and complete your notes. You might be tempted to repeat the exercise, but if you've got 119 more wines awaiting your attention, you'd better move on.

From this exercise, taking a couple of minutes at most, come the precision judgments and scores that may determine the commercial future and public perception of a wine. Yet consider the overwhelming flaws built into this theoretically clinical system.

First of all, imagine the sheer physical stamina necessary to get through dozens if not hundreds of tastes, so that the last one can be considered as objectively as the first. It is a consideration, though let's not make too much of it, as these are all professionals who believe they can fight their way through any situation. More important, though, is the effect one glass of wine can have on the next. Suppose you are tasting a series of pinot noirs from California. Even though each of these wines is made from the same grape, and possibly comes from the same vintage, they may all vary considerably in style. One may be lighter in texture and milder in flavor than another heavier, more powerful and vigorous wine. If you taste the lighter one first, you may not have a problem. But if the heavier, sweeter one comes first, it may obliterate the subtler flavors of the lighter wine. Trying to judge the second, lighter wine may be somewhat similar to tasting orange juice after brushing your teeth.

Again, these are professionals who are tasting. They may be aware of these issues, and they may try to compensate, or they may not. We don't know for sure. We do know, however, that blind mass tastings generally favor heavier, fruitier, more powerful wines over wines of subtlety and finesse.

Even more important, though, is the complete lack of background information and context available for assessing not only the way a particular wine tastes in the glass right now, but understanding where it came from and how it typically evolves. In the service of the claim of objectivity, important information that can help to judge a wine is ignored. The track record of a particular producer, for example, can be crucial to understanding how a wine will change over time. It's ludicrous to contend that a wine's performance year after year is irrelevant to evaluating it. Imagine a book critic reviewing a new novel from a noted writer without referring to past works, or a film critic, writing about the new Quentin Tarantino movie without using his accumulated knowledge to place it in the context of his previous films. Wine is more than the quick impression of aromas and flavors. History and intention count for much.

Yet by trumpeting the virtues of blind tastings, we ask wine critics to deprive themselves of this important context. Apparently we expect these writers to be professional enough to handle an overwhelming volume of wines, professional enough to be able to predict how a wine will age over a decade, and professional enough to overcome the handicap of tasting wines of very different styles at the same time, but we imagine they are too childish to compensate for any bias

they might feel toward famous or expensive wines. The justification for blind tastings can be infantilizing.

Despite my misgivings about blind tastings, I still engage in them. Half of the columns I write each year for the *New York Times* are the result of blind tastings. In a very comfortable room on the fifteenth floor of the glass tower the *Times* has called home since 2007, my colleague Florence Fabricant and I, along with two guests, taste our twenty to twenty-five wines, pulled together by our tasting coordinator, Bernie Kirsch. We then discuss and rate the wines, and finally, their identities are revealed to us. It's not unusual for a wine that in the past I've liked very much to receive a low rating from the wine panel.

Ordinarily I take this in stride. But sometimes I find it disturbing, and I make a point of calling attention to the discrepancy in the final published column. A perfect example: the rieslings of Joh. Jos. Prüm, from the Mosel region of Germany.

Prüm rieslings are among the most glorious wines in the world. In the 1980s I came to love German rieslings by drinking the Prüm wines. Yet in blind tasting after blind tasting at the *New York Times* we have almost never thought well of the Prüm rieslings. How is this possible?

When these wines are very young, as they invariably are in our tastings, they often display the sulfurous aroma of just-struck matches. It may be, as some people argue, that sulfur dioxide, used as a preserving agent for centuries in almost all wines, doesn't integrate well with the young Prüm wines. Or it may be the peculiar chemical result of their winemaking techniques. But for whatever reason, these wines always fail to impress at our blind tastings.

What does that mean? That the wines we preferred in the blind tastings are all better? Absolutely not! With a few years of aging, the offending aroma dissipates and the Prüm rieslings achieve a tense, fragile beauty. I like a lot of riesling producers from the Mosel, but I can't think of any that I prefer year in and year out to Joh. Jos. Prüm, regardless of the results of our tastings.

So what's the solution? I suppose we could wait until the Prüm wines are older before tasting them, but that would not be of much help to consumers. Almost all wines reach the marketplace when they are young, and consumers will be faced with the young Prüm wines in stores. If evaluations are to be useful to consumers, they must be available at the point of decision. Perhaps a better solution would be not to taste the wines blind, so that critics could use what they know to judge the wines.

This is not an isolated incident. Indeed, many New World producers who feel that their wines are overshadowed by their Old World forebears resort to blind tastings in an effort to put their wines on equal footing. I've seen it again and again: Pinot noirs from the Calera Wine Company in California against some of the best red wines Burgundy has to offer; sparkling wines from Schramsberg Vineyards in California against Krug Champagne; merlot from Lenz Winery on the North Fork of Long Island against Château Pétrus of Pomerol.

Invariably the New World upstarts do very well against their formidable, esteemed, and far-more-expensive counterparts. But what does it prove? Let me put it this way. I have not encountered a single person, including the American

producers who arrange these tastings, who would willingly trade their holdings of Bordeaux, Burgundy, or Champagne for the upstart wines that have just bested them in blind tastings. Certainly, bottle for bottle would not be an even trade according to their dollar value, but even so, could it be that people in the wine trade secretly understand that blind tastings can often be nonsense?

I am not saying that blind tastings are totally useless. They can be excellent tools for educating and orienting one's palate and tasting antenna. They can even be enjoyable games. But despite any consumer preconceptions about leveling the playing field, they are simply not the best method for assessing wines.

I haven't even offered my biggest objection, which applies to mass tastings of wine regardless of whether they are blind. These mass tastings simply bear no relation to the way most people drink wine, nor do they account for the fact that good wines change and evolve, not just over the course of a decade as they age, but over the course of an hour after they have been poured into a glass. The quick sniff and taste simply captures a moment. It's like when the music stops in a game of musical chairs—whoops! Sometimes it stops at a good moment, and sometimes not.

If you really want to get to know a wine, you need to open a bottle, pour yourself a glass and drink it, preferably with a meal. It could easily be argued that if you really want to know a wine, especially a good wine, you need a case, not just a bottle, so that you can track its evolution over years. Let's be clear—I'm talking about good wines, wines that are not necessarily expensive but are alive and are made

with care. Industrially made wines are more predictable, like mass-produced foods, where consistency is the foremost consideration.

But of course tasting wines over many years would hardly be practical. In fact, for writers to restrict themselves to assessing only wines that they have consumed with a meal would also be impractical. Thousands of wines come out every year and one's diet, not to mention one's liver, would hardly be up to the task. So, by necessity, we settle for mass tastings.

I accept that. You could even say I embrace it, as I regularly participate in these sorts of tastings. If that's a contradictory position to take, so be it. As I said, wine must be seen in all of its contradictory, ambiguous glory. What is missing, though, is the clear understanding by consumers and wine authorities that these mass tastings are not only fallible but often misguided. The scores and the tasting descriptions are guesses, often educated guesses. But they are not objective findings. Blind tastings do not eliminate other considerations beyond what's in the glass. They simply replace one set of potential influences with another. They should be taken not just with a grain of salt but with whole shakers full.

The Ambiguity of Wine

Every year I look forward to the annual New York tasting of the new vintage from Domaine de la Romanée-Conti, the most exalted producer in Burgundy. It's often held in a somewhat stuffy institution on the Upper East Side of Manhattan—the Carlyle Hotel, maybe, or the Metropolitan Club, where the high ceiling, fluted columns, ornate crystal chandeliers, and gold filigree perfectly match the hushed formality of the occasion.

It always begins on time, as the audience of merchants, collectors, sommeliers, and writers, dressed conservatively, is ushered into the tasting room. Tables have been set with glasses holding small splashes of six or seven reds and one magnificent white. And it ends on time. After an hour, a member of the importing company issues the equivalent of "Thank you, Mr. President," and off we stream into the afternoon. Aside from the soft sound of swishing and spitting, there is little chat or laughter. Mostly we are attentive to

Aubert de Villaine, a slender, courtly gentleman who is the codirector of the domaine and who speaks about the vintage and the wines in slow, careful English, occasionally groping for a word or resorting to a phrase in French.

Here, at this tasting, all the elements that people seem to fear about wine come together. The tiny pours underline the exclusive nature of this particular beverage. The furious note taking as people swirl and taste exaggerates the notion that a hidden language is being spoken, used to describe aromas and flavors that only a trained expert can detect. The stiff, elbow-to-elbow arrangement seems to amplify the danger of making a mistake, of saying the wrong thing or—catastrophe!—knocking over a few glasses. Even de Villaine looks uncomfortable buttoned up in his tie and checked sport coat, as if he would far prefer to be among the vines in Vosne-Romanée or almost anywhere outdoors rather than here in the stilted Manhattan splendor.

In the vast spectrum of opinion that encompasses the community of people who love wine, few would deny the greatness of D.R.C. The wines can cost thousands of dollars a bottle, and, sadly, outside of wealthy collectors or the privileged few who are invited to the tastings, most people will never have the opportunity to drink them. Even sadder, I think, is that people will not hear de Villaine as he speaks about the wines. What he has to say might encourage people who feel anxious about wine to reconsider their fears.

"These wines are quite elusive," he says. "You grasp and lose, grasp and lose." Then, ever the Frenchman, he adds, "They are like women."

So often, we look at wines as if they are the sum of defi-

nite qualities. They smell like raspberries and taste like cherries, we say. This wine goes with fish sautéed in butter and topped with herbs. That wine is just the thing for scallops and cream in puff pastry shells. Drink this wine within the next year. Don't drink that one for ten years.

Amid all the confident authority with which we assert our opinions about wine, perhaps only one thing is actually certain: Wine is ambiguous. Indeed, as de Villaine says, wine is elusive. The minute we think we have grasped the essence of a certain bottle, the wine changes. No sooner are those aromas and flavors set down on paper, in the unmistakably florid lingo of the tasting note, than they are not there anymore, if they ever really were.

The truth is, much about wine, especially how we talk about it, is subjective. What smells like figs and marzipan to you may be pineapple and lemon to me. And here lies a problem: What happens when these fleeting aromas and flavors, which differ so widely depending on who is perceiving them, are described with such omniscient certainty by wine authorities?

If your level of wine confidence is not already high, doubt enters the mind. One can almost hear the anxious internal inquiry: Why don't I smell the blueberries, plums, and linzer torte? What's wrong with me? I guess I just don't get wine. . . .

The tension between ambiguity and certainty is at the heart of wine anxiety. I don't expect it to go away. After all, why should the world treat the complexity of wine any differently than it treats the complexity of politics or religion?

Much of the world has little patience or ear for nuance

today. It hears shouting. It hears absolutes. It hears certainty. It wants to see the world in blacks and whites. It wants to frame the debate—about wine, politics, the economy, whatever—as a Manichean battle of good and evil. Leaving room for doubt is not what people want. They crave certainty. Yet with wine, which is complex, nuanced, and ever-changing, certainty is an enemy.

I would be foolish to deny the power of certainty. History reminds us all, over and over, in politics and religion, of the power of certainty. The destructive power, I might add.

In the wine field, certainty may be a good thing from a business point of view. It helps to make things simple. "Drink by 2014," a critic will assert. Simple. Yet nobody will remember such a directive when they're enjoying that bottle in 2018. Somebody's vintage chart tells you that 2000 was a bad year for Napa cabernet, while 2005 was a great year. Simple, right? Yet a 2000 from a good producer with dinner tonight may be absolutely delicious, while a 2005 may smack you over the head with its dense, youthful tannins and powerful fruitiness, and blot out the flavors of the food.

Wine, like so many things, is rarely simple. It can be simplified, which is often desirable, but it is not simple. Take the notion, repeated so often to perplexed wine novices, "All that matters is what you like."

Well, yes, of course. Everybody's taste is subjective, and we all like what we like. It's a great thing when people can identify their preferences, and a challenge in this country, where people often feel inhibited about their tastes in wine.

In fact, with wine, just as with books, art, theater, movies, and food, nobody need ever proceed beyond their

own preferences. Yet one should never mistake one's own likes and dislikes for an objective notion of good and bad. For example, to my mother's great chagrin, I've never loved Mozart, whose music she has passionately adored for almost her whole life. As a teenager I might well have been foolish enough to announce, to anyone who cared to listen, that Mozart sucked. Of course, nobody really wanted to hear my opinions, and eventually I came to understand that whether or not I personally was moved by Mozart's music was irrelevant to its greatness.

Yet with wine, we are all too often subject to the equivalent of "Mozart sucks." Opinions, from those who are qualified to have them and those who are not, are too often wielded like clubs to justify one's own position and to attack those who disagree with it.

I'm not suggesting that every opinion should carry equal weight, and I'm certainly not asserting a theory of general wine relativity. I'm just saying that when we toss out labels like "good" or "bad," we need to offer reasoning beyond the simple "I like it" or "I don't like it."

To offer such reasoning requires time, energy, and thought. To receive it requires interest and an attention span. Far simpler to sip, spit, say it tastes like berries and cherries, and give it a score. Much easier to look for the certainty of high scores and buy the wine. Easiest of all would be to call those who disagree with you a bunch of idiots, a conspiracy of grasping fools, the wine police, the antiflavor elite, or whatever. Shouting and name-calling and easy solutions make for lucrative television and talk radio, so why not for wine?

As important as it is to recognize the subjectivity of one's own opinions, it's equally crucial to understand that achieving an objective view of wine is exceedingly difficult. Many writers have tried to define a standard for greatness. The wine critic Robert M. Parker Jr. in his 2005 book *The World's Greatest Wine Estates* does a good job of listing eight characteristics that great wines have in common:

1. the ability to please both the palate and the intellect
2. the ability to hold the taster's interest
3. the ability to offer intense aromas and flavors without heaviness
4. the ability to taste better with each sip
5. the ability to improve with age
6. the ability to display a singular personality
7. the ability to reflect the place of origin
8. the passion and commitment of the producers

Few would quibble with any of these characteristics. Yet even if all wine authorities were to accept each of them, you could bet they would be at one another's throats over which wines actually met the criteria.

Recognizing the limits of one's own taste is far more of a struggle than most wine authorities would like to admit. You will often hear critics insisting that others must grasp the difference between objective and subjective, but rarely if ever will you see them demand this same admirable flexibility of themselves. So I will say it straight out: I have a great deal of difficulty recommending wines that I don't care

for myself. Oh, I've written about wines that I thought were well made though they were not to my taste. With wines we don't especially care for, such damning with faint praise is pretty much the best you can expect from me and from most other wine writers.

Is this a contradiction? A lack of rigor? Perhaps. Certainly, it illustrates a gap between a critical ideal and the limits of the human senses. Yet for all the differences in taste among critics, a Venn diagram of their favorite sorts of wines would indicate a significant overlap. Most likely, these would include the classic wines, the ones that generations have all agreed were worthy of the imprimatur *great*. They in fact would not be unfamiliar to the nineteenth-century connoisseur.

Hmm, was all this talk of vast changes in wine and among consumers pointless, since the canon of agreed-upon great wines is the same as it always was? Not at all. The world of wine has become far more democratic than it was one hundred years ago, or even forty years ago. More people have more access to more wines than ever before, so naturally they have more to say about it. With the arrival of the Internet, the number of opinions on wine has increased exponentially, as has the number of arguments and disagreements. More voices have more weight. Instead of one body of wines universally recognized as superior, we have many sets of wines thought to be great, each by their own balkanized, ever-certain clique of fans, each convinced of their own righteousness and dismissive of the rest.

———

The truth is that wine—good wine—refuses to conform to anybody's need for certainty. Good wines are alive. They change. As de Villaine so wisely says, they are elusive. They are not static, so a score today can be worthless tomorrow or next month or next year. Good wine is nuanced and subtle, and one must recognize the potential of good wine to go its own way regardless of any desire to sum it up in a phrase. Certainty is the enemy of good wine.

Many people falsely assume the opposite of certainty is indecisiveness. Nothing could be farther from the truth. Doubt is the opposite of certainty: doubt and questioning. The clerics who denounced Galileo were certain. Galileo arrived at truth through doubt and questioning. Of course, the clerics could simply assert their position. Galileo had to marshal evidence to explain his. Not simple.

How does that apply to wine? I have no simple answer— but you already knew that. I look to de Villaine, who makes some of the greatest wines in the world. As much as his audience at the annual tastings craves certainty—"How would you assess this vintage?" they ask him. "How long will these wines last? Name a vintage that this reminds you of?"—he refuses to commit himself. With each answer he expresses doubt and uncertainty, underlying the fragile ambiguity, the tension and polarity, that is at the heart of great wine. For him, it is a question of nuance, subtlety, and complexity, not certainty.

We all begin at the same place, knowing nothing about wine. Some of us, because it becomes our business, our passion, or our obsession, think endlessly about wine, and drink it as often as possible. Some of us go on to make wine and

even, like de Villaine, to make great wine. We approach it from every angle, analyze it intuitively and scientifically, historically and literarily. In the end, if we are being honest, we admit that good wine is elusive, uncertain, cryptic. We can learn a lot about wine—but what's in the glass at a particular moment almost never represents the full potential of a good wine. It offers a moment, a suggestion, which we can characterize, but it is almost never completely knowable. As the English writer Hugh Johnson once put it, "Great wines don't make statements, they pose questions." I don't think truer words about wine have ever been written.

Discovery

I have a confession to make, several of them actually: I have found wine confusing, and sometimes I still do. I've made plenty of mistakes when I've been given a glass of wine and been asked to guess its identity. I don't consider myself a gifted wine taster, nor do I aspire to become one—but I can tell you whether I like a particular wine and why. I don't know off the top of my head what the weather was like in Bordeaux in the summer of 1961 versus the summer of 1959. But I have the right reference book on my shelf, in case I have to look it up for some reason. Would it surprise you to know that wine has occasionally made me feel anxious, though most of the time it simply makes me very happy?

I hope not. I believe that everybody who really likes wine at one time or another feels uncertain about it. That's not an issue. It only becomes a problem if we imagine that our uncertainty is somehow isolated, and that if we really understood wine we'd always feel confident and assured, the

way wine authorities are supposed to feel. Me? I feel confident in my uncertainty.

Back in 1992 I began a new column called "$25 and Under," reviewing inexpensive restaurants for the *New York Times*. Shortly after my first column was published, an editor called me into his office.

"Congratulations!" he said. "You're now one of the foremost authorities on restaurants in the country."

Having written all of one column, I naturally asked him if he was insane. But the more I thought about it, I decided he had a point, exaggerated though it might have been. I was well aware of how little I knew at the time. But regardless of my callow state, the fact that my name was on an opinion column in the *New York Times* conferred an undeniable authority on me, regardless of my lack of experience. Now I would have to do my best to earn that authority.

Many other things came from having my name on a column, some of them quite amusing. Back in those days before the Internet, mobile-phone cameras, and ubiquitous surveillance techniques, it was still possible to maintain anonymity, which I found desirable. It meant that I could come and go in restaurants without being bothered. It also meant that readers were free to form their own opinions about my appearance, manner, and personality. If they actually met me, they were invariably surprised. Why? Restaurant reviewers begin life with a somewhat stereotyped image. This is even truer of wine writers.

Contributing somewhat to any misimpressions is my somewhat insufferable job title. I am the Chief Wine Critic of the *New York Times*. It sounds august, right? One of the

foremost authorities in the country, as my old editor would have said. And certainly the designation "chief" suggests that I have a fleet of assistants fetching bottles, polishing glasses, answering the phone, and making reservations for lunch.

I love my job and am grateful for it every day. But the sad truth is, I have no staff, no aides, and most days, no reservation for lunch. I am the chief and only wine critic. And while the *New York Times* is as stately an institution as any still standing in the newspaper world, putting together each day's issue is far more of a sweaty, desperate effort to meet deadlines than the decorous, orderly affair that many people seem to imagine, despite the way newspapers were portrayed in old black-and-white movies. Popular culture continues to harbor "Old Gray Lady" images of the *Times,* just as clichéd ideas of wine critics live on and on.

Not so long ago an editor from *Men's Journal* magazine called me. "We're doing a story on people with really cool jobs," he said, "and we'd love to photograph your wine cellar. It must be really cool!"

"Dude," I replied—using a word that I reserve for only the most appropriate occasions—"Dude, are you insane? I'm a journalist living in a tiny Manhattan apartment with my wife and two kids—who, I might add, attend private schools that I somehow imagined I would be able to afford on a journalist's salary. But if you want to photograph my wine cellar, here's what you do.

"Go out to Brooklyn, where my friend Larry's parents live, and in their basement Larry and I have rigged up some shelves and cinder blocks, and that's where we keep our

long-term storage. It stays pretty cool down there—at least, I think it does. Otherwise, I have a couple of wine refrigerators, which you're welcome to photograph."

He said he'd get back to me.

The image of the wine cellar is an attractive one. It certainly fires my imagination. I'd love to have a vast, or even a little, retreat where I could go to fondle my bottles, daydreaming about the pleasures awaiting me. Isn't that what happens in wine cellars?

We assume wine to be a domain of the prosperous, the property of those who have already achieved creature comforts, or have had them handed down to them. We think of manor houses with quaint names and older, well-upholstered men bedeviled by gout, red of face and big of nose.

If you live in a big city, though, you begin to see wine from another, younger perspective, of hipster wine bars in unexpected neighborhoods, where a different kind of insider knowledge that comes of worshipping indie-rock kinds of labels takes on a different sort of exclusivity. Either way, wine remains a clubby, exclusionary hobby viewed from afar with fear and suspicion.

Personally, I'm not overly concerned with what people think of me or of my taste in wine. After spending twelve years reviewing restaurants and another twelve years writing about wine, I've heard and read an awful lot of wrong assumptions and erroneous facts about me. I've actually received death threats for reviewing the wrong pizza place and anti-Semitic mail because I happen to love ham, which gives the fundamentalist Jews and the Jew-haters something in common: They don't like a Jew who likes ham. So I've

developed a thick skin and essentially don't bother trying
to correct anybody who's published mistaken information
about me. But now I think I have a good reason to paint a
more correct picture.

Preconceived notions about me often reflect people's at-
titudes about wine. People who've never met me almost in-
variably anticipate that I will be stuffy, intimidating, portly,
smug, intolerant, pretentious, or just plain snobby, if that's
not too much of an oxymoron.

Why on earth would they think that about me? Because
wine is always cast as a connoisseur's game, and we all know
what wine connoisseurs are like, right? They are omniscient,
intolerant, arrogant, and all that goes along with these un-
lovable attributes. I'm not surprised by this image—it's in
our culture. But if I think about it too long, I become mysti-
fied. Wine is one of the coolest things in the world! To love
it is a great joy. Why do we make it so hard?

I won't say that the prevailing wine culture has not pro-
vided ample reinforcement of these stereotypes. Some people
who go into the wine-writing trade or related occupations
adopt a supercilious pose because they've heard and read re-
peatedly that wine connoisseurs behave that way. The power
of suggestion is powerful indeed. Others go so far out of
their way to drape wine in casual, informal garb that the net
effect is just as ridiculous as the stiff and ponderous approach.

These preconceived notions about wine and the people
who love wine, often reinforced by the wine trade, can be
damaging. They interfere with the pleasure so easily avail-
able in wine, putting up unnecessary obstacles to enjoyment.

I don't know for sure how best to deflate these overblown

stereotypes. But I can start with myself and describe my own experience of becoming fascinated with wine. Perhaps it might expand the notion of who can understand wine and who cannot.

I don't mean to say that I lead an inspiring or emblematic life. It may be that my life has been decidedly ordinary, which makes my overall point even stronger—that anybody can learn to love wine. Loving it, of course, is not the same as being an expert. But to me it is a prerequisite, and far more important a goal.

At least in my own mind, I don't fit any of the stuffy, well-stuffed clichés about wine connoisseurs. To begin with I'm now in my midfifties, happily married to my wife, Deborah, with two sons in college. I love to eat and drink, but I've never made wine. I like to cook, but I'm not fussy about it. I love to read, and I love music—mostly old rock and roll, blues, jazz, and country—roots music. I love sports, watching and playing, although it's fair to say I don't get off the ground much on my jump shot anymore. But I can still throw the hardball around with my sons. I've trained in jujutsu and aikido for thirteen years now.

As a New York kid my fantasies were the usual material: play shortstop for the New York Yankees, point guard for the Knicks, or guitar in a band. But as a teenager, a time when I might have pursued garage-band dreams, I instead became obsessed with food and wine.

It certainly was not something I set out to do. In fact, as a sullen, self-centered, girl-crazy fourteen-year-old, what

I ate was pretty much unimportant to me as long as it was a hamburger. My mother seemed to fear above all that my younger sister, Nanette, and I would become what she called spoiled brats. No doubt I gave her plenty of reasons to worry about that.

This particular summer after the ninth grade was working out quite well for me. We lived in Roslyn Heights, a pleasant, shady Long Island suburb. In my preteen summers, I'd leave our Levitt-built house—Levitt of Levittown, that is—early in the morning for a day of baseball and basketball, returning only for meals. But for the first time in my life I had my eye on a girl, and I was getting very close to this lovely classmate. My hormonal craving didn't much matter to my parents, though. They were planning to take a trip to France—a big deal in those days before air travel became cheap and frequent—and, with my sister away at a summer camp, they were not about to leave me at home by myself. This did not sit at all well with me. Rather than accept my good fortune at having the opportunity to take a wonderful trip, I was disgruntled and not shy about expressing my unhappiness.

It was not an argument I was bound to win, so off we went, me in a horrible snit. I mooned about Paris, walking by myself through the streets of Saint-Germain-des-Prés, taking existential comfort in my martyred discontent. I was already an old-movie buff at fourteen, and I found a used bookstore on rue Dauphine where I bought a guide in English to the films of Humphrey Bogart. There I was, brooding and churlish, wishing I was back in New York and romanticizing myself as a world-weary Hollywood tough

guy. Nightmare! I still tease my mother, "Mom, we'll always have Paris."

It was a pique that did not wear off until Mom, in utter frustration, sent me out to lunch with my father and a couple of his friends who worked in Paris for the *International Herald Tribune*. Did I mention that my father was a newspaperman? That's what they were called before somebody decided that journalist sounded more important.

I'll never forget the restaurant, Allard, which is still open today, though not, perhaps, the archetypal bistro it seemed to be back then. As Dad and I walked in through the door—as usual giving it an unsuccessful American push before remembering to "tirez"—I saw the zinc bar, the paneled walls, the worn wooden floor, the soft leather banquette, and the waiters in their long black aprons and white shirts. I heard the clatter of glasses and dishes, and a convivial hum, broken by the occasional guffaw or voice raised to make a trenchant point.

We took a table at one end of the room, joined by my father's friends Dave and Bernie. My father spoke no French and really had no facility for languages. But, like all Asimov men, he was motivated by his stomach, and when faced with the French custom of serving dessert before coffee, and the unthinkable prospect of forgoing his habit of alternating bites of a sweet with swigs of black coffee, he eventually did learn to bleat out a plaintive, "Café avec le dessert, s'il vous plaît!" I had my elementary-school French, and with advice from Bernie and Dave, I managed to order quite the presentable lunch: entrecôte, haricots verts, and gratin dauphinoise.

To this day I can't remember anything in my life that

tasted better than this simple meal—rib steak with sublimely delicate, flavorful green beans and sliced potatoes oozing with cream and cheese. More than a delicious lunch, it was a revelation, a turning point—like the time a friend played a record for me of the abstract, seemingly abstruse music of Charles Mingus—crazy jazz—when suddenly it clicked and made perfect, soulful sense to me.

Back then, in the pre-Watergate 1970s, the culinary mystique of France was still at work. Food there indisputably tasted better, partly because the ingredients served in the typical American household, grown and processed for convenience, were so bad by comparison. Frozen green beans, commercial beef, and supermarket potatoes were all plentiful and cheap. American society had succeeded in creating a system of food production and distribution that was astounding. But flavor and quality had been neglected almost completely.

The green beans at Allard had a texture so different from the tough, rugged American beans. It was as if flavors, such dull shades of dreary gray before, had come alive in bright, beguiling colors. The beef had a tang and savor to it, and I was given a little bit of Beaujolais in my glass to taste with it. The wine itself was not an epiphany. In fact, I don't remember much about it at all, apart from a bitter, fruity sensation. But its presence made an impression on me. It was intrinsic to this wonderfully delectable meal. It belonged there, and I belonged there. The wine seemed to complete the sense of pleasure at the table.

I don't remember what we had for dessert—I've never been the biggest dessert eater. And I can't say that meal made

me less of a sullen teenager or alleviated Mom's fear that I
would become even more recalcitrant. But it changed my
life.

From then on I became a dedicated eater and restaurant
lover. I was a burden to my friends walking down a city
street. They rushed ahead of me to visit a record store or
catch up with some girls, but I lagged behind, finding it
constitutionally impossible to pass a restaurant without stop-
ping to examine the menu. I learned the rudiments of cook-
ing from my mother—how to scramble eggs so they'd be
feathery light and creamy rather than leathery, how to cook
a juicy, seasoned hamburger rather than a dried-out hockey
puck. I never developed the laboratory curiosity about in-
gredients that motivate the best chefs. I just wanted to assure
myself of having something good to eat.

I started to read cookbooks or, more precisely, books
about food. It was not recipes I was so much interested in, but
the culture and context of eating. I remember *Beard on Food,*
a collection of James Beard's essays that did not merely offer
arid recipes in a vacuum but placed each dish precisely in a
context of company, geography, and time. Edward Giobbi's
book *Italian Family Cooking* told stories of larger-than-life
Italian immigrants forced to hunt, fish, plant, and vinify
the ingredients they needed to re-create the joyous eating
culture of their lives in Italy. I loved Calvin Trillin's book
American Fried, for its evocative, mouthwatering message that
great food could be found anywhere. Later, I devoured Jane
and Michael Stern's *Roadfood* books as I took road trips of

my own around the United States, plotting my journeys to follow a scalene geography mandated by the location of cafés and truck stops, barbecue joints and fish shacks.

I liked wine, though as a high school student I liked beer much better. This was the 1970s and the country, with its mind on things like the Vietnam War and Watergate, was pretty laissez-faire about teenagers and their experimentation with drugs and alcohol. The drinking age was eighteen, not that anybody really thought about it. My friends and I never drank to excess, except for sometimes. But I also had an analytic attitude toward drinking early on.

In my junior year I began to write beer reviews for my high school newspaper. Three or four friends and I would gather for blind tastings in my bedroom, the stereo blasting Hendrix, Dylan, or the Doors. One of us would be designated to pour the beers into glasses and then serve them, identities withheld. Then we'd give it our best shot, analyzing the beers for aroma, flavor, body, and texture. Spit? Are you crazy?

Why the school allowed us to print beer reviews, I don't know. But in the rebellious spirit of the early 1970s, teenagers were permitted liberties that we now find perplexing. What we regard as dangerous today was back then thought to be experimental, and this feeling of daring and adventure extended in all directions, even to the suburban quietude of Roslyn Heights where, in the era before playdates, AMBER Alerts, and mobile phones, parents would think nothing of not hearing from their kids for hours.

Even our newspaper at the Wheatley School, where I was the features editor, had taken the rebellious stance of the

times, changing its name from the school-spirited *Wheatley Wildcat* to the pathetically bellicose *Wheatley Free Cat*. I guess no administrator wanted to mess with dedicated revolutionaries and their beer reviews, no matter how slack-jawed and pimply we were. Still, some thirty years later, as I was writing a column on India pale ales for the *New York Times,* I couldn't help thinking that I had found my destiny early on and just hadn't realized it.

My taste for beer was not inherited. Mom and Dad didn't drink much of anything as far as I knew, though they had a fully stocked liquor cabinet. As a child I had always been curious about all those bottles. Why did they have three bottles of Scotch and two of bourbon, all opened, all with different labels? What set each one apart from the other? Why was the Cherry Heering dressed like a pinup queen in its bottle of red velvet? Sometimes I would open the bottles and sniff them, committing the scents to memory. Occasionally, I would even taste them. Dad said the bottles were kept for guests, and to this day I have no reason to doubt him. I never saw him drink a cocktail at the end of a long day, nor drink a beer, though he did occasionally enjoy wine, especially toward the end of his life.

I had tasted beer as a child and naturally found it unpleasantly bitter. As a kid I loved soda, what else? Mom wasn't worried about an overdose of sugar. Instead she was concerned that I didn't like eggs and therefore lacked whatever miracle health-giving properties resided in these, nature's perfect meals. So every day of my preteen life she'd break a raw egg into a glass of milk, stir it up with a little vanilla flavoring, and watch carefully as I, complaining all the while,

drank every drop, hopefully in one gulp as I tried to mini-
mize the chance that egg flavor would make contact with my
taste buds. Somehow, this forced regimen did not turn me
into an egg-hater for life. Today I love eggs, though I almost
never drink milk or soda.

But back then, I drank Coke and Dr Pepper, 7Up and
Hoffman's Black Raspberry. I loved root beer, but above all
I was a fan of Mountain Dew. This was just a simple lemon-
lime soda, not the amped-up, hypercaffeinated beverage of
today. But when I came in from a day of baseball, street
hockey, or basketball, sweaty and parched, nothing was
better than a cold Mountain Dew.

In my preteen years, back in the late 1960s, my friends
and I liked to ride our bicycles to what we called the penny-
candy store. This particular shop still sold the one-cent can-
dies that my father and uncle, who grew up working in their
father's candy store in Brooklyn, knew so well—jawbreakers
and Atomic Fireballs, Root Beer Barrels, Mary Janes and
Smarties. They were the reward at the end of the two-mile
ride, made sweeter by the thrill of passing through enemy
territory, a stretch of blocks housing a few teenage anti-
Semites who would try to knock us off our bikes, if they
could catch us.

Like any candy store back then, this one had a lunch
counter, too. Hamburgers sizzled on the open grill, as Chuck
Berry once sang. Best of all were the sodas, which were not
prefabricated but were made to order in voluptuously curved
glasses held in silver caddies. The counterman would squirt
in some Coke syrup and then add seltzer and stir. I felt truly

lucky if he added a little more syrup than usual, leaving a sweet cola-flavored residue on the bottom of the glass to suck up through my straw.

As with any sugar-drenched soda drinker, the bitterness of beer was disturbing, almost a swift slap to the taste buds. My good friend Allen lived next door, and his father used to swig Ballantine ale in the evening. One night, when he had stepped away for a moment, I snuck a swallow. Instead of the rush of sweet, sugary flavor I was expecting, I got a grainy, bitter blast. For a youthful palate—I was eleven—it was a rude shock. But I adapted. And as I passed my sixteenth birthday I came to like it, especially in the social context of enjoying beer illicitly with my friends.

Yes, I liked to drink. I knew it was not permitted and that it was against the law. I was secretive about it—it would not have done to announce to my parents that I was going out for a few beers with my friends. Yet the line of demarcation was not as strict as it is today. In the summers I worked in the kitchen of a sleepaway camp in Vermont. The staff of counselors, mostly eighteen to forty, would have a party each Saturday night throughout the summer, to which we kitchen workers, fifteen, sixteen, or seventeen, were always invited. There would often be a keg of beer, and we were encouraged to partake. And, yes, I was writing beer reviews for my high school newspaper. So, if the civil authorities of school and camp did not protest, how bad could it be? I did not pretend not to enjoy beer.

I will also say that as much as I liked the novel buzz of a beer or two, I didn't enjoy getting drunk. Certainly, my first

experience of the dizzying, disorienting spin of the room as I tried to fall asleep and the head-pounding, dry-mouthed agony of a hangover discouraged me from overindulgence.

I found, as best as I could determine as a teenager, that I did not have an addictive personality. I had friends who seemed incapable of not drinking themselves to oblivion, but I seemed to know when to stop, when to leave things alone. I never did care for cigarettes—though in my Bogart phase I did develop an affectation for Chesterfield nonfilters, Bogie's brand. I would stand in front of a mirror, trying to figure out which method of holding the cigarette looked coolest. There was the Bogie style, two fingers on top, thumb underneath, also popular in World War II movies. There was the effeminate British rocker look, palm facing the mouth, the cigarette facing outward between index and middle fingertips, and the Spock look, cigarette clenched between middle and ring finger, reverse Vulcan-greeting style. It didn't really matter in the end—I hated cigarettes.

I turned eighteen just before I entered college, which was convenient as at least it made drinking legal. Just as the mid-seventies was a dark time for hairstyles and fashion, it was a nadir for beer lovers regardless of the drinking age. Local breweries had largely disappeared, either going out of business or having been absorbed by bigger units, and the market was dominated by bland, insipid brews. For a while back then, Coors was considered a cult beer on the East Coast. It wasn't distributed in the east, and the actor Paul Newman became identified with it for some reason, bizarrely lending his cool left-wing persona to a product that was owned by a family that was far to the right. If you listened to their

marketing, something about cold Rocky Mountain springs, you could fantasize that you were drinking something of rare purity. One winter night in high school, my friends and I had somehow gotten hold of a six-pack of Coors, which we buried in a bank of snow. We imagined we were drinking the cleanest, purest, coolest beer around. But really, I couldn't understand what all the fuss was about. I knew that Coors was as bland and boring as any other beer.

Looking back, I'm both amazed and happy that I was that concerned with how things smelled and tasted. As a teenager I wasn't particularly sophisticated. I didn't go to expensive restaurants or, Allard notwithstanding, develop a taste for French cuisine. But I do remember having a fresh egg for the first time one summer while visiting a friend on Martha's Vineyard. The eggs came from a chicken that lived next door. The yolk was a rich, warm, inviting yellow, and when the eggs were scrambled they, too, turned this deep color. And when I put a forkful into my mouth, it was as if I had never tasted an egg before, not a real egg, at least, regardless of Mom's egg fixation. The depth and concentration and lightness and intensity in that one bite eclipsed any egg dish I had ever had. And why was this? Simply because it was fresh and real, and not freighted with commercially desirable characteristics that had nothing to do with flavor.

This being the 1970s, I smoked my share of marijuana in high school and college. Experimentation was the ethos. I was eager to try just about anything. Nowadays, I'm sure I would be scared to death. I mention this only to bring up

the well-known side effect of pot smoking, which we used to call the munchies. Getting high would make even the most ridiculously inane foods taste great.

"Hey, man, don't bogart those Doo Dads!"

Did the pleasure of the stoned eating experience contribute to a fixation on food? Maybe, but I can't imagine that it led to a focus on the quality of ingredients, as pretty much anything tasted good. I will say, though, that I knew a lot of marijuana connoisseurs back then, students who could tell you in detail the differences in the buzz between a Thai stick, say, and golden buds from Mexico. That sort of connoisseurship was not really for me, and in fact, I lost my taste for marijuana when it began to get stronger and more expensive. I preferred the joyfully mild high of $20-an-ounce weed far more than the catatonia I experienced from $100-a-quarter-ounce sinsemilla, the standard by the time I got to graduate school. I gave it up for good in my early twenties.

While I entered college with a budding appreciation for fine but simple foods, I did not turn up my nose at the sort of things that typically found their way to dormitory parties back then—grain-alcohol punch was very popular. But I didn't want to settle for bad beer, either. I remember my very first night at Wesleyan University in Connecticut. As the college president droned on in his ceremonial welcoming address to the incoming freshman, a like-minded friend and I sneaked out so that we could get to the package store to buy beer before it closed at 8:00 P.M. Beer in hand, we returned to our dormitory to get down to the business of getting to know each other.

I could settle for Budweiser and Miller, the standard brews of the day, and of today for that matter. Imports like Heineken and Beck's were considered top-quality, though even then I knew better. And besides, we couldn't afford them. But we didn't have many alternatives. Still, I kept my eye out for rarities like Ballantine India Pale Ale—always a thrill to find—and Haffenreffer's, maybe not so rare in New England but still with a little more flavor than most. And it came in sixteen-ounce bottles nicknamed "green monsters."

Other than the occasional bottle of jug wine, beer was the preferred beverage of my undergraduate years. Unlike Oxford and Cambridge, where esteemed British wine writers like Jancis Robinson and Hugh Johnson underwent rigorous training in preparation for the two schools' annual wine-tasting match, Wesleyan University had no wine cellars. We had no training regimen, nor was there a Wine & Food Society, as at Cambridge, which, in Johnson's telling, was considered by the wine trade in London as a lucrative breeding ground for future customers. And so the British wine culture, residing primarily in the elite class, perpetuated itself.

Wine appreciation in the United States was not officially sanctioned back then by the bastions of higher education, or at least not by my bastions. I was once invited to a professor's apartment for dinner, and he opened a bottle of Korbel, a mass-produced California sparkling wine that in the 1970s was thought to be sophisticated. My real indoctrination into wine drinking would have to wait a bit, until I finished my undergraduate education and took off for several months of travel through Europe.

As much as I was interested in seeing the sights of Europe, I was interested in eating the foods of Europe. I scoured the guidebooks and planned my trip, meal by meal, from Norway to Greece, just as I had for my American road trips. Of course, I was traveling on a student budget, the saved proceeds of after-school jobs. I had a three-month Eurail pass and lists of cheap hostels and pensiones where I could set my backpack down. When I could, I took overnight trains to save on lodging. I wasn't exactly planning to splurge on food, but I made lists of the best cafés, rathskellers, railroad workers' cafeterias, *rijsttafels,* osterias, and sausage stands I could find.

In France, in Italy, in Greece, and in Spain I got in the habit of drinking wine with my meals. Not world-class wine, not even close. I was a student, after all, eating joyously in the cheapest of places, drinking flagons of simple house reds, whites, or rosés, memorable not because they Heimlich-maneuvered me into coughing up mouthfuls of adjectives but because these humble wines, dry and low-key, seemed to make every meal better.

It never would have occurred to me to try to describe these wines in the flowery, fruity language that too often passes for wine writing today. Did they taste like blackberries or gooseberries, violets or elderflowers, tar or, as a fellow in Campania once described a wine to me, "like crème de cacao that came out of a Bedouin's ass who had a high fever three days ago"? Who cared? The wines tasted good, they made the food taste good, they made meals more convivial, and occasionally they helped to make new friends.

Once, sitting in a little restaurant on a seaside main drag in Nice, I had splurged on steak frites with haricots verts, still trying to understand how the French could make green beans taste so good. Naturally, I had a pitcher of red wine, the uncomplicated kind that is so inviting you have to have a sip after each bite of food, rather like my father with his coffee and dessert. From across the room I heard a couple at another table speaking English, or at least one form of it. "Do you hear those Australian accents?" I said to the American woman sitting next to me, taking another sip.

"What do you mean accents, mate?" came a booming voice from the other table. And so began one of those weeklong friendships among low-budget backpackers, who discover mutual interests and itineraries that align ever so briefly. I thought my three-month trip was a big deal. We invited them to join us at our table and share our wine. That's when I learned that when Australians leave home to see the world, because of the distance and expense involved, they seldom go for less than a year or two.

On returning to the States, I made ready to enter graduate school. I loved college and never wanted to leave, and it was my plan to get my doctorate in American studies and become a college professor. Actually, I had more vague hopes than conviction on that score. I was a good student, but not a great one, though I did earn a fellowship to join the American Civilization program at the University of Texas at Austin.

Texas? For a Jewish boy from New York this was not

part of the formula. It wasn't the Ivy League. It wasn't any-where close. As far as I was concerned, Texas was the south, it was JFK and Dallas, it was cowboys with pickups and gun racks. It was guys who, as the old comedy routine had it, could compress the word *Jewish* into one mean syllable—"So, you're Jewsh?"—but stretch out *Jew* into an endless, perplexed, threatening litany—"Hey, fellas, he's a Je-ew-*ew*-ew!"

That wasn't my Texas, though. For me, Texas was Austin, and that meant rock and roll, barbecue, and Tex-Mex. It was country music, but blues and reggae, too. People I spoke with at the university tried to reassure me that Austin was a tolerant, hippie oasis in a redneck desert. But actually, when I did get to explore Texas, not only the central Hill Coun-try surrounding Austin, particularly Fredericksburg, but also farther west to San Angelo, south to San Antonio and Laredo, and over to Corpus Christi on the Gulf of Mexico, I found that I loved it, all of it. I love Texas to this day.

It did have some drawbacks, however. Scorpions were an annoying problem. You could find them on a sidewalk, in a garden, sometimes even in a house. And Austin was maybe a little too hip for its own good. Sixth Street on a Saturday night was a deadly mix of white guys in shorts puking on corners, their blond girlfriends with their Add-a-Pearl neck-laces looking fearful or just bored. The Sixth Street rock bars, with names like Club Foot, were packed, the music loud and dull. You could find great music in Austin, but not on Sixth Street. It was there on Sixth Street that I learned the essential truth about Austin: "You shoulda been here five

years ago," a weathered rocker told me. "That's when Austin was really great."

About twenty years later I was back in Austin covering a story for the *Times* and I struck up a conversation with some guy at a bar. "You shoulda been here five years ago," he told me. "That's when Austin was really great."

It has ever been so. Nonetheless, I loved Austin. In New England, colleges would have statues of revered presidents or religious leaders scattered about campus. At the University of Texas the primary edifice was a mock-up of Santa Rita No. 1, the oil rig that hit the original West Texas gusher in 1923, on lands owned by the University of Texas. The oil well contributed mightily to the university's coffers, and was at least indirectly responsible for my fellowship. So it was a fitting monument.

My friends and I would take little road trips outside of Austin—to Castroville, known as "Little Alsace." We'd head to Driftwood, where the Salt Lick served wonderful Texas barbecue and Shiner Bock, the official beer of the Texas Hill Country. And we'd head to Fredericksburg, the center of the massive immigration of Germans to Texas in the mid-nineteenth century.

In Fredericksburg, my friend Melissa and her boyfriend, John, were house-sitting at a big, airy place with flagstone walls, a beautiful swimming pool, and a gorgeous vegetable garden. We would visit them to cook and to hang out by the pool. There I heard the haunting story of this beautiful house and the couple who had built it.

The husband was a doctor who had met his wife while

working in Vista, the domestic version of the Peace Corps. Later, he had served in Vietnam, and had been so traumatized by his experience that, on returning to the United States, he wanted to settle far from other people. I'm not sure how they decided on Fredericksburg, which was rural but not isolated, but that's where they decided to build their house. The husband worked for a medical clinic, and he and his wife had a couple of children. By the late 1970s, though, he had become more and more concerned about the prospect of nuclear war. When Reagan was elected in 1980, this became an obsession, and he became something of a survivalist.

On their property he dug an elaborate underground shelter, to which the family would retreat when the bombs were finally dropped. He spared no expense in building this shelter. He didn't want it to be some sort of crude, rustic cave, but a comfortable dwelling for the family. In order to insure a steady supply of breathable air, he installed a compressor and pump to keep the oxygen flowing. One day, while testing out the compressor in the shelter, something went terribly wrong and it exploded, killing him in his supposedly safe haven. His widow and her children left, and John somehow ended up with the task of house-sitting.

Despite this ironic tragedy, we had no difficulty enjoying our visits. It was at this house that I had one of my first memorable pairings of food and wine, and to this day I continually disappoint people who have a vested interest in my epiphany coming with one of their favorite wines, whether Burgundy, Chinon, Bordeaux, or anything else.

It happened to be white zinfandel—Beringer white zinfandel—in all its pink, fizzy, semisweet glory.

White zinfandel is widely scorned and disparaged, and rightly so. It is a mass-produced commodity with little of the beauty or mystery that we associate with great wine. It is not great. It's rarely good. But on this particular night it was wonderful.

I don't remember who bought it or why. I do remember hanging out in the kitchen, shelling and cleaning pounds of Gulf shrimp and mincing garlic. We sautéed the shrimp in olive oil, butter, and garlic, these primal aromas sharpening the appetite, and served the shrimp over linguine with hot garlic bread and a big salad, and with the Beringer white zinfandel.

I never will forget how glorious that meal was. It was as if, for the first time, I could taste how food and wine could fit as one, how a sip of one could augment and intensify the pleasure of a bite of the other. I knew then that food and wine belonged together.

I also knew that this white zinfandel was not a great wine. I felt no compunction to go out and buy a case of white zinfandel, or, really, to have it ever again. Somehow, I did not become fixated on that wine with that food. I only knew that the pleasure of this particular meal was something I would want to repeat for the rest of my life.

It wasn't long, though, before I did have a wine that I thought was great.

Austin of the early 1980s was not exactly a cutting-edge food town. Not that you couldn't find great meals. Right in town the Iron Works served good Texas barbecue, by which

I mean beef brisket, smoky and delicious, crusty around the edges, pinkish-red right under the crust. If you had access to a car, within forty-five minutes of Austin were two of the greatest practitioners of Texas barbecue on the planet. Down in Lockhart was Kreuz Market, where the superb beef was served with a typical scarcity of creature comforts. The carver at Kreuz (pronounced *Krites*) would slice off a few hunks, always by hand, and drop them on a swatch of ruddy butcher paper with a couple of pieces of soft white bread or saltines. If you wanted, you could supplement the beef with a pickle or tomato slice, but I preferred the elemental meat alone. Then you would find a station on one of the worn wooden tables and grab a knife, which was kept chained to a post, as central Texas in the 1980s was presumably deprived of quality cutlery.

As much as I liked Kreuz, my favorite place of all was Louis Mueller in Taylor, a spacious, high-ceilinged room that had once been a gymnasium. Not that you could tell by entering the room. Years of barbecue smoke had layered a gorgeous patina over the walls, ceiling, and wooden floor. Stepping into Louis Mueller was like entering a holy temple of barbecue. All you had to do to get religion was inhale.

The beef was tender and imbued with smoke as if the cow had been born in a barbecue pit. As with all great Texas barbecue, sauce was superfluous. Each gloriously smoky bite made me wish I had been born in Texas, perhaps even in Taylor. Years later I met a woman who had in fact been born in Taylor. As I told her of my reverence for Louis Mueller and how I thought it was the best barbecue in all of Texas, maybe in the world, she kind of cocked an eyebrow and smiled.

"Louis Mueller isn't even the best barbecue in Taylor," she told me. I was so stunned I can't remember the name of the place she preferred.

But Austin had far more than barbecue. There was Mexican, by which I mean Tex-Mex, of course. Some Tex-Mex places you'd go to for dinner, and other places for lunch or a snack, and still others for a breakfast of migas, essentially scrambled eggs mixed with beans, strips of corn tortillas, and salsa. There was Threadgill's, a southwestern place where Janis Joplin was said to have gotten her start, and the Stallion, for chicken-fried steaks, fried chicken and onion rings, and the best hard-bitten waitresses this side of a James Cain novel. Of course, there were any number of hamburger joints and cafés and breakfast spots, too.

Anybody would expect to find those kinds of places in a Texas town. But Austin was also on the cusp of something more. As a New York boy I was shocked to find that Chinese food was somewhat rare. But I tasted Vietnamese food for the first time in Austin, as a small population of Vietnamese refugees had settled there. Steakhouses were beyond my budget, and so were the few small French places that had opened on the periphery of the city center, run by young chefs trying to make a statement in what they hoped would be the welcoming atmosphere of a college town.

A French bakery had opened, too, which I could afford and which was within walking distance of my little second-floor loft apartment. It was called Chez Fred, which in Austin was pronounced *Chezz* Fred. I would go in almost every other day for one of Chez Fred's dense, slender baguettes, which had far more heft and weight than a Parisian baguette,

but which I loved all the same for the doughy, yeasty flavor. Hanging out over coffee at Chez Fred was a great education in what you might call Texas French. More than a few times I heard somebody come in and ask for some of "this here chocolate *gat*-toe." In the fall, wine-drinking Texans' thoughts would drift to "Bo-jo-lay No-*voo*."

Not far from Chez Fred was where I found the first specific bottle of wine I ever loved, at a store that happened to be the very first Whole Foods Market ever. Within a few years, Whole Foods would be on its expansive path to global domination, but in the early 1980s it was just a good-looking grocery on Lamar and Sixth Street, where you could get whole grains and natural oils and where people smoked dope in the parking lot. Yet it was much more than a health food store. You could get meats there, even steaks, far from the vegetarian and patchouli ethos of most health food shops and neighborhood co-ops. And you could buy wine, bottles that were not stacked in cardboard boxes or stored upright on liquor store shelves but displayed lengthwise in handsome stained wooden bins. You got the sense that people actually cared about wine at Whole Foods, which was not something anybody expected in beer-loving Austin, Texas. Far more common were the drive-through Party Barns, where you could pick up a six-pack without cutting the engine. Why, at that time, it was still legal to drink beer while you drove, so long as you didn't speed or run a red light.

I usually went for the big 1.5-liter bottles back then, because I got the most wine for my money. Not jug wines, because these weren't jugs, though they might as well have

been. Many of these bottles came from the south of France, Minervois in the Languedoc, or even from Bordeaux. They were rough, rugged wines, but decidedly dry, and while they weren't memorable or particularly good, they served our purpose of going with whatever kind of cheap food we were preparing.

These were the sorts of wines that nowadays don't sell because their market has disappeared. They were cheap co-op wines from the outlying areas of Bordeaux, or from the great lake of the Languedoc that accounted for so much of the wine sold in France. It was easy to export those wines, too. Back then, thirty years ago, the shelves were not crowded with inexpensive bottles from South Africa, South America, Australia, and California. There was jug wine from California, and from Italy, too. But somehow these French bottles, without the cheesy labeling of the California jugs or the obvious low quality of the big Italian bottles, seemed more sophisticated to our innocent eyes. In the next three decades, winemaking would come of age the world over, leaving French winemakers to riot and demand government aid in an effort to sell their wine. That, or take subsidies to pull out the vines.

I don't know what came over me on one particular evening in 1982, but I decided to splurge. For $8 I ended up with a bottle of wine, from a producer I had never heard of, from a region in Italy I knew nothing about, but it made all the difference to me. It was a 1978 Barbera d'Alba from Giacomo Conterno, who despite my ignorance happened to be one of the greatest wine producers in all of Italy, to say

nothing of his home region of Piedmont in the northwest. Today, a new bottle of Conterno Barbera d'Alba goes for $50 or so. In 1982, it was expensive to me at $8.

I'm not sure how this bottle got to a hippie grocery in Austin, Texas. I do know that back then, few people recognized the greatness of Conterno or of Italian wines in general. If people bought them at all, it was to get one of those fiascos, as the straw-covered Chianti bottles are called, to use as a candle holder, or to get a big bottle of jug wine, offensively known as "dago red." I doubt any books on Italian wines were generally available. There were certainly no consumer wine magazines, and no place to look for information about a bottle.

Of course, this was all about to change very quickly. This was 1982, the year of the Bordeaux vintage on which Robert M. Parker Jr. was to make his reputation as a wine critic. The wine culture of the United States was about to take off. But that was the last thing on my mind. It didn't occur to me even to be curious about this particular producer, this wine, where it came from, or from which grape it was made. I just wanted to open it and drink it with dinner. What else would one do with a bottle of wine?

We were preparing spaghetti with meat sauce, always a joyous party occasion with friends, which was why I had chosen an Italian bottle as my contribution. Other people would bring wine, too. I didn't think much about it as I opened the bottle and poured wine into glasses. It was a pretty, dark ruby-red, luminous, in fact, but what was there to look at? Not until I tasted the wine did I give it a second thought. For this wine was different from any I'd ever had

before. The first thing I noticed was its power. Not strength
in terms of alcoholic kick, but the intensity of its fruit, a
bitter cherry tanginess that quite simply woke up the mouth.
Yet the wine was not heavy or syrupy, like some of those
Italian jug wines. Nor was it sweet—it was absolutely dry, a
term that had taken me a while to get a handle on, but which
I had finally figured out represented an absence of sugar in
the wine. And the flavor lasted and lasted in the mouth, even
after you swallowed. With the rich meat sauce, it was even
better. I was sorry I had bought only one bottle.

Looking back on this night years later, and having en-
joyed many more vintages of this wine, I can say that Bar-
bera d'Alba is not generally a complex wine. It's not a subtle
wine and rarely a great wine. But this was a great Barbera
d'Alba, and I somehow recognized at the very least that this
wine was different from the ones I had been used to drink-
ing. This wine was full of flavor and texture. It was not at all
forgettable. Like the Parisian lunch I'd had at Allard ten years
before, which propelled me again and again to seek out the
joy of discovery and of real flavors, I wanted to love every
wine as much as I did this one. This humble wine—Barbera
d'Alba is one of the everyday drinking wines of the Pied-
mont, steps below the aristocratic Barolos and Barbarescos
of the region—filled me with the ardor to discover just how
much pleasure could be found in a bottle.

The Tyranny of
the Tasting Note

In my years as a graduate student, I didn't know enough to be scared of wine. I had never read a book about wine, or seen a magazine devoted to the subject. I didn't know how things were supposed to taste, or how people were supposed to talk about them. What had fired my imagination were descriptions of wine as part of a meal.

In *Italian Family Cooking,* one of my first cookbooks, and one that I found tremendously inspiring, Edward Giobbi wrote of growing up in the Depression as the son of Italian immigrants. Food was a preoccupation. The aim was not simply to have enough to eat, but to eat well. With little money to spend on the proper ingredients, they took matters into their own hands. They grew their own vegetables and sought wild mushrooms. They gathered mussels and eels, they hunted and fished, they made pasta and bread, and they made their own wine. His father, Giobbi wrote, thought it was degrading not to have wine on the table.

That wasn't my experience growing up, of course, but I adopted the idea. As often as possible when I was a graduate student, my friends and I had wine on our table. We evaluated it just as we did the other dishes in the meal, briefly discussing whether we liked it and why, but no more so than whether the main dish was delicious or not. Looking back now, I feel fortunate to say that I didn't know any better. If I had sought out training back then, say, taken a class or bought a textbook, and learned the proper way to discuss wine, I might have become intimidated, or at least inhibited.

What is it that makes wine so scary to people, especially those who are just beginning to learn about it? Could it possibly be the wine itself? Of course not. Wine is harmless, existing only to give pleasure, though many people would say ruefully that its purpose is to baffle and confuse.

No, what's baffling and confusing is not the wine but the way we talk about wine. Perhaps you've felt the fear yourself, a sort of paralysis that comes over you if by chance you are privy to a discussion among wine connoisseurs and then suddenly are asked for your opinion. It's as if out of nowhere you were invited to expound on some odd point of logic by a philosopher you've never heard of, in a language you barely understand.

Describing a wine may not be an intuitive skill for anybody, but I've found that people who have no idea how one is supposed to talk about wine are far more creative and clear in discussing it than those who have read some books or undergone some training in wine classes. Having internalized what they consider to be a proper wine vocabulary, they can no longer communicate usefully. The words emerge easily

enough, spouting lists of aromas and flavors that they've detected in the glass. Yet, for all their intelligibility, the words are essentially meaningless. It's the way most people talk and write about wine nowadays, and it comes from tasting notes.

What are tasting notes? They are quick descriptions of the characteristics of a particular wine. Nowadays, that usually means a litany of esoteric aromas and flavors. Here are a couple of typical examples from recent issues of *Wine Spectator* magazine:

> *Still tightly wound, with a brooding core of mulled currant, warm fig sauce, and maduro tobacco, liberally laced with tapenade and lavender notes. The finish is long and grippy.*

> *Dark and winy up front with ambitious mocha and loam notes leading the way for fig, raspberry, and red plum fruit, followed by a brighter profile on the finish, where spice and licorice hints kick in as fresh acidity provides solid drives from behind.*

Tasting notes like these are the currency of American wine reviewers today. These particular notes might seem a trifle exaggerated in their jargon, their ungrammatical construction, and their reaching for obscure references, but they are by no means unusual. Some discerning wine writers are periodically driven to satirize this sort of winespeak, but the fact remains: This is the way the vast majority in the wine trade talk and write about wine today, so it can't simply be laughed off by people who take words seriously.

My former colleague Frank Prial, the longtime wine columnist at the *Times*, once traced winespeak back to English academia, "to the Gothic piles of Oxbridge, where, in the nineteenth century, certain dons, addled by claret, bested one another in fulsome tributes to the grape." It would be fair to say that the general public was spared their transporting muse.

Decades ago, tasting notes were largely a kind of shorthand, used by professionals in the wine trade and serious collectors to communicate among themselves. Even so, those sorts of notes did not have the elaborate, almost comical complexity that one sees so often today. Instead, these professionals had a series of agreed-upon characteristics found in particular wines. Gunflint, for example, was a frequent reference point for wines like Chablis and Sancerre. More typically, a wine might be complimented as fine, or denigrated as coarse, without a recital of specific aromas and flavors.

A. J. Liebling, the *New Yorker* writer who gave great weight to fine food and drink, might occasionally be moved to describe a wine as superb. More often he would reflect on how a particular bottle made him feel, as when, after going many years without, he encounters a Côte-Rôtie, a wine he had loved as a young man. "I approached it with foreboding, as you return to a favorite author whom you haven't read for a long time, hoping that he will be as good as you remember. But I need have had no fear. Like Dickens, Côte-Rôtie meets the test."

You could read through a classic early-twentieth-century work like George Saintsbury's *Notes on a Cellar-Book* and find nothing remotely resembling a modern tasting note.

Saintsbury had no difficulty communicating his likes and dislikes without resorting to descriptions beyond an occasional "flavor" or "majestical." One exception: He described a wine he found particularly awful as "ginger beer alternately stirred up with a stick of chocolate and a large sulfur match." Egad! No further elaboration necessary.

Somehow in the last quarter of the twentieth century, as the wine business began to grow, centering on tourism and consumer publications, the specialized vocabulary of the tasting note came to be understood as the common language for discussing wine. Nowadays, a vast majority of wine lovers who really ought to know better have convinced themselves that it is meaningful to know whether a wine has "aromas of apricot jam, guava, and jackfruit," or some equally overspecific description.

Imagine if a music critic, reviewing a recording, described a symphony in terms of wattage, intermodulation, and impedance output, or even worse, tried to enumerate the various notes and chords. In some vague way it might accurately describe the technical details of what was heard, but it would have nothing to do with a meaningful experience of the music. Similarly, the flowery litany of aromas and flavors does little to capture the experience of a fine glass of wine. Yet because tasting notes are now the primary way we write about wine, people assume that they are the proper mode for thinking about wine, too.

That is a disturbing notion. While tasting notes may be laughable, their exaggerated language makes it far more difficult for people to enjoy wine without fearing that they somehow don't understand what they are tasting, or lack the

proper equipment for enjoying wine. In their overly specific effort to beat a wine into submission, boil it down to its every last aroma and flavor, box it up and present it as fully known and understood, tasting notes become thoroughly off-putting and intimidating, leading directly to the sense of wine anxiety that so many people feel.

At best, tasting notes are a waste of time. At worst, they are pernicious. It's disturbing to imagine wine writers wracking their brains to decide whether a particular aroma reminds them of braised fig, roasted fig, fig sauce, or maduro tobacco. But writers do need to feel useful. What's worse, several generations of wine writers and consumers now believe that rolling out a litany of obscure flavors and aromas actually brings them closer to understanding the appeal and allure of a particular wine.

At this point, I would not be surprised if some of you are unhappy with this line of thinking. From where I sit, I hear you protesting that tasting notes are essential to help people understand what they can expect when they take a sip of the wine in question.

Obviously, that is the intent behind tasting notes, and some people even believe that they accomplish that goal. Several years ago I gave a talk to a group in Napa Valley made up largely of people trying to get into the business of writing about wine. I suggested to them that the best way they could make their marks in the wine-writing game was to find a different way to talk about wine beyond the tasting note. I was met with an immediate wall of objections.

"As critics and writers our jobs certainly must be to help people understand and appreciate wine," wrote Alder

Yarrow in his blog *Vinography,* displaying moderately high dudgeon. "And part of the way we do that must be to describe the wine—and wine tastes like things and smells like things."

Wine does indeed "taste like things and smell like things." But what, really, do any of those particular things tell you about the quality or experience of a wine? Not much at all. Does it really matter to any consumer, or indeed, even to experts, whether a wine smells more like crushed plum or plum compote? Does it arm you with useful foreknowledge? Not really. It's more like being told by a book reviewer that the author uses lots of nouns and verbs in his prose. Experts might argue that if, say, a chenin blanc wine is described as smelling like apples, it conveys a sense of the wine's acidity. Well, why not simply speak plainly? Why couch the characteristics of a wine in fruity, flowery language?

Indulge me, please, in a quick experiment: Let's take a single wine and compare three different tasting notes from three different critics. I've chosen a 2006 malbec from Argentina, produced by Viña Cobos from grapes grown in the Marchiori Vineyard.

Here's what James Molesworth of *Wine Spectator,* which gave the wine 93 points, has to say:

> *Very lush, with concentrated but silky layers of fig sauce, crushed plum, blackberry paste, and mocha that glide over muscular but well-rounded tannins. Long and velvety through the powerful finish. Drink now through 2012.*

Now let's hear from Stephen Tanzer's *International Wine Cellar*, which gave the wine 91 points:

> *Deep ruby-red. Superripe aromas of black raspberry, cassis, musky coffee, mocha, and graphite. Creamy, sweet, and fat with fruit, with just enough underlying minerality and tannic spine to give shape to the thick flavors of blueberry and cherry liqueur. Not especially complex but lush and mouthfilling. Fans of sheer size will no doubt score this higher than I did.*

And finally, Jay Miller of *The Wine Advocate*, which gave this bottle a whopping 99 points:

> *A glass-coating, saturated opaque purple/black in color, the wine offers up a sexy/kinky bouquet of pain grillé, Asian spices, pencil lead, mineral, lavender, blueberry, and black cherry. On the palate there is layer upon layer of savory fruit, spice notes, espresso, and chocolate as well as exquisite balance. The wine's finish lasts for more than a minute. Try a bottle, bury the rest in your cellar for ten years, and then drink them from 2018 to 2040.*

Three experienced critics, each from a respected wine-reviewing periodical, and yet the myriad flavors they use to describe this single wine only barely overlap. Molesworth finds "fig sauce, crushed plum, blackberry paste, and mocha." Tanzer has a point in common, also finding mocha, but he finds "thick flavors of blueberry and cherry liqueur" instead

of fig sauce, and so on, along with aromas of black raspberry, cassis, musky coffee, and graphite. Miller, meanwhile, may agree with Tanzer on the graphite—pencil lead and graphite are synonymous—and the blueberry, but otherwise he is in another universe entirely with pain grillé, Asian spices, and whatever struck him as "sexy/kinky."

None of these esoteric aromas and flavors tell you anything important about the wine. In fact, it defies reason to think that any of these flavors and aromas would be useful to consumers. Would you buy this wine because it reminds one critic of fig sauce? Or maybe you hate the combination of pain grillé and pencil lead. If we are all honest with ourselves for a moment, we have to admit that the particular flavors and aromas found by the critics are irrelevant to deciding whether or not we would like this wine.

Buried among all the aromas and flavors, though, are words that do indeed describe some salient characteristics of this wine, characteristics that each of the critics detected. Molesworth uses the words lush, concentrated, muscular, and powerful—all of which offer consumers a fair idea of what's in this particular bottle. Readers can determine from those words whether this style of wine is appealing or not. Tanzer, too, describes the wine as lush, superripe, and thick, and, finally, comes out with it in his last sentence, saying the wine will appeal to "fans of sheer size." That tells me far more about the wine than whether it smells like cassis and mocha, which might describe many red wines that have nothing in common. Miller's note, meanwhile, offers less useful information, beyond the coded terms "saturated," "glass-coating," and "layer upon layer." But they amount to the same thing.

This is a huge, powerful, concentrated red wine, regardless of whether it smells of fig paste or lavender or both or neither.

I have repeated this particular experiment over and over, and it always comes out the same way. I won't try your patience by offering more examples. Yet the verdict bears repeating: The myriad flavors and aromas that wine writers strain so hard to extract from the glass tell you nothing of importance about a particular wine. And yet, defenders of tasting notes insist they have something crucial to say.

"At the end of the day some people still want to know what the wine tastes like, and robbing them of that pleasure does those who are curious a great disservice," Alder Yarrow wrote after my talk in Napa. "Of course, there exists a whole segment of wine lovers who actually enjoy the intellectual dissection of a wine, just as those who appreciate music and theater might discuss the genre or set design."

To assert that tasting notes amount to an "intellectual dissection" of a wine is to ignore the fact that the more specific the description of flavors and aromas, the less one is actually saying about a wine and what it has to offer. People drink wine for many reasons. It makes them happy, it cheers them up, it is delicious, it makes meals better, it is intoxicating, it enhances friendships, it serves a spiritual purpose, and that is only the beginning. Wine can be transporting. It can, in one glass, embody culture, science, economics, personalities, history, and much more. Fine wines stimulate conversation. We may be moved to debate what makes it so fine. But very rarely, if ever, does a true intellectual dissection of a wine consist of sticking one's beak into a glass and reciting the components of a cornucopia.

Let's be clear: Every critic's references are going to be different, depending on their experiences, interests, and imaginations. If you'll continue to bear with me, let's compare notes on one more wine, this time the 2007 Bourgueil Franc de Pied from one of my favorite Loire Valley producers, Cathérine & Pierre Breton. In this wine, Molesworth of *Wine Spectator* finds "muscular black cherry and black currant fruit surrounding a core of dark olive, maduro tobacco, and mulled spice notes." Meanwhile, in *The Wine Advocate*, the critic David Schildknecht detects "blackberries, beet root, iodine, and pungent herbs" as well as "intriguing saline, smoky, herbal, and toasted nut nuances."

I would submit that, from these two very different descriptions of a single wine, a reader would have no idea what to expect to find in a glass. What you do learn are the sorts of flavors and references that tend to run through a particular critic's mind. I don't mean to pick on James Molesworth. I don't know him personally, but he is a fine reporter. Yet he does have a tendency to detect the aromas of maduro tobacco in an uncanny number of different red wines, whether cabernet franc from the Loire Valley, syrah from the Rhone Valley, carmenère and cabernet sauvignon from Chile, merlot from the Finger Lakes, a South African red blend or Châteauneuf-du-Pape. He pretty much finds fig in a wide variety of wines, too, whether braised, roasted, warm sauce, cake, creamy, or pristine fruit.

Again, I don't mean to single out Molesworth. But I have never read of another wine critic finding the aromas and flavors of maduro tobacco and the various manifestations of fig in as many different sorts of wines as he does. In fact,

I've never read a tasting note except those written by Molesworth that refer to maduro tobacco at all. Does that mean he has a sharper nose than the rest of us? Possibly. But, more likely, these are personal reference points for Molesworth that have little common ground with other writers, or with the general public.

Let's step back a moment. Let's assume that, regardless of how these various critics might differ in what they find in a glass of wine, they are all 100 percent accurate. All those aromas and flavors really are in that little glass. Would that make any difference to consumers trying to decide which wines to buy? I don't think so.

The absolutely wonderful, and sometimes maddening, thing about good wine is that it is alive. It evolves and changes over time, and it expresses itself in different ways depending on the context in which it is tasted. Now when critics taste wines for publication, they try to eliminate context. They are not eating food, for the most part, while they are tasting. They are not involved in a serious discussion with their spouses, or laughing with their friends. Some critics refuse to listen to music in the background, for fear of distraction, or forgo their morning coffee before a tasting so as not to compromise their palate. Of course, if they are tasting many other wines at the same time, that creates its own sort of context, in which heavier, lighter, sweeter, and drier wines can all taste different, depending on what comes before and what comes after.

Regardless of the conditions under which the critic tastes the wine, they will no doubt differ from the context in which you taste the wine at home. Unlike the critic, you

may well be drinking it with food while dining with your parents in a restaurant, or at home in front of the television with your children, laughing at a sitcom. That wine is going to taste very different than it did in the more clinical context of a critic's tasting room. It will taste different in the morning than it will at lunch, and different at lunch than it will at dinner. And trust me, outside of the figurative operating theater of the clinical tasting room, nobody is going to taste maduro tobacco, braised fig, beet root, or anything else unless one is determined to do so.

Now, while these overly specific flavors and aromas are laughable and communicate nothing important about a wine, consumers can in fact benefit greatly if they are informed about the more general traits of a specific wine. Those traits do not include which particular berries a wine smells like, beyond a general, agreed-upon profile for a particular wine. But, as we saw with the Argentine malbec, critics can indeed offer some useful information.

Is a wine big and heavy-bodied? Or is it light and agile? Is it tannic and closed, or soft and easily accessible? Is it dominated by an overt fruitiness, or does it offer other sorts of flavors (often characterized by earth and mineral adjectives)? Is it fresh, lively, or energetic? Or does it settle in the mouth with a dispiriting flaccidity? Rather than groping for just the right fruit analogy—was that Jonagold apple or was it Winesap?—and then piling them on, why not simply offer readers a general idea of the style they might find, with a few words on the quality as well?

Some people have suggested that the popular wine publications, like those I've quoted, have lost touch with younger

people who are just learning about wine. These would-be wine drinkers, it is thought, find older critics too formal and high-minded, overly clinical in their detachment. They would prefer a critic whose references came closer to their own life experiences, somebody, perhaps, like Gary Vaynerchuk.

Vaynerchuk, in his midthirties, was a little-known wine retailer in New Jersey until 2006, when he posted his first episode of *Wine Library TV* on his store's website. Before long he was a phenomenon, appearing on talk shows like Ellen DeGeneres's and Conan O'Brien's, where, in the guise of educating the host's palate to wine terms like sweaty, mineral, and earthy, he sniffed O'Brien's armpit and persuaded him to chew an old sock, lick a rock, and eat dirt (topped with shredded cigar tobacco and cherries). O'Brien, in turn, called Vaynerchuk an idiot.

His fans love him for his passion, enthusiasm, and sincerity. He's quite knowledgeable, though he conceals this behind his everyman character. He's also been celebrated for plunging into new media, bringing his message to people through the Internet, Twitter, and Facebook. But has he changed the wine world, as he claimed at the end of each episode of *Wine Library TV*?

Quite possibly, but not by virtue of his verbal tasting notes, in which he both extends and subverts the established vocabulary for describing the aromas and flavors of wine. "I'm getting a little banana peel," he'll say, as he tastes on camera. "Walnut and almond paste—it's definitely a nutty aroma." So far, so conventional. But after the usual citations of apricot and buttered popcorn, he'll go off, saying that a wine smells like Nerds or Big League Chew—popular

candies that connote good things to Vaynerchuk—or a
sheep's butt—perhaps also a good thing. He might compare
drinking a wine to biting into an engine, or once, describ-
ing a pinot noir from the Sonoma coast, he likened it to this:
"You hit a deer, you pull off to the side of the road, then you
stab the deer with a knife, cut it, and bite that venison, and
put a little black pepper and strawberries on it and eat it, like
a mean, awful human being."

For sheer entertainment and improvisational élan, Vay-
nerchuk is great. But his verbal tasting notes, though drawn
from a different well, perhaps spiked with a hallucinogen,
amount to the same litany of mystifying characteristics that
reveal next to nothing about a wine.

Vaynerchuk's big breakthrough as a wine personality has
nothing to do with the tasting references he uses. His success
is built on his engaging personality and his willingness to sit
figuratively at the same table with his audience rather than
adopt the omniscient pose of an older generation of critics.
He'll spill a wine on camera as he swirls and then he'll laugh
about it. He'll mispronounce a German wine and question
whether he's tasting alcohol or acidity. He will concede with
a smile when he doesn't know something without ever being
defensive. That sort of humility counts for a tremendous
amount with an audience of wine novices, and it helps to
make his tasting language palatable, if no less mysterious.

Vaynerchuk's attitude is ultimately disarming. He is not
threatening to his audience, except for those who have a
vested interest in preserving wine as some sort of a middle-
brow pastime, ready-made for public television. He has
been accused of dumbing down wine with his comparisons

to candies like Nerds or Bazooka Joe. But honestly, how is likening wine to Nerds any dumber than *Wine Spectator*–approved terms like melted licorice snaps and fig paste?

The truth is that trying to break down the complexities of a wine into elemental components is a useless, self-indulgent exercise that serves mostly to alienate the very people whom writers would like to entice. Omitting or simplifying tasting notes in no way panders to public ignorance about wine, because they are of such little value to anybody. But it would force wine writers to come up with smarter methods of conveying useful information, methods that fewer people would find threatening. In the end, tasting notes do nothing so much as discourage people who would find wine far more interesting if they could figure out what the writers were talking about.

Far more interesting to me is writing that treats wine generally, alluding to characteristics without the obsessive detailing, and, more important, that places wine in context, whether of a meal, a social situation or a culture. In a sense, you could say that the best way to write about wine is not to write about wine, or at least to write about it as part of a more intricate tableau. In his exquisite memoir *A Life Uncorked,* Hugh Johnson talked about white Burgundies using language that can easily be understood without a doctorate in obscure fruits:

> *There is no getting away from terroir in Burgundy. It explains the landscape, the culture, the economy, the social*

structure—even the folklore. In Puligny it seems myste-
rious; on the hill of Corton, on the other hand, it stares
you in the face. . . . This clay and this abrupt hill, facing
southwest, out of alignment with the Côte, give Corton-
Charlemagne a character of its own. Rather than fine
and penetrating with fruity acidity like a Puligny, or
mild and mealy like a Meursault, the hill produces some-
thing austere and flinty, almost burly in youth, certainly
tongue-tied. Some call it the Chablis of the Côte d'Or:
Grand Cru Chablis that is. Like a great Chablis it can
enter a charm-free period and stay there for six, seven,
maybe ten years. Even when it emerges, "charm" is
hardly the word for such a dense, dry, less fruity than
mineral puzzle of a wine.

These are fine, quick sketches that immediately convey
the crucial Burgundian notion that terroir is destiny, and
that the great Corton-Charlemagne is something of an out-
lier among its fellow white Burgundies. Perhaps the passage
is not intended for an audience unaware that the narrow strip
of land in eastern France known as the Côte d'Or is the
source of the most famous Burgundies, red and white, or that
Chablis is also part of Burgundy though some distance from
the Côte d'Or. Regardless, though, Johnson leads readers to
the essence of these wines, and conveys an understanding
of them that cannot be achieved by merely reciting aromas
and flavors. This is where wine achieves greatness, as an ex-
pression of a more general culture, not when forced to give
answers under the interrogation light of the tasting room.

Flirtation

I never thought of going into the wine or food business. I loved to eat and drink, but it never occurred to me that I could make a living in the field. It never even occurred to me to try. I had gone to Austin as a graduate student with the idea of becoming a college professor. But as much as I loved living in Austin, I realized it was not a place that I could stay.

My fantasy of an academic life had faded, given the economic difficulties of the early 1980s and projections of limited possibilities in the liberal arts. I came to the rueful conclusion that, while I was a good student with an agile mind, I was not setting the world on fire in my field of American studies. I had gotten a wonderfully well-rounded education, but I was more sponge than faucet. This multidisciplinary field allowed me to combine the more traditional academic disciplines of history, literature, and the arts with studies of pop culture—television, genre books, and food. I had learned ways of looking at the world, of seeing historical and

cultural patterns, that would serve me well for the rest of my life. I was clever enough, if I wanted to pursue academics, to absorb and synthesize my reading, to stay a step ahead of the students, and to perhaps even inspire them. But the fear that I had little original to say made me feel that the lovely little academic future I had conjured up—of spending my securely tenured days in a book-lined office, immersed in study with eager undergraduates ready to hang on my every word— would forever be beyond me. Instead, I imagined a path to a doctorate paved with fear, followed by more anxiety-ridden years desperately grasping for temporary appointments in undesirable places where I had no interest in living.

Lacking the passion to persevere regardless of the obstacles, I decided to exit academia, stage left. But where to go and what to do? I mentioned that my father, Stanley Asimov, was a newspaperman. He grew up in Brooklyn working on his high school newspaper at Brooklyn Tech and his college newspaper at N.Y.U. This was his life's dream, to work on a newspaper. After college he went to journalism school at Columbia University and was then hired immediately by *Newsday*, an up-and-coming young newspaper whose growth paralleled the postwar boom on Long Island. Dad stayed there forty years, his entire working life, rising from reporter and editor to become one of the paper's top executives. Aside from playing a key role in helping to develop the newspaper computer systems that sent typewriters the way of slide rules and horse-and-buggies, Dad hired many of the young reporters who went on to make *Newsday* one of the country's great newspapers from 1965 to 1995. He also developed a reputation for ironclad integrity and came to be

known as the soul of *Newsday,* a man whose optimism, principles, and determination were crucial to the newspaper's achieving greatness.

Maybe you can tell, I admired my father tremendously and loved him dearly. But the last thing in my life I wanted to become was a newspaperman.

Perhaps it was the natural desire on the part of a child to forge his own way in life. Dad was a powerful personality and it would have been too easy to get sucked into his world. I would have made him very happy if I had followed in his footsteps. I had my own reasons for working on my high school paper—I liked writing, and our skeletal staff—my friends and I, that is—wrote and edited the whole thing. But I didn't plan to continue in college, and in fact I never did. My sister, Nanette, on the other hand, very much wanted to go into journalism. Like my father, she attended Columbia's School of Journalism and has had a highly successful career as a reporter at the *San Francisco Chronicle.*

But I had no interest in journalism at all—not until I needed a job, at least. Just after college, when I had to earn enough money to finance my backpacking trip through Europe, I had answered a classified ad in the *Hartford Courant.* The newspaper was looking for copy editors, a job I foolishly believed I was equipped to do.

Though I had never worked at a newspaper, I felt as if I knew them well. Every night at the dinner table as I grew up Dad would regale us about the inner workings at *Newsday.* The editors, the writers—I felt as if I knew their personalities inside out. It was all there—the smell of soft pencils and erasers, the clacking of typewriters and teletype machines, the

stale coffee and cigarette smoke, the jokes and arguments, the alcoholics (the newspaper business was rife with them). Dad was a great storyteller. He'd do the colorful Southern accents, the grim, baleful deskmen, and later, as his milieu at the paper evolved, the office suites with the secretaries and executives.

At one point he'd insisted on teaching me how to edit copy and also how to write headlines. I told him I had no interest in learning these skills, but he argued that a good writer had to be a good editor. He could not instill in me the talent to be a good writer, he said, but whatever talent I did possess could be sharpened and improved by knowing how to edit myself. This was true, he believed, even if I insisted on becoming an academic, or a lawyer (he harbored hopes I'd turn down that wretched road, too). Lawyers and academics are frequently horrible writers, he said. Learning how to edit, and how to recognize good and bad writing, could easily make a world of difference in whatever field I finally decided on.

Reluctantly, I went along with his idea. For a couple of weeks one summer, he'd bring home dot-matrix printouts of newspaper stories, the ragged feeder holes dangling off the sides in torn strips. Sitting at our kitchen table he patiently taught me how to edit a piece of writing, which meant how to analyze a story and spot its missing pieces, how to write clearly and concisely, how to organize and, most important, how to recognize good writing and resist the urge to meddle with it if it didn't require changes.

Nothing came of this immediately, although without realizing it I now possessed a skill worthy of a salary. When I answered that classified ad in the *Hartford Courant* and visited the newspaper to take an editing test, those skills were evident enough to win a part-time job.

Although just out of college, I was now apparently a newspaperman, too, though not in any way that my father would recognize. I'd show up to work in long hair and beard, jeans, flannel shirt, and sandals, do my job, and leave. As a part-timer I was not really invested in the workings of the newspaper, although I met some great journalists who would later become colleagues for years at the *New York Times,* and an editor named Jim, who, with his soon-to-be wife, Christine, would become a dear friend. I also got one of the best pieces of advice I've ever had, from a lifer on the copy desk who happened to be sitting next to me one night. I asked him an innocent question, about the party affiliation of some low-level official in the state government. He took his time looking at me before answering.

"Kid," he said, "never listen to the fucking idiot sitting next to you."

I've taken those words to heart everywhere I've gone. Don't rely on what somebody else tells you, somebody who may be even more ignorant than you are. Check it out yourself!

Hartford itself was a dreary place back in the early 1980s, not unlike the Baltimore of *The Wire.* After the bars closed, editors would drift underneath the overpass of I-84 to drink beers. Lovely. Yet I have two distinctly wonderful memories of the town. First was Hal's Aquarius, a kind of Sylvia's of

Hartford's north end, a hangout for black politicians and a great place for Southern breakfasts, with spicy sausages and grits. The other was a dinner at Carbone's, an Italian institution at Hartford.

Unaccountably, one week I had won a headline contest—
THREAT OF SYZYGY LACKS GRAVITY.

My prize? Dinner for two at the restaurant of my choice. Naturally, my girlfriend and I picked what we imagined to be the best and most expensive restaurant in town, Carbone's, and went all out, as two innocent twenty-two-year-olds might do it, feeling guilty all the while—Caesar salad, fettuccine carbonara, veal—and wine, of course. I don't even remember what wine we drank, but it was a wonderful, luxurious meal, and we felt grown up and pampered, until I gave the bill to my editor, who freaked out at the extravagance (it could not have been $100), yet he paid up nonetheless. What did he think I was going to do, go to McDonald's? So came the second great lesson of my brief stay at the *Courant*: It's better to apologize than to ask permission.

Having now decided to leave the University of Texas, and with all of a few months of newspaper experience under my belt a few years earlier, I applied for jobs at newspapers all over the country. I still wasn't thrilled about a career in journalism. I wasn't really thinking of a career at all. If my working experience had been in construction, I would have looked for a job breaking rocks. I just wanted to have some money in my pocket. While I had no ties to Austin, I loved it there and would have liked to stay. But the idea of

working for the *Austin American-Statesman* (known locally as the *American Spaceman*) offended even me. It was so bad that many people preferred to read the university student newspaper, the *Daily Texan,* even though it was known as the *Daily Toxin* and clearly was also hard to swallow. I may not have wanted to be a journalist but I had innate standards.

Astoundingly, I did get a job offer, from the *Chicago Sun-Times.* I was thrilled! Of all the places I had applied, newspapers in towns like Minneapolis and Kansas City and Sacramento and Dallas, most didn't bother getting back to me. But Chicago? What a great city to explore.

I had actually never been to Chicago. But I was a fanatic about the blues, and moving from Austin to Chicago was like club hopping on a Saturday night. Not only that, but Chicago was square in the middle of the urban barbecue belt, and having honed the taste in Texas, I wasn't ready to leave barbecue behind. In fact, I didn't realize it until I arrived that Chicago was a wonderful restaurant city. Later, when I moved to New York, I used to tell people that Chicago had just as many good restaurants as New York and far fewer bad ones. That certainly wasn't true at the high end, but for a kid just starting to earn a salary, Chicago was like a great buffet of good, inexpensive places to eat.

Somehow, I lucked into a wonderful apartment, a duplex loft on the 2800 block of North Burling, which, after almost thirty years in Manhattan, I'm sad to say is still the nicest apartment I've ever lived in. It was an easy ride to the *Sun-Times,* steps away from the blues clubs on Lincoln, a short walk to the shops on Clark and Broadway, and not so far from Sam's, a dark, cavernous wine shop with stacks and

shelves of all sorts of mysterious bottles. I was surrounded by pizzerias and barbecue parlors, bistros and trattorias, great little Mexican joints, breakfast spots, and hot dog stands. I just knew I was going to love Chicago.

And I did, except for one thing. I had to work at the *Sun-Times*.

It was a big-city tabloid with a serious tradition—columnists like Mike Royko and Irv Kupcinet, Roger Ebert and Roger Simon and James Warren, along with the usual, almost cinematic crew of hard-drinking, hard-smoking crime reporters and cynical, taciturn editors. The *Sun-Times* didn't have an expansive, impressive newsroom. It was more a series of midsize rooms with forlorn linoleum floors and gray-green metal desks wreathed in tobacco smoke, housed in a blocky green building that bulked like a mesa near the confluence of Lake Michigan and the Chicago River. Compared with the impressively ornate Tribune Tower, belonging to the archrival *Chicago Tribune,* the *Sun-Times* building looked sadly like a construction trailer. Yet somehow it embodied the plucky workingman's spirit of the *Sun-Times,* a terrier nipping at the heels of the aristocratic *Tribune.*

Having practically no experience, I was going to be brought along slowly. My boss gave me little jobs—cobbling up brief news roundups from the wire services, once in a while editing a story and writing the occasional headline. I had only been on the job for three weeks and was beginning to get used to it when along came Rupert Murdoch.

Murdoch then was not nearly the global multimedia power that he is today, but I knew of him because he had bought the *New York Post* in 1976 and had turned it into a

sensationalist tabloid that blatantly pushed Murdoch's conservative political agenda. Now he was buying the *Sun-Times*.

While the sale gave me pause, it was far more meaningful to the people who had been at the *Sun-Times* for years. According to the union contract, if the ownership changed hands and employees decided to leave the newspaper within a window of several weeks of that ownership change, they would get an enormous severance payment that increased according to seniority. In other words, people who had been at the *Sun-Times* for years, the spine and soul of the newspaper, had an incentive to leave. They couldn't wait to get out the door. Not only would they escape Murdoch, they'd be paid handsomely for the privilege of leaving.

What did that mean for me? Well, I wasn't going anywhere. I'd been there all of three weeks. I'd yet to learn the names of all the senior people scrambling to exit, but any ideas of bringing me along slowly left with them. Regardless of how little experience I had doing anything except writing term papers, I was now being asked to do jobs for which I was completely unqualified.

One week, after only a couple of months at the *Sun-Times,* I was told I was in charge of foreign news for a week. Now, this didn't mean I had foreign correspondents around the globe waiting for me to send them their assignments. I think we had one guy in Jerusalem, and somebody else in Washington. Being in charge of foreign news at the *Sun-Times* consisted of monitoring the wire services for stories. But even that required a working knowledge of foreign affairs that

exceeded anything I possessed. I was in way over my head, and became all too familiar with the common psychological syndrome of waiting to be discovered for the imposter I was. But if I made any missteps in my week as foreign editor, apparently nobody noticed. Either that or nobody cared.

Though it was becoming clear to me that I was not going to develop a long-term attachment to the *Sun-Times,* I was having a great time in Chicago exploring the restaurants. One of my favorites was La Gare on West Fullerton, a sweet little bistro with a zinc bar, brick walls, and, no doubt, potted ferns. Occasionally I would sit alone at the bar with a bavette, a thin cut of steak somewhere between skirt and flank, with frites and haricots verts—that magical combination again—and consume it with a pitcher of the house red. The wine was lean and simple, somewhat like the bavette. Neither was noteworthy on its own. One more bistro steak, served with one more forgettable red wine.

The fact is, as with so many meals back then, I have no idea what wine I was drinking, other than that it was red and it was French. I had no real reason to keep track of anything at the time. If it were 2012 instead of 1983 and I was sitting with my bavette and red wine, I'd have taken a picture of the label with my phone. Maybe I'd have tweeted my experience, or blogged about it. My meal and all the irrelevant facts about it would have been preserved digitally for all who cared to participate voyeuristically.

But my aim back then was not to tote up or record the number of different bottles I had consumed. I didn't think of wines as trophies or as status symbols, not that it would have mattered if I had. For me, the food was the most important

thing, or, more accurately, the meal, whether I was with friends—which wasn't always so easy back then, as I worked the oddball schedule of the newspaper editor, 4:00 P.M. to midnight, Wednesday through Sunday—or by myself. The meal was the sum total of the event—the food, the wine, the people, the milieu. I always preferred the pleasure of sharing the meal with friends, but I was never afraid to sit in a restaurant by myself if necessary. I didn't mind solitude—I learned to love the almost hallucinatory experience of sitting with food and a glass of wine and letting the mind wander, always in directions that would have been impossible to predict.

Yet I always came back to the meal, like the bavette at La Gare. I would take a bite of the beef, which had the firm, chewy texture of a tannic red, and then a swallow of the wine, alternating bites and sips in the same way, I realized to my horror, as my father did with his coffee and dessert. Perhaps he felt the same way about coffee and a sweet as I did about food and wine, that the pleasure in the combination of the two far outweighed the essential, inherent quality of either considered alone.

Looking back on meals like that, I came to realize that the simple experience of consuming wine and food together, as people have for millennia, can offer a profound sense of emotional satisfaction. Not simply the animal security of satiation, like a lion sleeping in the sun after consuming a wildebeest, but an almost spiritual sensation of joy, of gratitude, and of understanding and acceptance. This sensation does not require bottles that have been rated 95 points or higher by the critics. It doesn't demand that one has memorized the communes of Barolo or can recite the names of

the Grand Cru vineyards of Burgundy. It most certainly does not compel one to give a laundry list of obscure aromas and flavors detected in a glass of wine. In short, this old-fashioned conception of connoisseurship is not required in order to love wine. An open mind and an open heart are far more important.

New York Bound

I'm not very good at delaying gratification, but in Chicago I had to set aside my growing desire to explore the world of wine. I was going to have to search for a new job.

My denouement at the *Sun-Times* came swiftly. Not long after my stint as "foreign editor," I was placed in charge of the Sunday edition. Of course I still had bosses to report to, but my job was essentially to decide what story should go on the cover of our fighting tabloid. At this point in my brief journalistic life, I retained the serious high-minded idealism of the graduate student, and was therefore spectacularly ill-equipped to select a story that would grab the attention of Chicagoans rushing past news stands. My thoughts most likely ran to a thoughtful piece on the fighting in Lebanon, perhaps, or early prospects in the 1984 presidential race. Who could doubt the historical importance of these stories?

My bosses, of course, now had British accents, or maybe Aussie accents, I don't remember. What I do recall is regu-

larly being lambasted for my plans and being directed, instead, to use other sorts of stories, like some hit-and-run accident downtown—tragedy, tears, and heartache. Add a little celebrity cheesecake, and you've got a winner, at least in the minds of the Murdoch men. Not that I was morally opposed to such choices. It simply didn't come naturally. For me, it meant decision making that required asking myself not *What works best here?* but *What would Rupert do?* By this time I had only been in Chicago six months or so, but I decided it was time to go.

Yes, I still loved Chicago. I was exploring it at every opportunity with my friends Jim and Christine, with my childhood buddy Pete, who was studying at the Northwestern business school, and in my halting efforts at a social life despite the odd hours I was working. I had endured my first Chicago winter, which wasn't easy as my northeastern blood had been thinned by my time in Austin. One day the wind chill hit minus 73. Waves froze on Lake Michigan in midbreak, yet steam rose from the ice as even the frozen water was warmer than the air. Somehow my little Honda Civic kept starting in the chill, and in my spare time I found my way to the South Side, to Buddy Guy's Checkerboard Lounge for great blues acts, and to Leon's, where the outrageously good barbecue pork ribs were dispensed from behind bulletproof glass. Closer to my home was Peralta's on North Lincoln, for the best biscuits and gravy, and the Twin Anchors on North Sedgewick, a rib parlor disguised as a pizzeria—how many barbecue spots play Sinatra, anyhow?

But I knew it was time for me to leave. My stint in Chicago had not inspired me to embrace the newspaper profes-

sion. As an editor, I found no joy in it. I liked to write, and I liked the attention I got when I occasionally did write. I have vague memories of writing an obituary for the inventor of the corn dog, but I can't find a copy of this masterpiece, so I'm left wondering whether I imagined the whole thing or not. It sounds exactly like something I would have done, though.

As I prepared to flood newspapers around the country with the latest iteration of my job application, I wondered whether I should apply as a reporter. Dad, ever practical, discouraged me.

"You can apply to the best papers in the country as an editor," he told me. "As a reporter, you'll have to start at the *Podunk Bugle.*" The *Bugle,* of course, being that mythical newspaper where every form of amateur-hour journalistic offense occurs nightly.

I was not interested in Podunk or any points south of the biggest cities in the country. This time, I was applying to places like the *New York Times, Boston Globe,* and *Philadelphia Inquirer.* My fondest hope was to go home to New York, but really, for me to expect a job at the *Times* was crazy. I had a combined total of less than one year's experience in the business and still felt more like a grad student than an actual journalist. I was passing time, trying to figure out what I was really going to do with my life. It was like some weekend bar band guitarist expecting to go on tour with Bob Dylan—oh, sure, it might happen, but better have a fallback plan.

I don't quite know how I did it, but I somehow managed to wangle offers to try out in both Philadelphia and New York, so I spent a few days working at the *Inquirer* on its city

desk, and then five days working on the national desk of the *New York Times.*

Was the *Times* really the big leagues? I remembered entering the third-floor newsroom at the *Times* for the first time in the spring of 1984. A huge, forbidding guy with an enormous white handlebar mustache was sitting behind the security desk. Without a smile and with barely a word, he abruptly ushered me in. The newsroom was vast compared to the *Sun-Times,* yet it was strangely awful as well, unbefitting what was widely considered the greatest newspaper in the land. The carpeting was a disastrous orange dulled to gray and brown by myriad spills and the endless trekking back and forth of editors and reporters rushing about. A smoky tobacco haze that had long ago settled over the room added to the carpet's patina. All over the newsroom, men and women worked, seemingly in states of agitation and annoyance.

The tapping of computer keyboards I heard was not the clattering cacophony I remembered from visiting my father at *Newsday,* back in the days of typewriters and wire service machines. Computers were the rule now, yet the tranquil tapping was the least of the noise. Every few minutes there would be a whoosh and a *buump* as a leather-clad plastic capsule containing a printout of a story would depart by pneumatic tube for the composing room, the empty capsule returning through the tubes soon after for another round of communication. These were the dying days of the tubes, which for so long had been the fast-moving veins and arteries of newsrooms everywhere. Computerized typesetting had rendered them obsolete, and they were soon to be on

their way out, presaging the disappearance in the near future of the remaining character of the classic big-city newsroom.

Every so often one of the editors would bellow, "Copy!" A dazed and confused copy clerk would start up from his seat and race over to do the editor's bidding. Sometimes these clerks were middle-aged men, who seemingly had decided that a paycheck was a paycheck, which was better than ambition. Others were green youths no younger, I sensed, than I was. They seemed to approach one slender, gray-haired, pipe-smoking man with particular dread, like a cowering dog who knows it is about to get its nose whacked.

Pretty soon, Mr. Mustache led me over to this same man, dressed in an orange shirt that matched the carpet, with a tie that looked like an optometrist's eye chart. He looked at me with distaste. "Sit over there" was all he said to me, which was a relief as he was yelling at everybody else, in between twirling his pipe and making wretched puns.

I don't remember much about my tryout other than every encounter with this editor, whose name was Dean, seemed to end with him looking at me in disgust.

"What's a pocket veto?" he snapped at me. "What do you mean by *bemused*?"

As I struggled to respond to these direct questions, revealing my ignorance, I felt myself cringing like those clerks who seemed so abused by him. He'd turn away from me to lash out at somebody else, and I was left to wonder what else I could do wrong. Little did I know then that this gentleman, Dean Gladfelter, would be one of the best writing teachers I would ever meet, though no doubt if I had the opportunity to tell him that today, he'd look at me in disgust.

I finished my tryout at the *Times* and went back to Chicago. Weeks went by, then a month, and I'd heard nothing back. I was itching to get out of Chicago when I got a phone call from the *Philadelphia Inquirer.* "We are pleased to offer you a job on our copy desk," I was told. "When can you start?"

"Um, may I have a few days to think about it?"

I got off the phone and called the executive at the *Times* who had my future in his hands. He was an editor named Allan M. Siegal, a short, wide man whom everybody regarded with abject fear, even more so than Dean. I had had a short interview with Siegal.

"Who are your favorite writers at the *Times*?" he had asked me right away, which seemed like a trick question intended to find out if I read the paper. I grew up reading it. This was easy.

"Michiko Kakutani," I said, "because she makes even the most difficult ideas easy to understand; Joseph Lelyveld, because he has such a beautiful way of allowing participants to tell the story through his use of quotes; and Frank Prial, because he makes wine seem so integral to life."

This either satisfied him or befuddled him, because our interview ended almost immediately.

When I called from Chicago, I got his secretary. I told her I had gotten a job offer from the *Inquirer,* but that I really, really wanted to come to work at the *Times*. Nonetheless, I had to give an answer to the *Inquirer*. Was there anything I could do to speed the *Times*'s process of making a decision about me?

She put me on hold for a minute. When she got back on, she said, "Call back at 11:50 tomorrow morning."

This puzzled me—11:50? Not 11:49 or 11:51? I was in Chicago. Did she mean Central time or Eastern time? How completely like the *Times* and Al Siegal this seemed to be— keep people off balance and uncertain. Did I really want to enter this culture of fear?

Nonetheless, I did my best to follow directions. The next morning, at 10:50 Central time, 11:50 Eastern, I called Al Siegal's office. "How would you like to come to New York and work at the *Times*?" he asked me.

"Would I!"

I was twenty-six years old. I hadn't even been out of college five years. I'd traveled in Europe, studied in Texas, worked a few months at the *Hartford Courant* and a few months more at the *Chicago Sun-Times*. I still had little idea what putting out a newspaper was all about. But I was going to the *New York Times*.

Embrace

By virtue of my job, I've had the regular opportunity to taste the greatest wines in the world. Far more rarely, I've had the opportunity to drink the greatest wines in the world. It's an important distinction.

Wine writers, like most people, generally can't afford what are considered the great historic wines, which can run to many thousands of dollars per bottle, particularly if they are old and well-aged. But, because we write about wine, we are often invited to occasions where these wines will be served. Needless to say, I consider this a great privilege.

These occasions can take many forms. One is an academic sort of tasting, in which dozens of bottles will be served in a somewhat clinical atmosphere. For example, a collector has decided to show off his cache of great wines. Perhaps with the help of a few other collectors, and maybe even the producer itself, the collector has assembled a vertical tasting; that is, a tasting of many vintages of a single wine,

say, twenty-five vintages of Clos Ste. Hune or thirty vintages of Cheval Blanc. A banquet room is rented, or maybe a restaurant. Many people are invited. Only a couple of bottles of each vintage are available, and each bottle may have to serve twenty or thirty people, which means only minute quantities in each glass.

People swirl and sniff and sip, taking in tiny amounts of wine, which they chew and swish in the mouth. They write down their impressions quickly, before moving on to the next glass. Many people may spit the wines, as professionals need to do when faced with such large quantities. Food may be served, in which case a little wine is consumed as well. One can learn a lot from such tastings about the sweep of a wine's history, its character, and how it evolves over time. One may feel truly awed by the wine. But one nevertheless remains on the outside looking in, having tasted without the opportunity to have savored.

Other tasting opportunities come at the free-form, party-style events, like dinners at the International Pinot Noir Celebrations, held annually in the Willamette Valley, or La Paulée de New York, an annual homage to the Burgundian harvest festival started by Daniel Johnnes, the sommelier and importer who probably did more than anybody to introduce Americans to the pleasures of Burgundy in the 1980s and '90s. At tasting events like these, generous collectors bring dozens of rare and valuable bottles, and if you are lucky enough to be sitting at one of their tables at one of the dinners, the onslaught of great wines can seem unreal and overwhelming. Indeed, at these events, with hundreds of people on hand, more great wine is dumped out of glasses

and tossed away than most people will have the opportunity to drink in a lifetime.

Midway through such meals, most guests are no longer in their seats. Instead, they are milling about glass in hand, visiting with friends, always with their eyes open, watching for great bottles, hoping perhaps to receive a pour and a taste of their own. It's an eerie, disconcerting feeling, always to have something great in the glass but always hoping for something better. And what, really, is a splash in the glass worth? Can one really say that a fleeting taste of the legendary 1928 Krug, or a mouthful of a '78 Cros Parantoux, can offer any understanding of a wine whatsoever? I suppose it can, in the same way that one is able to gain an inkling of Yosemite after viewing the park from a helicopter.

Some people are simply interested in toting up great wines, and crossing them off some master checklist, like a birder's life list. They begin such evenings determined to list every wine they taste, whether on the back of a tattered, wine-stained program or in a monogrammed, leather-bound tasting book. Sometimes the pursuit of more big names to add to the list overtakes in importance the pleasures of tasting the individual wines themselves. These people seem to be in a mode of constant acquisition, as if shoppers were to take their wrapped boxes home and toss them in a closet without ever taking the time to examine and enjoy what's inside.

The allure of great labels is powerful, yet over time I've come to realize that one glass of great wine, lingered over and ex-

amined from every angle for half an hour, is far more important and satisfying than ten great wines, each tossed away after three minutes. Make that one great bottle, rather than one great glass, and the pleasure increases exponentially.

Once, at one such dinner in New York, as the evening progressed into bacchanalian chaos, I saw Aubert de Villaine, the gentlemanly proprietor of Domaine de la Romanée-Conti, sitting at a long table by himself, head in hands. I seized the opportunity and grabbed the seat next to him. We knew each other peripherally; no introductions were required. He looked up at me, sizing me up.

"You," he said, squinting at me then gesturing to the mosh pit of wine lovers wandering the room, voices and laughter ricocheting back and forth over the music, "do you enjoy this?"

How to answer that question? Of course I enjoy these occasions. Indeed, I am awed by the generosity of the collectors, and I do revel in tasting these wines that would never come my way otherwise. But I hate them, too, because they can be so frustrating.

I've become a firm adherent of the notion that wine is for drinking, not tasting. Only by drinking, swallowing, savoring, and returning to a wine, and repeating the process over time, can one really get a full and complete idea of what's in a bottle and what that wine is all about. A taste is fine if you believe that understanding a bottle consists of writing down impressions of aromas and flavors. It's like buying music over the Internet—if a fifteen-second snippet offered everything you needed to know, why pay for the whole song?

That said, with many wines, a sniff and a taste does tell

you all you need to know. You don't need much more than that to evaluate a generic bottle—a wine that is routine and palatable but really does not have much of interest to offer. Nothing is really wrong with wines like these. Indeed, most of the wine consumed in the world probably falls into this category. But people who are passionately interested in wines do not settle for bottles like these, any more than food lovers can accept dining in franchise restaurants or eating commodity brands.

Good wines, interesting wines, and, without a doubt, great wines—these cannot be dispensed with quickly. In fact, with truly great wines, one bottle, opened, explored, and cherished in the course of a meal, is still not enough. Critics generally cannot evaluate wines over the course of time—it's simply impractical. But at home, it's a wonderful thing if you have the means, and the storage space, to buy a case, or at least several bottles, to be opened over the course of years, so the entire arc of a wine's evolution can be thoroughly examined. A great wine can be so many things, whether in the blush of youth, in the gangly awkward years of adolescence, in the prime of its powers, and of course in its slow descent through frailty to the end. I've got several cases that I'm exploring from the sweet fruit of youth to, well, check in with me in fifteen years to hear how they've unfolded. They include midrange Burgundies and Bordeaux, which I bought a few years ago when they were more affordable, as well as Barolos and other bottles that I love and that will evolve, like Beaujolais, Vouvrays, Bandols, and Riojas.

Sadly, as I said, such rigorous evaluations are largely impractical and seldom affordable. Great wines evolve at per-

ilously close to the same rate as human beings. As in life, there's no going back. So we compromise, and settle, and do the best we can with extrapolations and informed guess-work.

Nevertheless, the experience of a great, properly aged bottle of wine can be profound, especially if you have never had such a bottle before. I will never forget the first great bottle I enjoyed, and looking back now, I can see how easily my experience could have been different. It's often said that great wine is for rich people, because only rich people can afford the inevitable disappointments, particularly with old wines. If you have a case of a great thirty-year-old Bordeaux, one corked bottle may be frustrating but not crushing. If you've saved all your money to buy one such bottle and it's bad, well, it's a lot of money down the drain.

But I was lucky. I found a great bottle that I could afford, I drank it in the company of loved ones, and I will never forget it.

When I arrived in New York in August 1984, I was coming to a city both on its way up and on its way down. The sinister, threatening days of the late 1970s, of subway graffiti and random violence, were also a time of great ar-tistic creativity and opportunity. The effort to put New York's economy in order paved the way for gentrification and creative stultification. But in 1984 New York had not yet reached the nadir of the Giuliani years, when Disneyfication seemed the ideal and the police seemed free to intimidate with impunity.

Regardless of what was going on politically and eco-nomically, I was thrilled to be in Manhattan. I felt the same

way on arriving in Austin and Chicago, but this time I was coming home. I found an apartment on West 16th Street, an easy subway trip to almost every part of the city.

I didn't have many material possessions with me when I moved into my one-bedroom apartment. I was still in a collegiate mode of living—stereo, records, futon, milk crates, and cinder blocks comprised most of what I owned. I had not yet begun to amass a wine collection. It's fair to say that I loved wine, but my primary interest was still food, eating, and restaurants. Wine to me was part of the joy of the restaurant-going experience. If I were going to cook at home, I would go out and get a bottle for dinner. That's still the way most people buy wine—on the spur of the moment.

As much as I enjoyed wine, I had never had what many would consider a classic great bottle—a first-growth Bordeaux, for example, or a fine Burgundy. Great wines like these were once thought to be an ordinary part of one's wine education. Back in the early 1960s, when bottles of first-growth Bordeaux could still be found for under $10, they might have been considered relatively expensive, but they were still affordable if one were determined to understand the differences between Latour and Margaux. Of course, I say that with the despairing, forehead-smacking hindsight of one who was daunted by the prices of the early 1980s. In 1984, for example, you could find a bottle of Lafite in stores for $50 or $60. You could even get a bottle in restaurants for under $100. We pay that much for mediocre chardonnay today, but back then I felt as if those wines were way out of my price range.

The first time I did splurge it wasn't for myself. In 1985 my parents celebrated their thirtieth wedding anniversary, and I wanted all of us to share a memorable bottle. What could be more memorable than a thirty-year-old wine from the same vintage as their marriage, 1955? Alas, I knew very little about older wines. I'd never tasted an old wine. Beyond the fact that I liked to drink wine, I knew very little about how it aged, or how it evolved. I understood that certain wines, like Barolo and Port, had the ability to age for many years, but the wines that immediately came to mind as age-worthy were, of course, Bordeaux.

More than any other wine for a beginner like me, Bordeaux held a mystical attraction. The experts always called Bordeaux the world's greatest wine region, and who was I to doubt the experts? Champagne was something for celebrations. Burgundy? "I started out on Burgundy but soon hit the harder stuff," Bob Dylan sang in "Just Like Tom Thumb's Blues," and you knew he wasn't talking about fine French wine. Before the French recaptured the term, Burgundy had become, in the United States, at least, a synonym for any kind of cheap red hooch. But Bordeaux? There was no mistaking the prestige or the greatness of these wines.

Back in the early 1980s, even after the American success in the 1976 Judgment of Paris wine tasting, France still sat uncontested at the top of the wine heap. Except perhaps for the prices, no wine was as accessible to the abject beginner as Bordeaux. For one thing, the leading producers were all ranked. In 1855 the wines had been classified in five tiers, or growths, and this ranking still held with just a few alterations 130 years later. You didn't have to be an expert to know that

a first-growth Bordeaux was better than a second-growth, and that both were better than a fifth-growth. This was brilliant marketing.

Yet this marketing only applied to sixty producers in the Médoc, plus Haut-Brion in the Graves. Hundreds of Bordeaux producers were not included in the ranking. In stepped Sherry-Lehmann, the big New York wine merchant, which for years has run a promotion heralding "Unsung Heroes of Bordeaux." This promotion highlighted its collection of less-expensive, little-known Bordeaux producers, the so-called Cru Bourgeois, or what Sherry called petits châteaux. They may not have been classified, but Sherry-Lehmann not only gave them the stamp of approval, it identified them as bargains. This was brilliant marketing as well.

I was not at all sure how to go about acquiring a thirty-year-old bottle of wine, but I knew it had to be Bordeaux. I had a friend who worked in the restaurant industry, and I asked him how I could get my hands on a bottle. He called me a few days later and told me to contact a particular merchant who would sell me a bottle of 1955 Château La Mission Haut-Brion for $185.

What? Almost $200 for a bottle of wine? At least I had heard of La Mission. I knew it was one of the great names of Bordeaux and of Graves. I learned that it was not included in the 1855 classification, which ranked only wines from the Médoc region to the north. The only exception was the legendary Haut-Brion, La Mission's neighbor, also

in the Graves, which had been allowed into the charmed circle for its centuries-old reputation as one of Bordeaux's best. I learned that while 1955 was not considered one of the best vintages, neither was it one of the worst. But, my God, almost $200? Well, if this was going to be a great occasion I had better take a deep breath, swallow hard, and go through with it.

I have to laugh a little now, more than twenty-five years later, at my anxiety over spending $200 for the '55 La Mission. A wine like that today might cost $3,500 or $4,000! I remember how the old-timers in the 1980s used to reminisce about buying cases of '61 Latour for maybe $9 or $10 a bottle, and how I resented their easy access to legendary wines. Have I now become one of them?

At the time, though, I had no idea that the '55 La Mission qualified as legendary. I just hoped it would be good. In fact, my ignorance about the wine—about any great wine—saved me from considerable worry. Was the wine corked? I had yet to encounter a corked wine, as far as I can recall. How had it been stored? It never occurred to me to ask such a question. Could it, might it, was there a chance it was a fraudulent bottle? Ha! Such notions did not yet exist.

All I knew was that I had to handle it gingerly and that I had to open it carefully and perhaps even decant it, because old Bordeaux were notorious for being full of sediment. A mouthful of sediment was like drinking coffee grounds—to be avoided if possible.

———

I had presented the bottle to Dad and Mom on their anniversary, November 26, 1985, and not long afterward headed out to their house in Roslyn Heights for dinner and wine. Mom had prepared lamb chops, a classic accompaniment to fine Bordeaux, and with great excitement and some nervousness we prepared to decant the bottle.

I had read up on the age-old ritual of pouring the wine over a lighted candle in order to be able to see the first signs of sediment entering the neck of the bottle. A candle seemed overly precious so I used a flashlight, and slowly, standing over the kitchen sink so as not to spill a drop in Mom's spotless kitchen, I poured the wine into a glass pitcher etched with roses. With the bottle now empty except for a tantalizing bit at the bottom full of sediment, we took turns burying our faces in the pitcher to breathe it all in.

You didn't need to be a wine scholar to know that this was something unusually fine and wonderful. As I inhaled the aromas of the wine, I felt the sentimental history of my family wash over me, of the hopes and dreams of Mom and Dad over their thirty years of marriage, of the lives they had built for themselves and of the lives that their children, now adults, were trying to build. I was now twenty-eight years old, the same age my father was when I was born. Where would I be in thirty years? I wondered. Where would we all be?

Yes, I was moved by the emotional and symbolic value of this wine. But most of all, I remember how great the wine smelled. While it was hard for me to be entirely clinical in assessing it, simply because of the emotional context of opening this bottle, I couldn't help noting that the com-

plexity and beauty of the aromas were unlike anything I had tried before.

How do you serve a bottle of great wine? Today, with so much information to confuse matters, I can imagine being paralyzed with anxiety. Do I have the right glasses? Can one drink Bordeaux from a Burgundy glass? Or vice versa? What about the decanter? Must you cover it? Is the wine at the proper temperature?

I've heard all these questions so often, and so many more just like them. I completely understand. Whether you're spending $10, $20, $200, or $1,000 for a bottle, everybody wants to get their money's worth. Particularly with expensive bottles, expectations are heightened sometimes to ridiculous levels. We all think we need to be specialists, skilled in arcane arts, to reach the threshold necessary to enjoy a glass of wine.

The truth is that wine can be one of the simplest pleasures available to anybody: Pour beverage into glass, drink, enjoy. That's 90 percent of it right there! Anybody can do that, right?

The rest of it is just enhancements. Did you ever see the tiny baseball gloves used back in Babe Ruth's time? They look like little more than padded mittens, and at the end of an inning when the fielders ran in to take their turn at bat they stuffed their gloves into their back pockets. Were they not able to play the game with great skill despite lacking the refinement of today's tools? Of course they were. Ability was in the players, not in the gloves or the bats they used, just as the pleasure is in the wine and in the human ability to enjoy it, not in the particular sort of glassware involved. Not to say

that good-quality glasses are not a fine thing. Good glasses absolutely enhance the enjoyment of a fine wine, but precise matches of glassware to bottle border on the absurd.

Back in 1985 I didn't think about the glasses we used. Mom had two kinds of wineglasses—ordinary-looking goblets and heavier, fancier ones she had inherited from her mother, with a glass beading that embellished the bowls. I never liked those glasses. They felt heavy and shallow. So we poured the thirty-year-old La Mission into the sorts of glasses you might find on the table at any neighborhood bistro.

If I had such a wonderful bottle of wine today, I might make it the centerpiece of a dinner, building up to it with another bottle or two. Back then, I had no real sense of scale, and my parents might have considered two bottles of wine at dinner to be decadent and unhealthy. So we just plunged right in with dinner, sitting at the round white kitchen table where I had eaten so many meals growing up, gorging on the lamb chops and potatoes, and sipping this extraordinary wine that seemed to epitomize both grace and intensity.

What did the wine taste like? I knew somebody would ask me that.

Forgive me if I choose not to grope through the usual lexicon of fruits, flowers, herbs, spices, and so on. To say that the '55 La Mission smelled like pencil shavings, violets, truffles, and cedar may be correct on some vague level, but it was irrelevant to the pleasure we took in this wine and ulti-mately pointless information for assessing the wine.

Better to say that each sip was both a joy and a challenge.

One could simply enjoy a wine like this for its deliciousness, the way one can enter a museum gallery and take in a group of paintings with swift glances, admiring each and emerging with a sense of pleasure yet without feeling changed. I know we all loved the wine on that level. We sighed and pronounced it beautiful. We toasted Mom and Dad and their thirty years together. Mom still has that bottle, sitting on a shelf near a portrait of Dad.

But even amid the celebratory joy of the meal, I remember being mesmerized by the wine. I was riveted by my glass, as if it were a Cézanne still life in which you discover the apple that appeared to be red on first glance was actually myriad different shades and contours that collectively added up to red but were in fact much more.

It's not necessary for anybody to take the time to examine what's in a glass of wine, just as nobody feels obliged to stop in front of a painting for prolonged study. I don't begrudge anybody the choice of accepting the easy enjoyment and moving on to the next thing. But if you are inclined to stop and focus, well, then, a wine like the '55 La Mission has countless emotions, angles, and vistas to reveal, in itself and in you.

This desire to observe a wine more closely represents the moment when a casual drinker begins the transition to wine lover, connoisseur, obsessive wine geek, or whatever you want to call it. This transition comes not to fulfill a social obligation or to overcome a sense of inadequacy, it comes from an overwhelming curiosity, a need to understand the

source of such pleasure, and, yes, a hedonistic desire to repeat the experience again and again.

It sounds obvious, doesn't it? Why the hell else would anybody want to throw one's self into the study of wine, other than curiosity?

Yet this is the crux of wine anxiety, people somehow feeling compelled to know things that they in fact could not care less about. Not everybody is curious about wine. Some people—I know this is hard to believe—are bored to death by the microscopic examination of all things wine.

If you have no interest in wine beyond drinking it, that is fine with me. You simply have to be honest with yourself about it, just as you might be regarding your feelings about ice hockey or dance. Can you imagine the social embarrassment that comes from not knowing the name of the leading goal scorer or principal ballerina? Unfortunately, too many people find it all too easy to feel this way regarding wine.

Partly, this is because people in the wine business, whether they own wineries, run wine publications, want to teach you about wine, or simply are in the business of selling wine, have a vested interest in making people feel obliged to know something about wine. If being knowledgeable about wine can be made an emblem of civilization, like good manners or proper hygiene, those who strive for social approval will feel compelled to learn something about wine. Meanwhile, those who would just as soon thumb their noses at the idea of living up to some sort of social obligation would naturally target wine as a symbol of snobbishness. Wine becomes one more method of typecasting people, rather than simply a grocery. That's one reason we have a fascination

with athletes and rock and rollers who love wine—it goes
against type for those who might otherwise be considered
salt-of-the-earth types or rebels to embrace wine.

Not all wines reward close observation as much as the '55
La Mission. Of course, it was balanced and elegant, light-
bodied yet intense, complex and thought-provoking. It went
well with the food. Indeed, in the context of our meal, it was
perfect, encompassing family history, the ceremony of the
anniversary, and the joy of sharing something so wonderful
with loved ones. It was everything a great bottle of wine can
possibly be.

For me, it came at just the right moment in my develop-
ment as a wine drinker. At the time, I was indeed ignorant.
But I had drunk enough wine—good, daily bottles—that I
could recognize the qualities that made this wine profound,
even if I didn't particularly understand the physics of aging
(not really necessary, but interesting) or have the experience
to place this bottle in the context of other well-aged bottles
of Bordeaux. Frankly, all that additional knowledge may
deepen one's understanding of the experience, but it's not
essential. It's simply a matter of choice—how deep do you
want to go into wine?

Great historic bottles of wine, in their cost, their extrava-
gance, and their potential, are a little bit like great three-star
restaurants (to use the Michelin scale). Any of them, whether
French Laundry, Le Bernardin, Guy Savoy, or El Bulli, can
be daunting, and maybe a little scary to enter. But they are
essential to widening one's understanding of possibilities,

of enlarging one's context for judging other meals and for the simple, straightforward hedonistic experience they offer. Any time I've eaten at one of the world's great restaurants, I've felt privileged, my world expanded.

But while sampling great wines may be crucial for one's understanding of potential, the choices of great wines today are far more extensive than they were even twenty years ago. Today, the classic historic wines may go for hundreds if not thousands of dollars a bottle. They have become so rarefied that only a minute number of rich people can afford them.

It may be that the demand for these bottles has essentially turned them into dinosaurs. Nowadays, the great first growths, the wonderful red and white Burgundies—wines like these are available to so few people that they are essentially irrelevant. That is, many of the people I know who feel most passionately about wine never drink these sorts of bottles. They wouldn't turn them down if offered—indeed, they would leap at the chance to drink them. But so many other wonderful bottles are far more accessible that the need to dwell on bottles like these has diminished.

For centuries, the best wines from Bordeaux, and Burgundy to a lesser extent, have been the defining bottles for those considered to be connoisseurs. But while many experts continue to pay obsequious lip service to the greatness of these bottles, things have changed. Just as the world understands that great restaurants no longer have to be French and formal, it has come to the understanding that not all great

wines have to be top-of-the-line bottles from Bordeaux or Burgundy or from Napa Valley, for that matter.

Connoisseurs today are the ones who understand the greatness of wines from the Loire Valley, from Germany and Champagne, from the Rhône, from Barolo and Friuli-Venezia Giulia, from Chianti and the Jura and Ribeira Sacra, from the Santa Cruz Mountains and Beaujolais. They are the ones who see greatness or its potential all over, not just primarily in the regions anointed as great a century ago or even twenty-five years ago.

Wines from all these regions are different, but many of them too have the potential to age and evolve. Great wines don't all taste alike; they all taste distinctive. Wine lovers now come in all shades and sizes and economic backgrounds. Those without a lot of money who seek great bottles will still be able to find them. They just need the confidence to look in the places that are more affordable than the most historic regions, and perhaps have not received the same critical validation as the wines that have been prized for centuries.

Personally, you won't find any of those historically great bottles in my cellar, such as it is. First off, I can't afford to buy them. I've had storied bottles of wine simply as a privilege of my job, the way sportswriters attend Super Bowls. Almost each one has been through the generosity of somebody else, a far wealthier somebody else, including the *Times,* which might like to have back a little of my expense account right about now.

Unlike past generations of wine lovers, who might either have been privileged enough to have a family with a great cellar, or who were old enough and prosperous enough to

be able to afford great wines, I came of age at a time when these bottles conventionally thought of as great wines were beyond the means of most people.

I've never been able to buy a bottle of Domaine de Romanée-Conti, the world's most sought-after Burgundy, or a Montrachet, or very many first-growth Bordeaux. But I've bought a lot of great wines. I've just had to look elsewhere for peak experiences, to other regions of France, to Italy and Germany, California and Spain.

Great bottles can and do still come from Bordeaux and Burgundy, of course. But because the quality of winemaking has spread and soared around the world, it is no longer necessary to rely only on those historic names for a taste of a great wine. Even within those regions, for far less money than one of the greatest names would cost, one can buy lesser bottles that will still convey what a good Chambolle-Musigny is intended to be, or why a Puligny-Montrachet is different from a Meursault. And one can learn about greatness by drinking older Vouvrays, or Mosel spätleses, or Barolos. Wines like these do require a monetary commitment, though far less than a top Bordeaux or Burgundy. They require a time commitment as well, as great wine always has. But then so does golf or tennis.

Frankly, it's a great relief to have so many more choices today. Nowadays, our understanding of great restaurants encompasses so much more than the sorts of places that could earn three Michelin stars twenty-five years ago. We've liberated ourselves from older ideals of service and decor, just as we've freed ourselves from the notion that only certain kinds of cuisines can achieve greatness.

As I've gotten older, beauty for me lies more in simplicity and modesty than in extravagance. Sure an over-the-top luxurious meal is a wonderful thing—once in a great while—just as an exorbitant, lavish bottle is a great privilege to drink. I'm forever grateful that I had the opportunity to open that bottle of '55 La Mission. I know that if I were in my twenties today I could not afford a bottle like that. But I have no doubt I would be able to find an equally meaningful wine for a lot less.

Seeking Higher Learning

Wine industry analysts like to imagine that consumers follow a predictable pattern. They start off buying inexpensive, introductory wines, whether white zinfandel, Two-Buck Chuck, or cheap wines adorned with inviting labels of animals, bicycles, or cartoon characters. Once consumers get in the habit of buying these wines, whether good, mediocre, or dreadful, they are wine drinkers, the thinking goes, ready to progress to better and more expensive bottles.

The problem with this view is that few wine journeys follow the same predictable path. Some never embark on the journey at all. They drink wine on ceremonial occasions, and like it well enough, but don't seek it out or care to drink it otherwise. Others may drink wine more frequently, but simply buy the least expensive wine available and are quite content with it—except in restaurants, where every old hand knows that the least-expensive wine on the list never sells, while the second-cheapest is often a bestseller. Simply put,

people are too embarrassed in restaurants to order the cheapest bottle.

Rather than rationalizing the sales of terrible wines, why not introduce people to good, inexpensive wines? Because once people decide that they actually like wine, and are curious enough to want to try different sorts of bottles, I then see a steady progression of taste.

It would be too simple to suggest that everybody advances in the same direction and at the same rate. While the path differs for everybody, this journey nonetheless progresses in a roughly predictable fashion, even if it's full of hairpin turns and switchbacks, leading from wines and regions that are immediately pleasing and relatively easy to understand to those that are more subtle, understated, perhaps more austere and require some study. That's certainly the way it was with me.

If I needed any inspiration to plunge more deeply into wine, it was that bottle of '55 La Mission. Its effect was certain, though not particularly dramatic. I didn't look into the mirror and announce to myself, "I'm going to try to become a wine expert, a connoisseur." As with learning to cook, I was motivated by self-interest. I couldn't stand the idea of not having something good to eat and drink.

I knew other people my age who were getting into wine in the mid-1980s. Some worked on Wall Street, where expensive, high-status bottles were just another emblem of what the writer Michael Lewis called "Big Swinging Dicks," aggressive, successful traders and salesmen. Other peers, as they got a bit older, found wine an enjoyable and mellow adjunct to the more strenuous means of intoxication that were common at the time.

As for me, I learned simply that I loved wine, just as I loved restaurants and eating. But what was it exactly that I loved? The flavors and aromas? The act of consuming? Well, of course that was a major part of it. But something more was involved.

While occasionally I would drink wine on its own at a party or reception, I always preferred wine with food. I could happily down a few beers at a ballgame or in a bar. I like a glass of wine as I'm preparing dinner, or one more glass of wine after I've finished eating. But for the most part, the experience of wine without food often seems to lack something important. Obviously, not everybody feels the same way about this. I know plenty of people—even people in the wine industry—who don't really care whether they are drinking wine by itself or drinking it with food. Some actively refuse to drink wine with food. They may drink a glass or two before dinner, and another couple after they've pushed away from the table, while sticking with water during the meal. I understand this, but personally, I don't get it. I might enjoy a glass of wine as an aperitif (I especially like fino sherry), but to me, wine and food simply belong together. Each element is certainly pleasing, but together they construct joy.

Clearly, though, wine's appeal stemmed from more than its synergy with food. Sure, I could sit alone, by myself, with a glass of wine and a plate of food, and I could enjoy myself tremendously. And yet, to share the meal with other people was so much more fun. We might be brought together as family or by shared interests that had nothing to do with food and wine. We might cook together, or maybe

just order pizza together, or hang out in a restaurant. The affinity comes before the bottle, but the wine amplifies the affinity.

Is it just the alcohol? That feeling of well-being inherent in a glass or two of wine? Nobody likes to talk about the buzz factor, but clearly that's a part of the wine experience. I don't mean intoxication, inebriation, or drunkenness. But alcohol is an essential part of wine. It adds a warmth and conviviality to the experience. Nonetheless, alcohol is not the decisive factor. For those who care about wine, sharing a bad bottle brings no warmth at all, despite the alcohol. Instead, it results in a crestfallen feeling of discontent. Good wine, shared with friends and family, with a good meal, offers so much more than a buzz. It increases happiness, augments a sense of well-being, and can even comfort sadness. Of course, one can experience all of these feelings with loved ones standing in a garden or holding hands. But if you love food and wine, the emotional and social sustenance of sharing them with your friends and family takes on an almost spiritual dimension.

Good wine together with good food, that's what I came to crave. While a modest wine can be elevated by the context in which it is consumed, a bad wine can suck the air out of the room. On fire with my first taste of great wine, I became absorbed with the idea of identifying good wines, mostly as a way to protect myself from the bad.

But how to do it? How does one learn to find good wines?

I decided to take a wine course. It seemed like the natural way for learning anything—take a course. You want to learn how to play piano, you take lessons, right? You want to explore Victorian literature, you take a class.

Perhaps this was not quite as intuitive as I'm making it sound. My own instinct is generally to want to teach myself. I never took a cooking class, but had certainly learned how to cook adequately, through trial and error. I might not have been able to turn out classic French dishes from the haute cuisine canon, but I could roast a chicken well enough.

As a child I had taken some guitar lessons, and years later when the yearning to play returned, I took more. Of course, my guitar teacher taught me basic techniques that anyone would need to be able to play. But rather than teach me songs or scales, he helped me improve my ear so that I could hear for myself how to play the songs I wanted to learn. This suited my sense of self-reliance. Years later, I played in a garage band with some colleagues at the *Times,* strictly for our own amusement. It was great fun, but I always felt lucky they tolerated my presence on guitar—despite the lessons my musical abilities are the triumph of willpower over lack of talent.

Still, for wine, classes seemed the way to go. The subject seemed too arcane for plunging into on my own. Unlike with cooking, few practical recipes were available to guide me. Instead, I took a quick turn through the Yellow Pages in the pre-Google era of the late 1980s and found more than a few schools offering wine courses.

I decided to start from the beginning with an elementary class at one of the better-known wine schools. On the first day, a cold, gray winter afternoon, I entered the school, situated on an upper floor in a nondescript office building in midtown Manhattan. It's one of the quaint characteristics of Manhattan that small businesses like wine schools, film-

editing studios, and modeling agencies are hidden away on the middle floors of office buildings, right among the importers, accountants, and lawyers, rather than in suburban strip malls with storefronts advertising their existence.

My fellow students and I were ushered into a large seminar room with three rectangular tables arranged in a horseshoe. We took seats around the outer rim. In front of each of us were six empty glasses on a white paper placemat, along with a small dish containing a few slices of baguette, a pen and paper, and a tall paper cup for spitting wine. At the head of the class a woman began to speak as assistants walked around, pouring small portions of wine into the six glasses. The subject this day was white wine.

She explained to us how each grape had its signature aroma and flavor, how through practice we would be able to identify wines simply by smelling them. First we were to examine the color of the wine by holding the glass up to the light against the white background of the placemat. Pale and transparent? Rich and golden? Green-tinged? These would offer important clues as to what was in the glass. I wasn't sure why we couldn't just read the label on the bottle for that information, but I went along with the assignment.

The instructor showed us how to rotate the glass on the table, counterclockwise with our right hands, holding it by the stem and swirling the liquid within. This, she said, would blend the wine with air, releasing its aromas. Following her instructions, we swirled and then stuck our noses deep into the glass, taking a series of short, quick sniffs like inquisitive dogs. Then, we were asked to describe what we sensed in the wine.

It all seemed logical. This was how the experts appraised wine, right? We went around the table. One man said the wine was pungent. The next said it smelled like a taxi-cab deodorizer. That got a laugh. I said it smelled like mint and tarragon. A woman said she smelled grass and nectarines. "Yes," the instructor said, "I'm getting that, too, along with wet stones and gooseberries."

This was a bit stupefying, as none of us seemed to know what gooseberries smelled like. In the end, each of us described different aromas, and the instructor told us we were all right. She passed around a chart in the shape of a wheel, which had recently been devised by Ann C. Noble, a professor at the University of California, Davis, in an effort to standardize descriptions of wine aromas.

The three-ringed wheel divided aromas into twelve categories, from fruity, vegetative, and nutty to chemical and microbiological. Many of the categories were further subdivided—fruity, for example, into citrus, berry, tree fruit, tropical, dried, and other. Finally, on the outer ring, were dozens of terms to describe aromas. I wondered how useful this wheel could be, since I could find neither gooseberry nor nectarine among the approved terms. I couldn't find mint or tarragon, either. But the instructor said the wheel was not meant to be complete. It was intended to provide a framework, a way of analyzing and categorizing aromas, facilitating communication.

Now came the tasting. After twirling our glasses again, we were to take a sip into our mouth without swallowing. We were to draw air in, too, to help release the flavors, and to "chew" the wine, so that it covered all the internal

surfaces of the mouth. Note, she said, how the wine feels. Was it light-bodied or full? Were the flavors intense or diffused? Was the wine lively and energetic or thick and heavy? Smooth or raspy? And finally, how long did the taste last in the mouth before evaporating?

Needless to say, the instructor recommended that we spit into the cup so that we could assess all six wines with a clear mind, a suggestion that drew amused titters. I did spit, though I couldn't help swallowing a little bit, too. I wasn't sure that I could fully understand the wine if I didn't swallow at least a little bit. I still have my doubts today. Again, we were to go around the room and describe our various impressions.

Spicy, one person said. Tangy citrus, I said, aware that I was giving a different answer than I had during the discussion of aromas. One woman said it tasted like lime. Everybody laughed when the taxi-deodorizer guy said it now smelled like cat piss. The instructor told us this was a classic description of sauvignon blanc, which in fact was the wine in our glasses, by way of New Zealand, from where wines were just beginning to arrive in New York.

And on we went, through chardonnays from California and France, riesling, gewürztraminer and pinot grigio, sniffing, tasting, spitting, discussing, and occasionally swallowing. Each wine seemed to smell and taste different (except for the pinot grigio, which really didn't smell or taste like anything much at all). In fact, it was not hard for any of us to distinguish between the wines. And yet it seemed as if all the impressions we had of aromas and smells were different, as if each of us was in a different universe when it came to describing the same wine.

I left the class puzzled by what exactly I was learning to do there. Clearly, the skills of sniffing and tasting would be useful. The swirling most definitely would take some practice, though. I wanted to know more about wine, of course, but when I really thought about it, I wanted something different. I wanted to feel confident about wine, to understand how best to enjoy it. I wanted to figure out how I could open myself up to the wine-drinking epiphanies that were so rapturously described in the books and magazines I had started to read. I didn't so much care about learning to taste like a professional, or about "wine appreciation." Did it really matter whether I could identify a glass of wine simply by smelling it? Was that really a useful skill? Perhaps that wasn't an end, but simply a means for learning to enjoy wine better. But still, the whole process seemed sterile compared with the way I actually drank wine.

Looking back now, I suppose in some circles the lessons must be considered extremely useful. More than a few wine writers today point to a crucial moment in their development where they were handed a glass of wine without being told what was in it, and, to the consternation and astonishment of the crowd, they were able to identify it as Haut-Brion '82 or Monfortino '85, or some other great bottle. Regardless of whether the story is told in a smug or self-deprecating manner, the writer points to this signal event as a triumphant rite of passage, in which the writer gains recognition, credibility, and the confidence to press on.

Personally, I never really understood the point of the

story. In my blind-tasting experience, I've been wrong far more often than I've been right, but so what? Blind tasting is an informed guessing game, in which you try to narrow down the possibilities as best you can and then hope for a lucky stab. But right or wrong, what does it prove? Conventional wine lore has it that the expert can pick out a bottle of wine blind at fifty paces, but at best this is a parlor skill. It demonstrates nothing about one's taste, one's discrimination, or one's ability to communicate. But it does intimidate the vast majority of wine drinkers who most likely have never tasted the wine that the exalted critic has just identified, and almost certainly have never tasted multiple vintages of the bottle in question.

Ultimately, it's a way of keeping the wine-drinking public in its place while solidifying the omniscient status of the critic. But is omniscience a good thing in a wine writer or critic?

The beauty of wine is due in significant portion to its mystery. Wine critics need to embrace this. Great wine is by its nature ambiguous, existing on a fragile balance and ever-changing. It enthralls us because it is unpredictable, not because it tastes like a written description or evolves in a linear fashion. The goal is not so much to unravel the mystery as it is to revel in it.

It may serve us all to understand how a ruby or diamond is formed, and perhaps this understanding helps us to appreciate the beauty of a precious gem even more. But in the end, that beauty is not explainable; it just is. Wine offers so many wonderful qualities that we don't yet fully understand. How do wines age and flavors evolve? What is the importance of

the soil in which grapevines are planted, and how does that soil affect the flavors in the wine? We have so much still to learn about wine, yet to comprehend wine in its physical, chemical, and biological complexities makes it no less wondrous. Hugh Johnson's wonderful dictum bears repeating: "Great wines don't make statements, they pose questions." Boiling wine down to its constituent aromas and flavors does not help us to understand it better, although it does make the critic feel more in control. Lifting up a wine to see it in its entirety does help understanding, although it comes at the cost of accepting the fact that not all is explainable and we don't know everything.

Can you imagine an art critic discussing a masterpiece merely by listing the various shades of paint observed on the canvas? Of course not. What bearing would that list of colors have on understanding and absorbing the entirety of that piece of art? Similarly, great wine is best experienced by the sense of wonder and intrigue it provokes. The interplay of weightlessness and intensity and sweet beauty in a fine Burgundy, for example, or the cloudlike, airy delicacy of a wonderful Champagne require no discussion of hazelnuts, moss, jasmine, and orange rind.

Yet, by turning away from omniscience, does a critic risk giving up authority? About ten years after this particular wine class, not long before I began writing about wine professionally, I had the pleasure of sitting next to Hugh Johnson at a tasting of some old red Burgundies at Montrachet, the ground-breaking, wine-oriented restaurant in Tribeca that hit its peak in the early 1990s. We had been making pleasant conversation while enjoying quite a few glasses of wine, and

after one particularly lovely sip, I asked him how he would describe what was in the glass. He looked at it carefully, took a few deep sniffs, just as I had been taught in my class on white wines, and took a mouthful, drawing in air, swishing, and swallowing (no spitting at this dinner).

"Marvelous, marvelous," he said, "just lovely, and redolent of, oh, I don't know what!"

It was the perfect answer. Of course, we could have put that wine through the atom-smashing machine, breaking down the aromas and flavors, but to what end? It would not have defined what made the wine so beautiful. With wine, sometimes it's better to feel it than to try to own it.

The Arc of Discovery

After my one class, I never felt the inclination to return for another. I don't mean to denigrate wine classes. They have their proper time and place. But at the point that I was getting serious about wine, I intuitively felt that taking more classes, or investigating different schools, was not right for me. I didn't want to learn how to taste, I wanted to feel the pleasure of good wines. Reading about food made me hungry. I craved the joy of good food, not classes in how to describe how food tasted. I felt the same way about wine. Taking a wine class seemed to me about the same as traveling in a tour group with a guide telling you where to look. I felt perfectly capable of traveling by myself and discovering wine by myself.

As fascinated as I was by food and wine, I still never considered getting into the wine business. I was not exactly passionate about my job at the *Times*. I had spent a few years as an editor on the national news desk, and I now thought of

myself as a journalist. But my professional ambition was not, as my father would have wished, to manage a newspaper. Looking back now, it's amazing to me how transparent he was in shifting his own ambition to me. He wanted to run a newspaper, and he had gotten high in the hierarchy at *Newsday,* but never received the top job.

"When you know what you're doing," he once said to me, "you want to be in charge. The problem is that too many people with authority have no idea what they are doing."

He would emphasize the joy of planning, of managing, of control. If he heard me tell him repeatedly that I was going to be a reporter, and that managing other people was the last thing I wanted to do, he wasn't buying it.

When I joined the *Times,* I made no secret of my desire to write, but I was warned that the newspaper had no tolerance for people who got their feet in the door as editors, then set about to become writers. I was told the job tracks were kept separate, and if I knew what was good for me I'd stick to what I was hired to do.

These were threatening words, and they were repeated often—at meetings with bosses, in evaluations, in casual conversations after work or in the cafeteria as inexperienced young editors like me tried to figure out their places in this intimidating new world. Yet as I looked around the newsroom and began to learn people's personal histories I could see that the notion of an impermeable barrier between editors and writers simply wasn't true. Plenty of editors had gone on to become reporters, and almost all of the star editors at the paper had started out as reporters.

The *Times* was an intimidating place in the mid-1980s.

Each evening's work seemed animated by yelling, cursing, frowning, and scowling, all seemingly fueled by alcohol and tobacco and the general set of personality disorders that used to drive many people into the newspaper business. Far more effort was put into doling out blame—in figuring out who should be responsible for each mistake, no matter how small—than in offering praise for jobs well done.

Yet as I took my place in this newsroom, thrown into a national news desk made up of difficult, eccentric personalities who in their own individual ways were utterly brilliant, I began to feel as if the threats and warnings were not to be taken at face value. They seemed more aimed at cowering those whose ambition was casual, who back in those days of *All the President's Men* fantasized about the romance of being a reporter rather than about the actual work. By setting up obstacles, it seemed to me, the newspaper was testing the scale of the desire, the power of the determination.

So professionally I began to focus on writing for the *Times,* and therefore never considered throwing myself into the wine or restaurant business. As I worked nights, I had my days to myself, and I looked for opportunities to write for the Living section, as the Dining section was then known. I introduced myself to Margot Slade, the slender and thoroughly intimidating Living editor. I managed to wangle an assignment—shades of my high school writing career—on the difficulties of finding decent draft beer in Manhattan. At the time of the *Challenger* disaster in 1986 I was in one of the first brewpubs in Manhattan, interviewing the brewer. Slowly, and somewhat erratically, my career writing for the *Times* got under way.

Of course, this did not solve the issue of learning about wine. Without really having a plan in mind, I began to do what seemed most reasonable in pursuing this hobby: I started to buy a lot of wine to drink and I began to read as much as I could about it.

Why hadn't I done this before, in Texas or in Chicago? Well, for one thing, as a graduate student I had no money and in Chicago I was not settled enough to do much more than experiment indiscriminately with the wines I found at Sam's, the huge warehouse of bottles not far from my apartment. What's more, while I knew I loved wine, it had simply never occurred to me that I could study it on my own, as I would any other subject. Thinking back on this, I'm puzzled at my inaction. While I am not especially obsessive, I've always pursued my interests deeply, whether in music, history, sports, or food. As much as I loved wine, had I somehow not taken it as seriously as other interests in my life? Or did wine require a different sort of confidence to pursue?

Either way, now, things had changed. My head had been turned, and I began in my spare time to learn what I could. Despite my discontent with the wine school, I again turned to the experts.

No longer did it seem advisable to me to pick bottles randomly at wine shops and to drink them without thought. Clearly I needed help. Why not? I didn't buy anything expensive—a car, a microwave, a mutual fund, and, yes, a computer—without study. This was the mid-1980s, and few people outside of M.I.T. had ever heard of anything like the Internet.

But I was now the proud owner of my first computer, a Leading Edge Model D, with two floppy disk drives, an amber monochrome monitor, and a dial-up modem that could connect to computer bulletin board systems at the unheard-of speed of 1,200 bits per second, whatever that meant.

I had read up on the computer in *Consumer Reports*. It seemed natural to find a place to read up on wine. Of course, I had been a longtime reader of Frank Prial, the *New York Times* wine writer. Prial had a way of making wine seem witty and literary yet down-to-earth as well. Even if I didn't care about the subject I would have found his articles entertaining. He had a way of never taking himself or wine too seriously. But in the 1980s he had pulled back from full-time wine writing and had been sharing his column with Terry Robards and Howard Goldberg, both more earnest and perhaps more inclined toward practical advice than Prial, who gravitated more toward issues and personalities. I liked reading Gerald Asher, the thoughtful, erudite wine columnist in *Gourmet* magazine, too. Nonetheless, in order to buy wine, I felt I had to supplement my reading.

Two sources came to mind immediately. The first was *Wine Spectator,* a consumer magazine published out of San Francisco at the time, full of feature articles, practical advice, and ratings of individual bottles. The second was Robert M. Parker Jr., an independent wine critic who published a newsletter, *The Wine Advocate,* that essentially only rated bottles. His ratings, along with summaries laying out basic information about the major wine regions of the world, were collected in a big book, *Parker's Wine Buyer's Guide,* which I bought and began to scan as closely as I had *Roadfood* and

Beard on Food when they were inspiring me to cook and to seek out new and different foods.

Years later, Parker became a polarizing figure in wine. Some people blamed him for the homogenization of styles as wine became a global commodity. Though he denied it adamantly, commercially minded producers the world over tried to make wines that they believed would appeal to his taste. Increasingly, even as he retained great influence over wine-buying decisions, particularly of Bordeaux, his voice took on an angry, peevish tone. At times he seemed to put more energy into protecting his legacy than into exploration. Yet I believe his legacy will ultimately be positive. He inspired countless people to explore wine, and I was one of them, even if I did eventually favor different sorts of wines than he did, and reject his emphasis on mass tastings, florid tasting notes, and omniscient authority. Chalk it up to another ambiguity in the world of wine.

Like so many people back then in the mid-1980s, I began by focusing on Bordeaux. With its own classification system and easily parsed geography, Bordeaux seemed simple to understand, or simpler, at least, than Burgundy with its mindnumbing array of appellations and producers who could not confine themselves to making just one or two wines, as they did in Bordeaux. Parker and other critics, like Hugh Johnson, Edmund Penning-Rowsell, and David Peppercorn of Britain, Asher of *Gourmet*, and Prial himself, all seemed to agree that Bordeaux was the greatest wine region in the world. American wines were not highly esteemed at the time, al-

though certainly there were some well-respected producers.

Both Parker and the *Spectator* used the 100-point rating system, which made wine even easier to understand, at least for anybody who'd gone through the American school system. It could not have been simpler. Wines rated 90 and over were great wines, those 80 to 89 were good, and those below 80 were not even worth thinking about. Every American gets it right away.

Of course, I still had little money. My idea of storing wine was to stick shelving—that is, the cardboard cases the wines arrived in—in the coolest place in my apartment. But Bordeaux was affordable, and I started buying bottles. I would scour Parker and the *Spectator* for their verdicts on the best Bordeaux wines that cost the least, and I would buy what I could afford, which meant not the most famous producers but midlevel guys, augmented by a handful of Sherry-Lehmann's "Unsung Heroes."

Parker had earned his initial reputation by raving about the 1982 Bordeaux vintage as the finest in years. This immediately put the '82 vintage out of my price range. But the '83s were decent enough, and I bought quite a few of those. The 1984 vintage was said by everybody to be horrible, but I bought some of those, too, because a bad vintage caused even in-demand producers like Léoville-Las-Cases to plummet into my price range.

Some of the bottles I put away, but many of them I drank nightly with dinner, whether we were cooking ourselves or doing what so many New Yorkers do to get through the night—ordering takeout. I went through Napa cabernets and zinfandels, Chiantis and Beaujolais, cheap Riojas and

cheap Burgundies (they really did exist!), and the occasional Champagne. We drank plenty of white wine, too, California chardonnays and Sancerres, Mâconnais, and even exotica like rieslings.

In the late 1980s far too many people I knew would drink only white wine, saying red wine gave them headaches. Later on, as tastes gravitated toward red, people would blame white wine for the headaches. I never understood this thinking, nor did I care for the reactionary "the first duty of a wine is to be red" types. It reminded me of beer drinkers who confined themselves to Heineken, or people who refused to eat seafood. Why would people want to narrow their range of experience when so much pleasure is out there awaiting us? Nonetheless, I understood that many people, including some of my best friends, did not share my enthusiasm for food and wine. They simplified their lives by making decisions in advance, by settling on the equivalent of brand names that would be their beers or their wines of choice. If it made them happy to reflexively order of a glass of chardonnay in a restaurant, no matter what they were eating, so be it.

While much of my own daily drinking was indiscriminate, I did try to track my consumption of Bordeaux. I tried to follow the Parker ratings in my purchases. Right away I learned that two bottles of Bordeaux from different producers that had received identical ratings could nonetheless seem very different. I might like one bottle very much, yet find the other unpleasant. One might be focused and bright, the other blurred and dull. This was puzzling, and of course it raised immediate questions about the value of ratings. How could the two bottles seem so different in quality? If they

received the same rating, and were impossible to distinguish on the basis of the tasting notes, what other variables might be at work here?

These sorts of questions were the stirrings of awareness that I might have my own personal sense of taste, which might be very different from what the critics wrote. I learned that some wines consistently appealed to me, while others did not. In the vintages of the 1980s, Bordeaux producers like Gruaud-Larose and Talbot, for example, were esteemed and often received very good ratings. Yet in general these wines did not move me. They seemed soft, and lacked the clarity and almost dignified style that I found and enjoyed in other producers. Yet even as I began to recognize that my own opinions about the wines I was drinking might actually have value, I felt insecure and struggled to reconcile my own thoughts with those of the experts.

I liked other producers much more, like Langoa-Barton and Léoville-Barton, which both were owned by the same family, and Grand-Puy-Lacoste and Cantemerle. Strangely, I found that I liked very few of the "Unsung Heroes." These little châteaux were always touted as brilliant value selections because, though they were undiscovered, they were said to be just like Margaux or from a vineyard across the street from Mouton-Rothschild or some other top producer. They had an innate appeal to the value-conscious consumer, and it was easy to wonder what I was missing when I found many of them actually had very little appeal to me. I began to sense there were good reasons for their obscurity. Some did have allure, but many were merely adequate, and some were tart, astringent wines of little or no character. This, of course, is a

vast generalization. Forgive me if I've unfairly maligned the many worthy small Bordeaux producers. But this did seem to be a useful introduction to the world of wine hype, where obscure producers are merely undiscovered, where undistinguished plots of land are always adjacent to great vineyards, where good years are vintages of the century and bad years charming.

As easy as the organization of Bordeaux seemed for a wine novice to understand, I began to feel a bit impatient with the region and the wines in general. Bordeaux was still the choice for special occasions. Yet few of the Bordeaux wines I drank offered the sort of transporting experience that I'd found in the '55 La Mission. While I understood the difference between a five-year-old bottle from a modest producer and a thirty-year-old great bottle, I did not have the money, the patience, or the storage capacity to invest heavily in the future. Though I retained an interest in Bordeaux, I began to cast my eyes elsewhere.

By the late 1980s, California was on the rise, or so said the writers. What American would not want to take pride in the nation's wines? I had paid my first visit to a winery on a family vacation when I was ten years old. Back in the 1960s, Napa Valley was a far sleepier place than today, better known for the mud-bath spas of Calistoga than the luxurious wine limousine trips of today. We stopped at the ornate Victorian Rhine House, the headquarters for a winery that eventually evolved into a multinational conglomerate but back then was known simply as Beringer Brothers. Such was the latent

power of wine marketing that my parents, occasional wine drinkers at best, left there having bought two cases of wine, one white, made from the pleasant but deservedly obscure Green Hungarian grape, and one innocuous but palatable red, called Barenblut, or Bear's Blood, which I later learned was a mixture of grignolino and pinot noir. Times have indeed changed, even if the power of marketing has not.

I bought all sorts of California wines and liked many of them. Even then, though, I had little interest in oaky chardonnay, and I was not a merlot fan. But I loved zinfandel— Ridge and Ravenswood, of course, and little-known producers that friends in the Bay Area brought to my attention, like Rafanelli and Quivira. I drank cabernet sauvignon, and was especially partial to pinot noir, even though the critics back then seemed convinced that California could not produce decent examples of what they always called a finicky grape.

My journey took me through Italy. I reacquainted myself with barberas, while exploring Chiantis, Montepulcianos d'Abruzzo, and the affordable wines of southern Italy, like ripe and fruity Salice Salentinos from Dr. Cosimo Taurino, which were the first that many Americans heard of wines from regions like Apulia. From Spain I tried crisp, citrusy albariños, which were just beginning to appear in the United States as the 1980s transitioned into the '90s. I fell in love with Châteauneuf-du-Pape, particularly the mid-1980s Châteauneufs of Bosquet des Papes, which were splurges, perhaps, but definitely reachable without serious consequences. I learned that Champagne was delicious almost anytime, not just at celebrations, and I discovered Savennières and the

brilliance of the chenin blanc grape. I found myself drinking a lot of Sancerre, particularly on several trips to France, and through a convoluted set of circumstances paid my first tasting visit to a winery in 1989—to Vincent Pinard in Bué, where he still makes exquisite Sancerres.

Most important of all were two revelatory bottles that, if they did not change my taste in wine immediately, came at precisely the right moment to shape the development of my tastes from then on. The first was a modest bottle of Burgundy, a 1986 Hautes Côtes de Nuits from Antonin Guyon. It probably cost no more than $10. But, oh my God, I was not prepared for this shimmery, graceful wine, which had a sort of ethereal lightness that I had never experienced before, along with a graceful, sweet fruitiness that stayed in the mouth after I swallowed, turning pleasingly tart. The effect of that dry last note was to punctuate the sip and prompt another, the way you are compelled to turn the page in a captivating novel. This was the least of Burgundies, coming from nondescript vineyards and made by a producer who has gone fairly unrecognized over the years, but it contained the seeds of what great Burgundy is all about. This combination of textural lightness and flavor intensity, I came to see, is a hallmark of great wine. I have pursued these qualities ever since.

The other wine was a Mosel riesling, a 1988 kabinett from the Graacher Himmelreich vineyard, made by Joh. Jos. Prüm, one of the great Mosel winemakers. I kind of lucked into this wine, as I recall, knowing at the time next to nothing about German wines. As so often happens, I was influenced by something I had read—not a textbook, but a novel.

Think about it: All you have to do is read the scene in *The Godfather,* where Clemenza lectures the troops on how to make a proper ragù, and suddenly you are hopelessly, ravenously hungry for spaghetti with meat sauce. In this case I was reading *The Winds of War,* the World War II saga by Herman Wouk, in which, as international tensions rise in 1939, the protagonists gather alfresco outside Berlin for a family lunch at which much fragrant "Moselle" is consumed. It was one more case of being inspired not by tasting notes or technical descriptions but by a narrative of pleasurable consumption. For me, this was what I was after, the companionable gathering of family and friends with wine and food at the center, not the tedious procession of aromas and flavors.

Appetite piqued, I had to find some Mosel, and the Prüm is what I found. How fortunate, because it was a wonderful wine—modest only in the sense that kabinett wines are inherently modest. They are slightly sweet, the grapes not having been picked as gloriously ripe as spätleses and ausleses, and as ripeness is often considered a primary virtue among German riesling, kabinett wines do not often receive their full measure of appreciation. The indignities suffered by kabinetts are many. Not the least of which is when a particular kabinett is advertised as "declassified spätlese." That's supposed to be a good thing? No! A delicate kabinett riesling is a lovely wine in and of itself, and it deserves respect. Why freight it with added weight?

Well, that's another issue. The fact was that I fell in love with this wine. It had it all! A lightly fruity flavor, a graceful sweetness that was made refreshing by an equal measure of acidity, a precise balance that gave this wine a sheer, gos-

samer weightlessness, and a stony, rocky quality that many experts say reflects the slate soils on which the vineyards are planted.

The qualities of these two wines, the red Burgundy and the Mosel riesling, set a sort of template for me. They were not the end of my arc of discovery, not nearly. I had a long, long way to go, and am still traveling. But, though I didn't realize it then, the characteristics they hinted at—their combination of lightness and intensity, their subtlety and grace, these wines I experienced as achingly beautiful—were imprinted on my brain. I would end up pursuing wines like these everywhere, in many different forms, wines that were subtle rather than powerful, graceful rather than insistent, that spoke above all of the places they were made. I've found wines like these all over the world, in the most acclaimed of wine regions—Barolo, Burgundy, Bordeaux, Montalcino, Napa Valley, Rioja, Champagne, and all the rest—and in the least heralded—the Jura, Slovenia, Beaujolais, the Valle d'Aosta, Saumur-Champigny, Mendocino, Sicily, Campania, Ribeira Sacra, Franken. The quest never gets old, and the thrills keep coming.

Nowadays, most Americans no longer start out with Bordeaux. Instead they often begin with New World wines, whether from North or South America, Australia, New Zealand, or South Africa. These wines are the easiest to understand on a shelf or in a restaurant. The labels are simple, spelling out grape and place. They tend to offer rich, full-bodied textures, plenty of fruit and perhaps a bit of sweet-

ness. Some people stop right there, and remain perfectly happy to explore wines of this profile. You can spend a lot of money collecting wines like these, and for some, California cult wines are the epitome of great winemaking today.

Many new wine drinkers, when offered an older, drier style, often describe it first as tart, bitter, or sour. They are used to sweetness in beverages, and if the wines they like are technically dry, they may find that sense of sweetness in the prominent fruit flavors. Eventually, some people develop a taste for drier, lighter-bodied styles. But of course everybody's journey is unique, including my own, even if I do see a rough pattern in the many other people who have followed an arc similar to mine. But the evolution does not go only one way. There's no right and wrong, no pot of gold or nirvana at the end. I've known many people who, like me, worked their way from Bordeaux to Burgundy only to rediscover the beauty of Bordeaux. I've experienced that rediscovery myself, although the soulful excitement I feel for Bordeaux is not as constant as what I feel for Burgundy.

One more thing about this journey: It ought to be free of moral judgment. To put it another way, I can't hold with some of the more strident people in the wine trade who tend to see one's choice of wine as a statement of character. Some of the people I love most in the world have vastly different tastes in wine than I do. This simply means that in restaurants I have to beat them to the wine list. It does not mean they are bad people, or that I need to reevaluate my relationships with them. Wine is a wonderful thing, a great joy, not an ideology. A little perspective is in order.

Still, wine does have its political side. I know people

who will not drink a wine if they know it has been pro-
duced with the aid of chemical herbicides and pesticides. I'm
sympathetic to this view. Just as I prefer not to eat fast food
or factory-farmed food, I prefer wines made by producers
who make an effort to farm without poisons and to make
the wine without adding enzymes, hormones, or anything
else. But wines come in many styles regardless of whether
a producer employs even the most rigorous form of natural
farming and winemaking, and the sorts of wines that people
enjoy are expressions of taste. You can't tell people they are
wrong if they like a different sort of wine than you do. But
you can tell them what you like and explain why.

Drinking by Numbers

Just as surely as wine and food go together, so do tasting notes and scores. Yet, as clearly as I see the unintentional damage that tasting notes inflict, I am a little more ambivalent about the issue of scoring wines. Let me put that another way: Wine scores can interfere with consumers developing their own standards and preferences. They are too easy to misunderstand and misinterpret. But I completely understand why so many consumers are wed to them.

Quite simply, numbers cut through the confusion caused by thousands of bottles and the mysterious words used to describe them. That is especially true in the United States, where wine buying is ruled by the 100-point scoring system, a scale instilled in every schoolchild around the time they learn to hold a pencil. It's easy to understand the appeal of scores, especially for consumers who like wine but are not particularly interested in studying the subject. Whether they want to know more about wine or not is beside the point.

When they go into a store to buy a bottle they are about to part with hard-earned money, sometimes a lot of it. Nobody wants to make a mistake.

Naturally, consumers facing this situation want to put themselves into the hands of an expert. Ideally, that expert should be their local wine merchant. No resource is more important or potentially more influential than a good wine merchant. By definition, good merchants should offer a wide-ranging selection. Just as important, they need to take the time to speak with and understand their customers, so they can direct them to bottles that meet their sometimes inchoate desires. But good merchants and great wine shops are not found in every neighborhood. Consumers have to be highly motivated to seek them out. Everywhere I've lived, in Austin, in Chicago, and now nearly thirty years in Manhattan, I've had easy access to wonderful wine shops run by passionate wine lovers. But the sad fact is that a great deal of the wine buying in this country takes place in supermarkets and warehouses where experts are in short supply and consumers are largely left to themselves.

Enter the consumer advocates—people like Robert M. Parker Jr., who actually patterned himself on Ralph Nader—as well as an assortment of traditional wine publications like *Wine Spectator, Wine Enthusiast, Wine & Spirits,* Stephen Tanzer's *International Wine Cellar,* and a growing number of Internet publications like Allen Meadows's *Burghound* and John Gilman's *View from the Cellar.* While all of these publications differ in terms of taste, attitude, and point of view, they all use the 100-point scale.

British publications, like *The World of Fine Wine,* seem to

view the American 100-point scale as typically exaggerated and over-the-top. After all, their scoring scale only goes up to 20 in the case of *The World of Fine Wine* and Jancis Robinson. Even so, it's the same idea, fixing a grade to a wine that will allow consumers to judge it in comparison to other bottles.

Novice wine buyers are not likely to read these publications, unless they aspire to become something more, but that doesn't matter. The stores bring these publications right onto the sales floor in the form of shelf talkers, those little marketing aids that generally include a critic's score. Using shelf talkers as a guide, even the most flustered consumer can pick out a bottle rated highly by at least one critic. Is it any wonder scores are so influential, or that many winemakers have little conscience when it comes to weighing their personal tastes against doing whatever it takes to get a high score?

So what's the problem with scores? Some wine writers argue that assigning scores to bottles of wine is offensive, as it would be to score works of art in a museum, say giving *Mona Lisa* a 98 and *Guernica* a 94. While that may suggest an excellent project for an enterprising art historian, it is absurd to think of wines as masterpieces not to be sullied by commercial considerations. Great winemakers must have passion, courage, and a profound sense of vision and understanding, along with certain technical skills, but wine for the most part is not a work of the imagination. It is an agricultural product. Growers and winemakers are more like stewards who understand the potential of a particular piece of earth. Through farming and production they are able to realize that

potential, which is sometimes mistaken for self-expression. Occasionally, parallels can be seen between a winemaker's personality and the wine itself, but that is not the same as a work of art created from scratch.

No, scores for wine are not offensive. They simply don't offer enough information to be useful and therefore are too often misleading. For one thing, scores suffer from the same disadvantage as tasting notes: They are generally the products of mass tastings that give a quick experience of a wine at a single, solitary moment in its evolution, amid many other wines. A wine that a critic scores highly in these artificial conditions may not be the best wine to drink at home on a Monday night or at a dinner party a couple of years later.

While scores offer an easy shorthand for consumers, they unfortunately require that every wine be judged on the same seemingly objective scale, regardless of the subjective nature of taste and context. A 90 always beats an 89, right? Let's not even think of comparing a 95 with an 85. With such a clear disparity between bottles, why would anybody want to drink an 85?

Such clarity, unfortunately, comes at the price of completely ignoring the single most important consideration to the enjoyment of wine: context. Quite simply, nothing matters more to how we perceive wine than the context in which it is consumed. Context can make a modest wine memorable. It can also render a profound wine irrelevant.

Some examples? The proverbial little red wine, so delicious consumed in the archetypal Tuscan hillside village with your sweetheart as you drown in the loving pools of each other's eyes. Alas, it never tastes the same back home

in New Jersey, with the kids running around and an impor-
tant report to deliver at work the next day. Meanwhile, the
big California cabernet that you enjoyed so much with your
work buddies at a steakhouse, ties tucked between the but-
tons of your shirt, doesn't offer nearly the same triumphant
lift when its flavors are canceled out by a bowl of spaghetti
and meatballs.

Considering context requires asking crucial questions.
Where will you be drinking this wine? With whom will you
be drinking it? What will you eat? What's the weather, the
mood? The more experience you have in choosing wines, the
more instinctive this becomes, like knowing what clothes to
wear to a particular sort of event, or when to begin slowing
down your car when you approach a red light. If you are
not used to dealing with these questions, or don't have the
background knowledge to apply to choosing a wine, it's easy
to fall back on scores.

But scores ignore context, and that's not good. Even
worse, many wine critics almost reflexively offer higher
scores to the sorts of wines they consider to be of higher
status. That is, established critics like Parker or *Wine Specta-
tor* generally give much higher scores to bottles in the genres
they consider great, like Bordeaux or Napa Valley cabernet
sauvignon, than they do in genres they consider merely good
or easygoing, like Beaujolais, Chinon, or Rioja crianza. Ul-
timately, scores tend to tell you more about the tastes and
preferences of the scorer than they do about the wines.

Paradoxically, the lower-scoring genres may be far
better choices for many occasions. For one thing, many of
the wines that receive higher scores offer the least amount

of pleasure in the short term because they are too young. A young Napa cabernet from a great vintage may receive a higher score than another Napa cabernet from a vintage deemed mediocre. But that higher-scoring bottle may need quite a few years of aging before it becomes more enjoyable than the lower-scoring bottle. Similarly, while I believe that many people are too fussy in their anxiety about finding perfect matches between foods and wines, you still have to give at least modest consideration to what you are eating when selecting a bottle. And selecting wines by score doesn't take food into account at all.

Even within a single genre of wines, scores tend to reward ambition over simplicity. So a wine that strives for greatness, or shows the trappings of greatness, will often score higher than a wine that aims to be immediately enjoyable.

It's often the case in any up-and-coming region, for example, that winemakers can gain higher scores by adhering to certain formulas. Take a wine that's become highly popular in the United States, Argentine malbec. The wines I've found most enjoyable and versatile are the most casual and inexpensive. Why? They are the least pretentious. When made in an easygoing style, malbec offers juicy, dark, plummy pleasures and can be good with a wide range of equally easygoing meals.

But more and more often these wines are tarted up by ambitious producers who want higher scores, along with the higher prices and status that go along with them. They might cut yields to make denser, more concentrated wines. They will invest in small barrels of new French oak, which polishes the wine to a fine sheen while conferring the vanilla

and chocolate flavors that make the wine taste generic rather than distinctive. The effort to turn good malbec into great malbec renders them unfit for the easygoing table. But guess what? They do indeed score higher, and they end up costing more. A consumer seeking a wine for dinner tonight who is buying strictly by the score may well end up selecting the inferior bottle, even if it does have a higher score.

The same scenario has played out across the wine-producing world, whether with the aglianicos of Campania, the mencías of Bierzo, or the pinot noirs of Oregon.

Simply put, a wine with a higher rating is not always the better choice—not nearly! It is one of the crucial lessons of experience. Recognizing this fact is a sign that independent thinking is taking hold. Even more important, many consumers eventually come to understand that wine ratings have major limitations. They begin to search for other sources of knowledge. That's about the time when you develop the motivation to abandon the supermarket in favor of a wine shop with knowledgeable merchants who can guide your selection. That's why they will ask you questions, like what you are eating, what kind of wines you've liked in the past, and so on. They are asking you to provide the context that will help them make informed recommendations. Of course, not every merchant really cares about your needs. Instead of making their own considered recommendations, these merchants will recite the scores to you. My advice: Look for another shop.

———

Critics themselves are well aware of the limitations of ratings. Most urge their readers never to divorce their ratings from their written evaluations of those same wines. Their point would be well taken if their evaluations supplied useful information about the wine—its general style and nature, for example, and what sorts of foods or occasions might be suitable. Instead, the critical information they offer is in the form of tasting notes, and we've already seen where they lead.

Some critical sources do understand the need for context, yet just as with tasting notes, they err on the side of overspecificity, like friends who cannot contain themselves from offering too much information. Perhaps wine writers find speaking in generalities unsatisfying, as if their creative acumen can only be displayed by piling on irritating details. For example, I generally love *Wine & Spirits* magazine—its articles are excellent, provocative, and highly readable—but its policy of offering absurdly specific food suggestions in its tasting notes would be maddening if it weren't so comical. In a recent note on a 2007 pinot grigio from Swanson, a California producer, the critic asserts that the wine is "for grilled unagi," as if this bottle could *only* go with a meal of grilled freshwater eels—crazy! Meanwhile, in the same column, the critic writes that the next vintage of the same wine, the 2008 Swanson pinot grigio, is "a match for barely seared albacore with green zebra tomato salsa."

What if you want to prepare the albacore dish but you only have the 2007 pinot grigio? Out of luck? Or will readers know to extrapolate from these instructions that the wines will most likely go with hearty seafood dishes, eel,

tuna, or whatever? Why not just say that? Or is the green zebra tomato salsa actually a crucial component? More likely, when consumers are told to "match its bone-dry intensity with grilled quail wrapped in pancetta," they will want to punch a wall or reach for the aspirin bottle.

Just as with tasting notes, overly specific instructions for matching wines and foods are mystifying and intimidating for novices and useless for experienced wine drinkers. They should be avoided.

The wine industry itself has a tormented relationship with scores. Most winemakers know how artificial the whole process is, yet they feel compelled to go along with it, especially when the benefits from a high score are so tangible and commercially rewarding. In a global marketplace, too, scores have the advantage of selling internationally. A 95 from Parker requires no translation in Hong Kong, where descriptions like "explosively rich with gobs of crushed blackberries and raspberries" may fall flat.

Strangely, other numerical scales are not nearly so transposable. Americans who try to mentally translate the British 20-point scale into the 100-point system find it as frustrating as converting Celsius temperatures to Fahrenheit—there is no easy correspondence. The easygoing wine that the British critic praises earns a 16. Multiply by 5 and you get 80, well beneath a score that will appeal to Americans. Perhaps because of its added flexibility, the 100-point scale has achieved worldwide hegemony. It has taken hold in Italy and Spain, and even some in Britain are now using it, too.

In the end, though, scores are a poor substitute for wisdom, a conclusion that, alas, offers two potentially unsatisfying alternatives. On the one hand, you can continue to trust in scores, knowing you may miss out on many highly satisfying wines that are not the type that earn high scores. On the other, you can begin the quest for understanding, which consists simply of thought and judgment applied to experience. This is a highly pleasurable pursuit, I must say, but one that demands some time and effort, to say nothing of money. It's a journey that cannot be taken out of a sense of obligation. But if the motivation is curiosity, joy, and pleasure, then the possibilities for fulfillment are unlimited.

Passion Rewarded

Once I began to write about food for the Living section, I knew exactly what I wanted to do at the *Times*. It was not as if I had tremendous competition. Most young writers and editors at the *Times* were interested in politics, business, or foreign affairs. I was passionate about food and wine. I was marching in the wrong professional direction, which was completely to my advantage. It took a few years, but by 1989 I was the deputy editor of Living, and by 1991 I was its editor. I wasn't able to do much writing during this time, but I was absorbing an awful lot from the gifted people I worked with, and none more so than Frank J. Prial, the newspaper's longtime wine columnist.

On joining Living, I was surprised to discover how little interest my new colleagues seemed to have in wine, or at least among the new team of editors taking over. I volunteered immediately to become Frank's editor, and the others seemed relieved. One of the great joys at that time was get-

ting to know Frank, which wasn't easy as he rarely came into the office, instead splitting his time between his house in New Jersey, his house in eastern Long Island, and his apartment in Paris.

In those days, before most people became tethered to the workplace by smart phones and computers, Frank was not an easy person to find. He seemed to revel in playing hard-to-get with editors. Perhaps that was a result of his experience as a foreign correspondent, where he got used to working independently, far from the intrusions of desk workers who might feel compelled to offer their own generally harebrained ideas for stories. Frank was a master of patiently listening to your ideas and agreeing in full—"Yeah, yeah," he'd say in quick repetition. His manner suggested intent interest, disguising his desire to get off the phone as quickly as possible, with the hope that your brilliant thoughts would never be mentioned again and die of neglect. Eventually he did get a cell phone, but for years it apparently did not occur to him to give his colleagues the number.

Until I joined Living, I knew Frank only as a byline, but I came to understand him a little better on the rare occasions that I could pin him down for conversation or lunch. Concealed within a down-to-earth, puckish, everyman persona, Frank was one of the most intelligent, literate, acutely aware people I had met at the *Times*. He was one of my favorite writers there (as I told Allan Siegal in my job interview back in 1984), and almost always managed to pierce the pompous, self-righteous veneer of those who took wine too seriously. He was cultured but concrete, witty but not nasty, pointed but never obvious.

Most important, Frank was a man of complete integrity who never forgot his constituency. For anybody who writes about wine, the temptations are many. The world of wine begs you to be one of them. Wealthy people wish desperately to pay for your first-class travel and lodgings in beautiful parts of the world. They yearn to buy your food, to send you off with fancy, expensive wines and to keep you entertained. In return, they merely ask that you keep their interests in mind when you write your articles. Serious journalists avoid such blandishments, but they also face personal temptations. Perhaps most seductive is the allure around wealthy people of living as they do, to order a bottle equivalent to what they've just opened, to join them in the first-class section of the airplane or at the clubs they frequent, to befriend them. This can be both professionally compromising and, on a journalist's salary, financially destructive. Frank's loyalties and common sense never blurred.

When Frank began writing about wine in 1972, it was not uncommon for wine writers also to be in the wine trade. In fact, some of the best American books on wine have been written by merchants like Frank Schoonmaker, Kermit Lynch, Neal Rosenthal, Terry Theise, and Sergio Esposito. What's more, the tendency among many wine writers— even those not in the trade—was to imagine that their job was to further the interests of the American wine industry, just as the loyalty of many food writers of that period was to the food and restaurant world rather than to their newspaper and audience. But Frank was adamant about his independence. He never forgot he was a journalist first, and that his loyalty was to his readers and to his newspaper, not to the

wine trade. This made him an important role model for me and for the wine journalists who followed him.

For all this, Frank was surprisingly dismissive of his wine writing. Something in his manner conveyed the idea that he did not consider the wine beat to be serious journalism. According to Frank, he'd tried to return to what he considered more meaningful jobs—foreign correspondent, covering the courts, trooping through the Khyber Pass, whatever—but the top editors at the *Times* would not permit him to relinquish the wine job for more than a year or two at a time. So he, Mr. Hard-Bitten Reporter, was stuck doing this girly-man job.

Naturally, this got me to thinking. As I had only just gotten to know Frank, and he'd shared his feelings with me, I thought I had a solution that could help both of us out. One day in 1989 or 1990 I cornered him—I'm not sure how— and offered an idea. If he really disliked writing about wine as much as he said he did, how about if I trailed him for six months or so. He could introduce me to people in the business, teach me what was important, and when the moment was right, I would take over for him and he could go on to do what he wanted. "Yeah, yeah," he said, which I had not yet learned was his dismissal-by-agreement response, and off he went—not to speak to me again for three months or so. Had my idea really been that threatening? Perhaps. I decided that despite the pose of gruff indifference he put up, he truly cherished writing about wine. Nonetheless, that did not stop me from trailing him and learning from him. It just took fifteen years before he retired and I took over, rather than six months.

Among the many things I did learn from Frank during those years of observation and absorption was to overcome some of the assumptions about wine to which I continued to cling. For instance, my primary means of learning about wine at the time was reading *Wine Spectator* and Robert M. Parker Jr. It had not yet occurred to me that there were other, better ways to discuss wines, and more interesting things to talk about, than obscure aromas and vintage charts, wine tastings and great bottles. Frank was not so much a teacher, though. He most definitely was not pedantic. But he did lead by example.

"Frank, *Wine Spectator* is having this huge tasting in Manhattan next month—350 wineries, 20,000 bottles!" I'd say into the phone, suggesting it might be something he'd want to write about. "Yeah, yeah," he'd reply, consigning my enthusiasm to its deserved fate.

Or, "Frank, you have to update your vintage chart, people are counting on it!"

"Yeah, yeah." Eventually, he wrote a column, "Who Needs Vintage Charts?" in which he explained their futility.

I came to learn that wine shibboleths like the vintage chart are doomed efforts at control. We think that we can protect ourselves from bad wines by only buying in great vintages. As a result we lose out on many good wines, while laying in a stock of bottles that may take years before they can offer pleasure (because great vintages are not only long-lived but often need years before they can show their stuff). What's more, buying by the vintage offers no protection against poor producers, while good producers can make interesting wines even in mediocre vintages. Finally, one

critic's great vintage is another's loser. Knowing the charac-
teristics of a vintage are important, but they must be viewed
in context. Using vintage as a shortcut to selecting wines can
be a disastrous mistake.

Of course, if your aim is to buy wine as an investment
rather than as a beverage, well, then a vintage pronounced
great by the critic-gods is crucial to the value of your bottles,
worth far more than if it were from a vintage merely deemed
good. But that was not what wine represented to Frank, or
to me.

Frank went against the model of the wine critic, at least
as I imagined it from the example of Parker and the *Spectator*
writers. He wasn't particularly curious about wine tastings,
and he certainly could not be enticed or persuaded to write
tasting notes. While the technical side of winemaking may
have been of passing interest, he refused to engage in the
minutiae and jargon that passed for discussion. The mere
mention of a term like *brix* or *malolactic* might set him off on a
tangent of ridicule, because, really, this was part of the pom-
posity and pretension that he felt endangered the enjoyment
of what, after all, was simply a fermented beverage.

Of course, Frank knew there was more to wine than
that. He, as much as anybody in his era, was able to see the
joy of wine, and the pleasure it provided. And he saw beyond
what was in the glass, to the many unusual and fascinating
personalities in the wine business, the politics and econom-
ics that surrounded it, and the culture of wine, which ex-
tended back centuries before the first zillionaire decided to
buy a winery in Napa Valley "for the lifestyle." In fact, while
Frank often was assailed in the California wine industry for

an alleged preference for French wines—"frank-o-prial," as in *francophile,* was one industry nickname—few people wrote more lovingly of the priceless wine characters of California, figures like Joe Heitz and August Sebastiani, André Tchelist-cheff and Dick Graff, Robert Mondavi and Randall Grahm. He simply had little patience with hauteur or arriviste arrogance.

If I wasn't going to be replacing Frank Prial as the wine writer, at least I was immersed in the coverage of food and wine. In 1992, with the inception of the $25 and Under column of restaurant reviews, I finally had my opportunity to write regularly, reviewing the myriad inexpensive restaurants of New York City.

The *Times* in the 1980s was without peer in its coverage of high-end restaurants. It seemed as if the entire city held its breath to see which place Bryan Miller, who became the restaurant critic shortly after I joined the *Times,* was going to review next. If there was a perennial criticism of the *Times*'s restaurant coverage back then, it was that we gave short shrift to inexpensive neighborhood restaurants and the sorts of places found throughout the city that catered to New York's immigrant population. In addition to his restaurant review, Miller had a catchall column, Diner's Journal, in which he would occasionally explore the cheaper side of New York's restaurant world, but it was an infrequent foray at best.

I was among those who would suggest from time to time that we were really missing an essential layer of New York dining, but calls for an additional critic to focus on these res-

taurants were routinely parried by the top editors. "Publishing an additional restaurant review would dilute the critical voice of the *Times*," one top editor told me, in what seemed like a bad parody of lockjawed Gray Lady–ism, neglecting the obvious fact that we published multiple movie, theater, art, and book reviews by a multitude of critics.

As with ocean liners, attitudes are hard to turn at the *Times*. The editors seemed oblivious to the fact that many New Yorkers—not just students and young people—were obsessed with the sort of inexpensive dining that the *Times* virtually ignored. Others were filling the vacuum. *New York* magazine, with its Underground Gourmet column, had been covering these restaurants for years. Robert Sietsema, who eventually became the restaurant critic of the *Village Voice*, had started *Down the Hatch*, a newsletter chronicling his travels through the city trawling for fascinating, inexpensive restaurants that served the cuisine of every conceivable ethnicity. Things finally reached a breaking point after *Newsday*, the Long Island newspaper where my father worked, began its foray into New York City in the mid-1980s with a new edition, *New York Newsday*. Among its many virtues, *New York Newsday* published multiple restaurant reviews, including a column by Sylvia Carter dedicated to the inexpensive restaurants of New York. The *Times* was getting beaten soundly, yet it wasn't until 1991 that the editors finally decided to add a restaurant column dedicated to New York's inexpensive and offbeat restaurants.

I was not privy to their tribunal; I don't know what finally caused them to change their minds, though I couldn't help but imagine that countering *Newsday* was at least a

consideration. Once they made their decision to add reviews of inexpensive restaurants, I was asked to be on a committee to decide who would write the new column. By this time I was the editor of the Living section, happy to be immersed in this world of food and wine but not relishing some of the primary tasks of an editor. I worked with an incredibly talented team of reporters, but I discovered they each needed a specific sort of relationship with me that met their individual needs for motivation and encouragement. Gifted editors are able to forge these relationships almost instinctively. It's an essential part of the job. Perhaps I was too self-absorbed, or simply worked better independently, but I was hungry for a different form of self-expression, eager for a break from the deskbound culture of the editor, and desperate to get out of the newsroom.

In the first meeting of this new committee, we tackled the issue right away: Who should write this new column? Some familiar names were mentioned, and then, half joking to hide my fear that the others would laugh, I said, "What about me?" To my complete astonishment, the editor in charge of the committee took me seriously. "Really? That's a great idea!"

Thinking back, I suppose I can understand why they were receptive. I was an easy in-house answer. I had proven I could write and that I knew the field. I was cheap, a consideration that is never to be underestimated. What's more, I don't think anybody except me took a column on inexpensive restaurants seriously, or believed in the crucial importance of these sorts of restaurants to the lives of our readers. So perhaps a quick and easy solution was the best way to

make a minor problem go away, always important in any bureaucracy. Regardless, it was not long before the idea was approved, and after writing one test column just to demonstrate that I could do the job, I was in business.

As far as I was concerned, I was the perfect person for this job. Job? This was my avocation, my dream! Since that meal as a fourteen-year-old in Paris, I had been obsessed with restaurants. Had I been trained as a chef? No. Had I ever worked in a restaurant? Well, as a teenager I had been a busboy and done prep work in institutional kitchens and in bars that served what passed for meals. So the answer is, not really. I had never cooked professionally. Yet I had little doubt that I knew the difference between a good meal and a bad one, between a warm, welcoming restaurant where food was prepared with passion and care, and an indifferent place that went through the motions. I felt as if I was the ultimate restaurant consumer, and that I knew what I was doing because I had been doing it for decades. The difference now was that I was writing, too.

As a consequence of my new gig, I was now going out to restaurants all the time. I had to largely abandon my efforts at home to drink my way around the wine world, as most of my dinners were now in somebody else's dining room. Of course, that didn't stop my pleasurable self-education. My editors wanted some sense of what people were drinking in these restaurants, whether it was a Jamaican jerk house on Gun Hill Road in the Bronx; a taqueria in Sunset Park, Brooklyn; a twenty-four-hour Korean joint in the Garment District; or a little bistro or trattoria in the East Village. Wine was always on my table, or if not wine, beer, soju,

sake, agua fresca, or whatever else seemed appropriate to the meal at hand. I learned that wine could combine beautifully with a meal even when it seemed not to be appropriate, like Champagne with fried chicken, Savennières with sushi, pinot noir with Asian-Mexican fusion (yes, indeed, in the course of twelve years of reviewing restaurants I found two Asian-Mexican fusion joints, one of which I judged the best Asian-Mexican combination since Cheech and Chong).

Needless to say, I was having the time of my life. I had found a job that was meant for me, and I now spent a good bit of my time out among the joyfully food-obsessed people in New York, exploring neighborhoods that I might never have set foot in had I not heard a tip about a new Peruvian chicken joint in Jackson Heights, a barbecue shack out near Kennedy airport, or Central American street vendors near a complex of soccer fields in Red Hook. The food was delicious enough, but the beat led to a much deeper understanding of New York City. Simply by examining restaurant trends, you could follow the demographic evolution of the city. It was fascinating, for example, to watch the leap in Mexican immigration through the 1990s, even if it wasn't immediately obvious to casual observers. These new New Yorkers, largely from the Puebla region of Mexico, did not congregate in one neighborhood, leading to a visible explosion of new Mexican-oriented businesses, as was the case with Korean restaurants in midtown Manhattan. They settled in little pockets—in Corona, Queens; Sunset Park, Brooklyn; East Harlem; and Manhattan Valley. Within these neighborhoods, one could find excellent little restaurants and taco trucks, and of course wonderful soccer games.

I soon took on another column, this one reviewing take-out food throughout New York City, which helped to put wine back on the table at home. But the next big thrill for me came in 1999, when I was asked to begin a new column, Tastings, that would look at a different category of wine each week. Why me? Well, as I said, Frank Prial was far more interested in the social, economic, and cultural history of wine than he was in recommending a half-dozen bottles every week. With the growing American interest in wine throughout the 1990s, the editors of what was now called the Dining In, Dining Out section felt they ought to devote a little more space to wine, especially if that space offered practical value to readers. I had demonstrated my interest in wine both as an editor and now as a writer, yet when the Dining editor asked me if I was interested in taking on this column I was surprised and excited, both because I had yearned to write more about wine, and because this meant my learning curve was going to accelerate rapidly.

Learning curve? Well, I suppose the *Times* could have hired an expert for the column they had just given to me. But what, after all, would an expert have offered that I could not? True, an expert might have been far better schooled in the history and context of wine. My knowledge and experience with the benchmark bottles of the world was still painfully slight. I could not yet discourse on great Bordeaux vintages or recite the communes of the Côte d'Or. I was lacking in other professional measures. I could not name for you the various appellations in the Languedoc region, for example, or enumerate from memory the thirteen grapes (or was it twelve?) that are permitted in red Châteauneuf-du-Pape.

But my attitude was, that's what reference books are for. I wasn't being asked to produce a technical treatise on malolactic fermentation or on the soil composition of Napa Valley. In fact, it had been my experience that such information in the hands of the wrong writer or sommelier could be turned into a pedantic weapon. Not that I thought ignorance was bliss. But I felt instinctively that I understood what people wanted to know about wine, and I hoped that I could tell them in an engaging, unthreatening manner.

The Importance
of Being Humble

I don't particularly enjoy calling attention to myself, a characteristic that served me well when I was reviewing restaurants. While many people imagine restaurant critics donning wigs, false beards, and costumes before heading out into the lively night, it never occurred to me to disguise myself in pursuit of anonymity. I thought of a disguise as the last resort of the exhibitionist. Instead, my technique was to fade into the background. It's a lot easier to be nondescript if you sincerely don't want to be noticed, although it may not make as good a story.

Modesty may cause one to be overlooked, but in my restaurant job, that was the idea, right? In the field of wine, modesty is a great strength as well, although in this bombastic world of ours, it can cause people to be discounted or just plain ignored. In fact, some of the greatest, most inspirational winemakers I've met have been some of the most modest, humble individuals I have known. Without egos?

Not at all. They all had a very healthy sense of themselves. But they had perspective as well.

In wine—good wine, at least—modesty and humility stem from recognizing that humans will never have the ultimate power. In winemaking, that role belongs to nature. Humans can do their best to manage their vineyards to counteract whatever curveballs nature throws their way. They can anticipate. They can compensate. But they cannot control, not, at least, if they want to make great wine.

To control means to eliminate as many variables as possible. But great wines are made by bowing to the inevitability of variation and accepting the special characteristics that each vintage offers. To put it in plainer terms: Shit happens. As a winemaker, you can recognize that and try to manage things well enough so that your wine survives whatever shit comes its way, and maybe is even better for it. Or you can do your best to ensure that shit never affects your wine, which, like a life free of bumps and bruises, may make for a smoother countenance but a far less interesting one.

What kind of shit? From the initial decision of where to plant a vineyard, control is an issue. Great wines tend to be made from vineyards planted in risky places, perhaps in a climate that is barely warm enough to ripen the grapes, or on slopes so steep that only mountain goats would be foolhardy enough to try to climb them, or on soil so poor that the vines have to struggle to find enough nutrition to survive. This was the kind of wondrous natural adaptation that might make even the most committed atheist ponder a possible intelligence behind the design of the universe. In the agrarian local economies of long ago, the most nutritious soils,

which were the easiest to farm, were reserved for the food crops most crucial for sustaining life. Meanwhile, grapevines, which improve the quality of life but are not exactly necessary for sustenance, did not compete for space because they were adapted to poor soils and sites that were difficult to farm. Wine was in a sense a luxury for those willing to make the laborious effort, but judging by the vast number of ancient vineyards put in difficult, inaccessible places, wine must have been considered worth the work.

Nowadays, we no longer have to decide which soils are suitable for food crops and which are best for grapevines. For better or worse, modern technology permits food to be grown pretty much wherever it is convenient to do so, which gives modern grape growers far more freedom in deciding where to plant their vines. This is not so true in the Old World, where many of the decisions on the best places to plant vines were made and codified centuries ago in agrarian societies, when the need for each community, sometimes each family, to grow sufficient amounts of its own food was imperative. Sadly, some of the greatest, most difficult-to-farm vineyard sites were abandoned in the twentieth century. After the scourges of phylloxera, the ravenous aphid that attacked the roots of grapevines, and the two world wars, the economics in places like the northern Rhône Valley offered little incentive to continue farming these sites. What's more, labor-saving automated equipment, introduced after World War II, offered a powerful inducement to war-weary farmers to abandon steep hillside sites, where such equipment could not be used, in favor of inferior but flat sites. Fortunately, some of these historical vineyards are now being recovered,

as the modern economy beckons with newly attractive rewards to people who can make distinctive wines.

Not every Old World vineyard is in an ideal place, obviously. For centuries, far more bad wine than good was made in Europe, which everybody ought to acknowledge regardless of a desire to romanticize winemaking of the past. But without the ancient imperatives guiding the selection of vineyard sites, New World growers have had far more freedom in deciding where to create vineyards, and far more options.

In California once, as I was driving south on Highway 101 through the Salinas Valley toward Paso Robles, I saw an absolutely astounding vineyard. It was an extraordinary flat expanse that started first on the east side of the highway, then jumped over to the west side across from a series of oil rigs. This vineyard extended for miles, covering thousands of acres. If you told a worker to go prune a row of vines, and not to come back until he finished, you might not see him again for months.

Nobody hoping to make great wine would conceive of such a vineyard. This is a modern-day creation planted for the purpose of control. The climate is predictable. The crops can be managed with the help of fertilizers and irrigation. Threats are parried with pesticides and herbicides. Harvests are automated, and winemaking is industrial. These wines won't be exciting, or even interesting, but they will be cheap and palatable.

Of course, the managers of vineyards like this are not trying to make fine wine. Their aim is profit and little else. But the same questions of control come up for more ambi-

tious winemaking projects. Anybody trying to grow great grapes and make fine wine will face crucial issues in the vineyard, like water management. Leaving aside questions of conservation, growers could insure a healthy crop by irrigating the vines, but the grapes are less likely to make interesting wine than if growers take the riskier approach of not irrigating at all or minimally, forcing the roots of the vine to dig deep into the earth in search of moisture. The same is true with fertilizers, pesticides, and herbicides. Using these chemical products insures predictable results, though they may cause long-term harm to the vineyard as well as to the planet. The wines, alas, will suffer for it, too.

The more labor-intensive approach of farming organically or biodynamically can lead to better-quality grapes and healthier vineyards, but they are riskier and more expensive. Relying on cover crops and mulching for nutrition, and supporting beneficial insects to control pests in the vineyard requires more work as well as a leap of faith and a recognition that things may not go exactly as you plan. In other words, great growers cede certitude. Instead, through hard work they try to stack the odds in their favor. But nothing is ever assured.

The issue is perhaps easier to understand by looking at it in restaurant terms. On the one side you have fast-food franchise restaurants that make a profitable virtue out of consistency and predictability. With occasional exceptions, ingredients are prefabricated and recipes are codified. Consumers will always know what they are getting, regardless of regional or seasonal differences. Many people take comfort in that. The food is simple, satisfying basic desires for savory

warmth, and people who do not spend a great deal of time thinking about what they are eating, which may be the vast majority, are content with that.

On the other side are certain individual chefs who shop daily and allow their menus to be dictated by what they find in the market. Their customers may not know exactly what they are going to get when they come to the restaurant. Whatever it is, though, if they know and trust the chef, they can assume that the quality will be high and they will be satisfied. Just as the chefs cede control of their menus to the ingredients that beckon, these customers relinquish control of their experience to the chef.

I leave you no doubt about which sort of experience I prefer. But while the fast-food industry may be repugnant in many ways, I have no problem with people who simply prefer a predictable consistency in their food. Just as with wine, nobody is obliged to care about the experience of eating. Oh, sure, one can make a case about the moral and political consequences of eating, as people like Michael Pollan and Eric Schlosser have done so convincingly. That's not my point. You can think of food simply as fuel and satisfy the need to eat in many politically acceptable ways, just as you can drink wine without being curious as to how it's made, where it comes from, and whether it's any good. You get no points in life for caring about wine or food. If whatever you pick up in the supermarket on the way home does the trick for you, that's fine.

But if you do care about what you eat and what you drink, and you take pleasure in being intrigued, then you appreciate the other qualities that are far more important than

consistency. You cede control, and essentially allow yourself to take a journey with a restaurant or a wine producer.

Of course, the idea of letting go can easily be abused. Marketers, bless their crafty little minds, understand both sides of the issue. Just as they know how to appeal to those craving consistency, they have targeted the other end, those who see the winemaker as kind of a hands-off farmer merely allowing the grapes to make themselves into world-class wines. For these people, the marketers coined the clumsy buzzword *non-interventionist*.

What is a non-interventionist winemaker? A successful producer of bird food and vinegar! Seriously, if you stick around the wine business you hear all sorts of clichés, like "good wine is made in the vineyard." Of course, the gist is true: you must have excellent raw materials to make excellent wine. But the truth is, winemakers must intervene all the time. Every decision they make—how to prune the vines, how to position them relative to the sun as they grow, how to handle the fermentation, how and where the wine will settle and age before bottling—each of these decisions requires intervention. This sort of intervention, however, is not the same as control. It's a form of guidance in which you do your unstinting utmost to grow the best possible grapes and make the best possible wines, but nonetheless remember your place.

Even the best grapes can be made mediocre or ruined in the cellar. Again, it's an issue of control and power. Very good wines can certainly be made by the most controlling of winemakers, those who might choose all sorts of manipula-

tive techniques to ensure a predictable outcome. They might choose a specific kind of yeast to initiate fermentation and guarantee that the fermentation completes, because the behavior of the indigenous yeasts that populate the grapes is not quite as certain. They might add particular bacteria to spur the malolactic fermentation; that is, the transformation of malic acid into lactic acid, so that it takes place when the winemaker prefers, rather than when it might occur naturally. These winemakers might add water to reduce the amount of alcohol in the wine, or they might add sugar before fermentation to produce more alcohol. They might add enzymes to darken the color if it's red wine, since the public seems to associate darker wines with higher quality. They might add tartaric acid if it's lacking in verve and vitality. They might use microoxygenation technology to make the wine more supple, or send it through a concentrator to intensify it. To a lesser extent, they might use temperature control to manage the fermentation process. Many winemakers use one or another of these techniques. The more they employ, the greater their control over the wine.

If winemakers start off with great grapes, as I said, they may make very good wine. But in general to make great wine, winemakers must again cede control. They must have, in the proverbial words of a legendary Burgundian, "the courage to do nothing." Instead of overtly manipulating the wine to achieve a desired result, they try merely to shepherd the wine along its way, guiding it for sure but ultimately allowing nature to take its course. If fermentation with indigenous yeast doesn't begin right away, well, they wait. If the cold of winter impedes the malolactic fermentation, well,

they wait until spring for it to occur. Sometimes wine is not ready to leave the cellar on schedule. This can be a real problem in small facilities, which might have only enough space to store and age one or two vintages at a time. Then commercial considerations trump the winemaker's heart—the wine is bottled and it departs. But with enough space, that stubborn vintage will simply be stored to age until it is ready to go.

Regardless of the status of the wine in question, Beaujolais or Grand Cru Burgundy, Contra Costa zinfandel or Napa Valley cabernet, barbera or Barolo, Cru Bourgeois Bordeaux or first-growth Bordeaux, the more the winemaker plays shepherd rather than dictator, the more interesting the wine will be.

It takes modesty and humility for winemakers to cede control, because they realize that ultimately they are subject to the whims and fortunes of nature. I particularly notice this sense of modesty and humility in people who have a long history of association with their vineyards and wine. Aubert de Villaine of Domaine de la Romanée-Conti is one of the most humble individuals in wine. So is Maria-José López de Heredia, one of the proprietors of the great and venerable Rioja producer R. López de Heredia. Roberto Conterno of Giacomo Conterno, the great Barolo producer, is modest about his role in the winemaking process, as was Bartolo Mascarello, who kept the faith that old-school Barolo, produced using the methods he learned from his own father, was worth preserving even as others ridiculed him.

I will emphasize again that being modest and humble

does not preclude having a strong ego. All of these wine-makers I've mentioned have a sure sense of themselves and their worth. Some might even be described as more than sure of themselves. But when it comes to their wines they understand the limitations of the human role.

Josko Gravner, the relentlessly experimental wizard of Friuli-Venezia Giulia, has always gone his own way and does not suffer fools gladly. But in his relation to his vineyards and his role in the greater scheme of winemaking, I would describe him as modest and humble. I would say the same of Anselme Selosse, who makes wonderful Champagnes labeled with his father's name, Jacques Selosse, and Aleš Kristančič of Movia, whose family has farmed its estate in Slovenia, just over the border from Italy, since 1820. None of these men are shy—they are most definite in their opinions—and they are not coy about their own abilities. But their well-earned pride does not place them above the natural processes of great winemaking. "The greatest danger is man, who can upset the balance," Anselme Selosse once told me, discussing his vineyard work. His job, he said, is to guide with a gentle hand, but to stay out of the way.

A powerful sense of self-worth is not at odds with a humble approach toward wine. Gianfranco Soldera, who makes one of the great Brunellos di Montalcino, is most definitely not a modest individual. He will tell you without prompting why his wines are so much better than those of many of his peers. He nonetheless subordinates himself to his vineyard and his wines, which are sublime. I never met Robert Mondavi in his prime, but my impression was that humility was not one of his primary virtues. Still, I was always struck by some-

thing he told Rémi Krug, of the Champagne Krugs, back in 1983. "Rémi, I believe we can say that, in only a few years, we have been able to make great quality wines," Krug recalled Mondavi saying, as he spoke to me twenty years later. "But they still lack subtlety, and this will take generations to achieve." Regardless of how Mondavi felt about his own abilities, this indicates a recognition of the inherent limitations of a winemaker's power.

Without a long history of successful winemaking in the New World, it's not as easy for American winemakers to display their modest sides as perhaps it is for their Old World counterparts. In both Napa and Sonoma, I've met many people in the wine trade who relentlessly put forth the message that as far as wine goes, they live in God's country. There's a sort of manifest destiny to their attitudes that I find unattractive, as it indicates the insecurity that so often is at the root of arrogance.

Nonetheless, California is not without its share of modest individuals who manage to produce great wines. I would cite Bob Travers of Mayacamas, who makes wonderful cabernet sauvignons on Mt. Veeder, as a man who sees his role as a steward of the land, and who perhaps has paid a critical price for not being a louder advocate for his own wines. Paul Draper of Ridge Vineyards will strike nobody as lacking an ego, but when it comes to his wines, I think he keeps the human role in a proper perspective. The same is true of Ted Lemon of Littorai, Wells Guthrie of Copain, and Ehren Jordan of Failla.

Jim Clendenen of Au Bon Climat is a larger-than-life personality, and he is proud of his wines, but he does not mistake his ambition for his achievements. Kevin Harvey of Rhys Vineyards, like a lot of newcomers to the American wine business, made his fortune doing something else. He is now spending a good deal of it establishing vineyards in the Santa Cruz Mountains. He is highly ambitious, and hopes to achieve greatness, but he also recognizes that the wine business moves at an agricultural pace, and that there is a huge difference between claiming greatness and achieving it. He makes the best wines he can make while acknowledging that his estate is in its infancy.

Just as the attitudes of the winemakers and grape growers can play a significant role in what people eventually consume, I believe that the attitudes of the people who think and write about wine for a living contribute significantly to how consumers feel about what they are drinking. Wine writers are not by nature the most modest and humble individuals. After all, we are confident enough of our opinions to imagine the public will find them at least useful, and possibly even entertaining and inspiring. Yet ultimately, consumers would be far better served if wine writers were less certain and less defensive, and more willing to concede the possibility of errors and mistakes.

I don't mean that critics should not be assertive in their opinions. Nobody wants a wishy-washy approach to wine. But again, it comes down to recognizing the ambiguities of wine, and the possibility that differences of opinion might be

legitimate and mistakes occur in part because wine is tem-
peramental.

This is a difficult point, because wine writers must make
a living, and that requires selling oneself or one's publication.
Demeaning one's competitors while exalting number one
may not be so much an accurate expression of one's beliefs as
it is a concerted if unconscious effort to maintain one's earn-
ing power. Nonetheless, I believe many people would feel
more comfortable with wine if the authorities in the field
were less concerned with seeming godlike and all-knowing.

Harry Waugh, the great British wine merchant, is today
best remembered for his response to the question "Have you
ever mistaken Bordeaux for Burgundy?" His answer: "Not
since lunch."

This quip is often cited as a reminder of how even the
most knowledgeable in the wine trade can be easily fooled,
yet the wisdom in it seems to have been lost. The joy of wine
is not about getting the right answer in a guessing game. It's
not memorizing soil compositions and the weather charac-
teristics of old vintages. It's most certainly not identifying
peculiar aromas to see who has the keenest sense of smell,
or the most florid imagination. These activities may all be
rewarding pastimes for wine professionals—a bunch of som-
meliers amusing themselves after hours, or merchants gath-
ering at a Bordeaux tasting. But for ordinary people who
may yearn to experience the pleasures that wine has to offer,
the idea that one must engage in and master these rituals
before one can enjoy wine contributes greatly to the anxiety
that so many feel.

I'm willing to 'fess up right now: My career in wine has

been riddled with mistakes. I've mistaken syrah for pinot noir at dinner. In blind tastings, I've harshly judged wines that seemed too tannic or too dense, only to learn later that they were bottles that I ordinarily love. Did that demonstrate that my beloved wines are in fact not so good? No. But I believe it demonstrates the limits of blind tastings. I've indeed guessed wrong when I've been given a glass of something and been asked to identify it. It's a silly game of fool the wine writer, and I don't mind playing along. You know what? I'm not ashamed at all.

All of these activities, assumed to measure one's connoisseurship, instead have more to do with ego gratification than they do with understanding the important things about wine. Personally, I feel I can contribute far more to the public discourse on wine by showing how wrong I can be rather than demonstrating that I'm infallible.

One area where I can safely say I've never been wrong is in conveying the pleasure that I get from a good bottle of wine. I may not be adequate to the task. I might not be able to communicate the depths of emotion I feel or the sense of awe that washes over me when consuming a great wine, and sometimes even a good wine. But it's not a matter of right or wrong. It's simply a feeling. Being open to these feelings is much more important than mastering a list of wine facts. If you fall in love with wine, you may be inspired to learn things that you never imagined you would care about. But it's the rare individual who is force-fed the dry facts about wine first, and then falls for what's in the glass.

The Home Wine School

I admit that I'm something of a romantic. You almost have to be if you love wine, at least the kinds of unpredictable wines that I like. Think about it. From the producer's point of view, you go into each year taking chances, a lot of them. You're hoping it won't be too hot, or too cold, that it won't rain too much, or, God forbid, hail. If you're in California, you're counting on the probability that the annual summer forest fires won't throw a fog of smoke over your vineyard, infusing the grapes with the aroma of old ashtrays. If you're in Australia, you're summoning the gods against drought, and, yes, locusts. Those are the fears, and if you're overly practical about life the dread of the unknown can send you into the insurance business, or turn you into the kind of controlling winemaker who eliminates variables at the expense of wonder. And sometimes even that's not enough to overcome nature.

Winemaking is a business above all. Nobody is in it to

lose money, except for wealthy types who operate wineries
as vanity projects and can afford the red ink. Like any other
business, it's ruled by the bottom line—winemakers must
make enough money to survive and to sustain. For all the ac-
countants of the corporate wine companies, whose decisions
must necessarily revolve around balance sheets and office
politics, nobody is more concerned about the future than
the small growers and producers whose lives and livelihoods
are inextricably wound around the vineyards and the wines.
Yet as practical as they must be, the good ones are ruled by
romantic ideals as well. They do not simply trust in chance.
They believe that whatever obstacles come their way, their
philosophy will lead them to make the best possible wines,
at least according to their own lights. These wines will find
their audience, and the estates will continue, legacies intact.
Sometimes, though, the struggle to stay with principles can
be difficult, if not ruinous.

For years, for example, in the placid rolling hills of the
Langhe region of northwestern Italy, the land of Barolo and
Barbaresco, producers were bitterly divided between those
who sought to preserve traditional methods and innovators
who adapted new technology and techniques in an effort to
build overseas markets for their wines. It's a philosophical
conflict that has been fought all over the winemaking world,
but it was particularly resonant in the Langhe because neb-
biolo, the grape from which the wines are made, flourishes
in few other places on earth. In the 1990s, it practically split
Barolo into warring camps.

Perhaps no other winemaker embodied traditionalism in
the Langhe as much as Bartolo Mascarello. He made long-

lived, reticent Barolos that, though they took years to reveal their beauty, were wines of rare purity and character. He had no use for the new methods and styles. While Barolo, and many other Italian red wines, had traditionally been aged in botti, huge oak vats that contribute little in the way of wood flavors to the wine, practitioners of the newer style aged their wines in barriques, small French barrels of new oak that can impart plush vanilla and chocolate flavors. The modernists employed other tools and techniques as well, intended to make the wines darker, softer, and more accessible at an earlier age. To Mascarello, these wines were not Barolo as he understood it, but something alien.

"Barolo made here should have, must have, the aromas, scents, and flavors of this land, not those of some wood grown in Limousin, France," he once said. For years, visitors to the winery, behind the town house in which he lived in the village of Barolo, would be treated to his philosophy, recited in the form of a mantra. "No barriques, no California, no cabernet, no chardonnay, no wines with made-up names," he would say, often impishly adding, "No Berlusconi," for political effect.

Even as his modernist colleagues won high critical praise and sales for their wines, he refused to alter his methods. As he saw it, his culture was expressed through the wines. To change the wines was to tamper with cultural identity. "I'm loyal to the traditions of my father and grandfather," he told me when I visited him in 2002. "I don't want to lose them to make wine as they do in Australia and Chile and Sicily."

Perhaps most painful was the criticism of his wines in his own country, by leading Italian critics. I've seen this happen

in other countries as well, particularly at the point when wine regions are making the transition from local to global enterprises. The desire for international acceptance, and to appeal to foreign palates, results in rejecting what's essentially one's own heritage.

Bartolo Mascarello rarely betrayed hurt feelings, but his daughter, Maria-Téresa Mascarello, who made wine with him and took over the estate after Bartolo died in 2005, did not try to contain her bitterness at the treatment of her father's estate.

"We were criticized and attacked by people who wanted to promote barriques," she said. "The press would speak well of them and attack us as people who couldn't keep up with the times, who made dirty wines from filthy wood."

And yet, times changed. Criticism often comes in cycles. By 2003 the Mascarello wines that previously had been denigrated by Italian critics were now being celebrated, though Maria-Téresa was not mollified. "Now they want to make wines like us," she told me. "Now it's trendy to talk about terroir."

Then and now, the Bartolo Mascarello Barolos have been some of the most beautiful wines I've ever had. How easy would it have been for Bartolo to shift his principles with the critical winds and make a different kind of wine. Yet how much would the world have lost had he not been so determined and passionate, so romantic yet so firm? His wine was not and never will be something to be measured in points and tasting notes. It is an expression of culture and cannot be fully understood and appreciated outside of that context. But it's a wine to be loved from the depths of the soul.

Wine merchants have their own romantic point of view. Put yourself in the position of an importer: You buy wines from producers overseas, hoping and betting that you will be able to sell them at home for a profit. It's one thing if you treat it simply as a business, buying wines you know you will be able to sell, or at least, wines you believe the public wants. It's another thing entirely if you buy wines that you yourself actually love. Sometimes that means taking a chance on persuading a skeptical public to buy those wines, especially at a price that will benefit both you and the producer. If you want to establish long-term relationships with producers, you may even have to buy wines in years when you are not at all sure you can sell them, in poor vintages, for example, or when the economy is in the tank. It takes good business sense, but also faith and a belief in the romance of wine to justify doing that sort of business.

Of course, you could go about it in the way of any other merchandise, like soap, breakfast cereal, or luxury goods like handbags or fancy watches. You could work hard to establish the brand name, promising consistency and marketing it using tried and true commercial techniques. In that case, if you're a sensible merchant, you seek out the kinds of wines that fit into more predictable categories, rather than the riskier sorts of propositions that I might favor. I remember a few years ago Beringer, the Napa Valley wine company, produced radio commercials suggesting that people should drink their wines because it would put them in a Napa Valley state of mind. What does Napa connote? According to Beringer,

wealth, a deck surrounded by vines, steaks on the grill, a pastel sunset, a smug assurance. The commercials annoyed me because they treated wine the way the big breweries treat beer, linking the brand name to the aspirations of its audience. In the case of mass-market beer, that means male frathouse fantasies. For Beringer, it meant the self-satisfied Napa Valley good life. Such lifestyle advertising works, as business schools will tell you, but you might as well be talking about a car or the proverbial widget. Wine that is the product of such carefully orchestrated commercial thinking, presumably having passed muster with focus groups, is most likely sound, flavorful stuff. But it's not for romantics, who look for wines that are expressions of culture rather than commercial products.

Romantics like me and many other wine consumers take chances on wines because we have an emotional stake in them. When we buy wines for aging—whether for two years, five years, ten years, or more—we've already written the story in our minds, though we have no way of knowing precisely how the story will turn out. That is, we might buy bottles knowing that we won't open them for some time, and when we do open them we won't know exactly what we'll be getting. But we have faith, based on experience, and we have hopes, based on a rational bit of projection. We're not taking blind stabs with age-worthy wines, since we have a rough idea how they might behave. Above all, though, we have romance; that is, a spirit of adventure and a love of the journey. No matter how it all turns out, part of the joy is the unfolding. What appeals to romantics like me is the joy of discovery, not a bloodless consistency. It's the uncertainty of

what's in the bottle, and the belief that the wine will touch us emotionally. A great wine, even a good wine, has the capacity to surprise and to move, and perhaps even to scare.

A great deal of the wine culture in this country has been established in an effort to offset this sense of uncertainty. We look to all-knowing critics, with noses insured for millions of dollars, to tell us what to buy. We allow them to characterize thousands of bottles down to the last wisp of fruited fragrance, and then we want them to lock it down with a score. What they say is good, we assume, must be good. If we disagree, then something is wrong with us, or, if we're feeling belligerent, with them. If by chance we stumble unaided onto a wine that we love, we look to the critics for affirmation. We might love the wine, but we could be wrong about whether it's any good. After all, what do we know about wine?

Many merchants who could presumably stock their shelves with any wines they like instead abdicate their task of selection. These merchants choose only bottles that have already met with the approval of the powerful critics. They post the scores on the shelves to draw attention to these bottles. In this manner, they've taken themselves out of the realm of skilled worker, bringing their expertise to the public, and taken on the role of assembly-line worker, another cog in the machine. No doubt this is sound commercial practice, but if you're a wine lover, the romance is gone. Instead, it's the equivalent of painting by numbers, or by scores.

It's a system aimed at the fearful, and it's understandable.

Wine scares people, and the chain of critics, scores, tasting notes, and all that goes with them is a way of alleviating those fears, of making an anxiety-ridden situation tolerable. But it also fosters dependency.

For people who feel they don't want to invest the time and the money needed to learn about wine, this sort of dependency is a simple solution to their fears. It's far easier to buy wines according to critics' scores than to set out on the long and convoluted journey of developing one's own sense of one's taste.

If you happen to fall in love with wine, though, then the scores and tasting notes will soon no longer be enough. You want to develop your own relationship with wine, your own easygoing back-and-forth. You want to become independent—at least that's the idea. Nobody who loves wine becomes independent in the sense that they isolate themselves. Instead, wine independence means cultivating your own sense of taste and your own way of thinking about wine, free of cant and conventional wisdom. Wine independence does not mean ignoring other voices. Indeed, independence requires absorbing many sides of a discussion but being able to make up your own mind. Wine becomes a dialogue between your evolving taste and the bottles you drink, between you and your friends, you and the articles and commentaries you read. Independent wine lovers always have a place for critics—but the relationship becomes different. Instead of relying on them to tell you what to buy and what to think, you count on them to inspire, with suggestions of new wines to try, and new ways of thinking about the familiar ones. They will broaden your choices rather than narrow them.

So let's say you do decide you care about wine, enough at least to see what all the fuss is about. Then what?

My suggestion is going to sound a little romantic, naturally. Home-school yourself! The best wine education you can possibly have is at your own dinner table, where you can open bottles, drink them at leisure, get to know wines, and get to know your own tastes. This is not an overnight project. It will take some time, particularly if you find the exercise rewarding. But time with wine is a necessity. Comfort does not develop overnight, easily, or after reading a book.

You may have heard many people toss off the notion that the best way to learn about wine is to drink a lot of it. Or, as Alexis Lichine, the mid-twentieth-century wine promoter put it, "Buy a corkscrew, and use it." Yes, it's become quite the hackneyed suggestion, but I take it quite seriously, and believe it totally.

However, if you are going to drink a lot of wine, and want to learn from the experience, you must approach your consumption systematically. Of course, this will be fun and enjoyable, but some work and discipline is required as well. Because you will need to write down basic information about each wine, along with your thoughts and impressions, it's much easier to perform this exercise at home than in restaurants, though any sort of supplemental wine drinking you do is fine with me.

Now, as I've said, wine classes are best if you already know a little something and have decided that you are

enthusiastic enough to pursue a passion. They can be an enlightening and educational next step. But for beginners they can be daunting, and they tend to focus much more on how to describe wines rather than on helping you develop an easier, more comfortable relationship with wine. Books can be informative and entertaining. They are essential, but they play a supporting role. Reading books about wine can be inspiring, especially those that do not purport to be textbooks, or to teach you all you need to know about wine. I would reject books that claim such all-encompassing powers. Do you think you can learn to dance the tango by reading a book? Of course not. You have to get out there and strut, and stay with it for years, most likely. Learning about wine requires similar devotion and discipline. Books can galvanize and nurture a fascination with wine, but drinking it is the most important thing you can do to develop ease and familiarity.

To repeat, in order for my approach to be effective, it will require a little thought and a modest amount of work, though, because you will learn more quickly if you pursue wine in an organized, methodical manner.

The first tasks, I'm afraid, are the most difficult, and the most crucial. You need to identify a good wine shop near you. If the answer isn't obvious, ask a wine-obsessed friend for some recommendations. Then you must find somebody at the shop with whom you seem to have a rapport and who is passionate about wine. Certain clues will help you gauge the quality of the shop and the salesperson's passion. For example, as I've suggested, if a salesperson tries to entice you by quoting scores from a consumer magazine, forget it. But

if the salesperson explains why he or she loves a particular wine, it's a very good sign. I've always thought great wine shops have a lot in common with good reference libraries. You may think you know what you are searching for, but the salesperson, like the librarian, has a detailed and intimate knowledge of the collection. They will take you to places you never imagined, and sometimes talk your ear off while doing it and take far more time than you had allotted for the task. You may have to prod the proceedings along. Remember, though, an open mind and a romantic disposition are crucial.

One benefit to living in the modern world: You've got the Internet and the telephone! If you don't have the ideal shop near you, great wine is still within reach, provided you live in a place where all the laws line up in your favor. It's not so much fun to do this over the phone, but you can still find passionate salespeople, even if you can't see them.

Once you've found the shop, and the representative, you are ready to get down to business. Ask the salesperson to select a mixed case of twelve different wines—ideally, six red and six white, though you can juggle the proportion if you want. Give the shop a spending limit. You don't need to be extravagant, but it's not a time to stint, either. I suggest $250, give or take $50. Why $250? My feeling has long been that $15 to $20 a bottle is the sweet spot for great wine values. Below $10, it's easy to find wines that are sound, but a struggle to find bottles that inspire. And this is the time for inspiration! If all goes well, it's an investment in a lifetime of pleasure. If not, and you find that you really don't care enough about wine to pursue it any further, you're left with a

modest loss of money and tremendous surge in available time and energy you can devote to other pastimes.

How will you decide what goes into the case? This is where passionate salespeople come in handy. They love nothing better than to turn people on to wines they love. Putting yourself in their hands invests them in the outcome. They won't simply choose safe, inoffensive bottles. They will do their best to select wines that they think will move you. They may ask you if you remember any bottles you particularly liked, or didn't like. They might try to gauge your desires by what sort of food you like to cook and eat. But if you are lucky, they will select bottles that may not be familiar, that will provoke a response but that won't be so polarizing as to offend. Indeed, some wines can be alarming at first sniff, and until you have a grasp of the fundamentals, or at least a firm curiosity about wine in general, it's best not to go there immediately.

I tried the mixed-case experiment a few years ago for a newspaper column. I arranged with salespeople at two very different shops in Manhattan to put together beginner's cases for me. One was kind of an establishment shop, specializing in big, familiar names and an annual promotion of the Bordeaux vintage. The other was a more idiosyncratic place, which seemed to reject much of standard connoisseur wisdom and go its own way.

Surprisingly, each of them suggested cases that were very similar conceptually, even though the particular bottles were totally different. Both contained a Bordeaux, a red Burgundy and a white Burgundy, a riesling and a zinfandel. Both included a sauvignon blanc, a Côtes du Rhône and a red from

Italy. Both included a Champagne. That breakdown is a fine basis for designing your own case, if it came down to that. To fill out the twelve bottles, I might include a Rioja crianza, a dry Vouvray, and, if I can say that the first Italian red would be a barbera, I'd pick another Italian red, either a Chianti or some other sangiovese wine.

If all goes well, you will be taking home a general guide to a few of the diverse and wonderful forms wine can take around the world. Some you will love, others you may detest. Either way, tasting a range is essential to learning about wine and about your own tastes.

Now comes the fun. Every night, or however often seems right, open one of the bottles with dinner. This is important. You want to drink a wine with food for the full experience. I'm not saying that you can't drink wine on its own. You absolutely can, and it's very enjoyable. But when wine and food appear on the table together, with family and friends, it makes for a different sort of experience that captures wine as part of the ensemble. Some of the bottles in your selection will be companionable wines, as the importer and writer Terry Theise calls them, amiable partners in the exercise. Others might be shrill or off-putting. But when wine and food harmonize, it changes both for the better.

Over time you may gain a pretty good idea of which wines correspond with which foods. Maybe not on your first case of wine, but in time it will become instinctive. Perhaps your wine shop will even have suggested general food pairings with the wines. But honestly, picking a wine to serve with a particular meal is nothing to sweat about. Just as with describing every last aroma and flavor of a wine, seeking

exact matches of wine and food can be fetishistic, and is best left to the high-end restaurant and wine professionals with the time and resources to pursue the perfect rather than the good.

As fun as this all sounds, a bit of work is involved, too. You will have to keep a little journal with some notes about your experiences. Write down all the pertinent information about the wine: the producer, the appellation, the subappellation if it has one, and the vintage. Also write down what you ate with it, and if there was anything in particular you liked or didn't like about the pairing. Don't try to second-guess yourself by making assumptions about how things ought to taste. Just as if you were in a therapist's office, or confiding in a diary, this is the time for honesty! If not now, when?

First, just focus on the wine, and your reaction to it. Don't worry so much about specific aromas and flavors as more general impressions. Was it fresh and tangy, or heavy and dull? Did it strike you as sweetly fruity, or was it more on the savory side, tasting of herbs, spices, and minerals? What's most important, though, is not to worry about describing the wine itself with precision. It's to describe in detail your reaction to the wine, what you liked about it or didn't like about it. Of course, make sure you save all your notes about each wine. By the way, it's just as important to note wines that you do not like as those that you do. Why you may not like particular wines may give you great insight into your own tastes. But remember, don't write a wine off immediately on first sip. Stick with it for a while, through a whole meal if you can. Good wines change—very slowly as they age, and quite rapidly once you pour them in a glass. How

they taste to you will evolve from the moment you take your first sip, to when you add food into the equation, to an hour later when the wine's been exposed to air and its temperature has changed. On first taste, straight out of the refrigerator, a young, relatively inexpensive white Burgundy might seem a little plump and almost buttery. But let that wine come to nearly room temperature, and a lean, minerally delight might emerge.

Just as good wines can evolve in the glass, so can one's own tastes evolve over time. In fact, after you complete this initial exercise, you might want to throw your notes into the bottom desk drawer so you can check them out in a few years. You might be surprised how your own tastes will have changed.

By the time you finish the first case, perhaps a pattern will have emerged, or an incipient theme, at least. If you've enjoyed the wines, and the experience, return to the wine shop and put together a second case, this time going over your notes with the salesperson. This second case will partly expand on the first, including regions that didn't make the first cut. But it will also try to follow up on your notes, offering variations on the wines that seem to fit your tastes. You can repeat this exercise as many times as you want, as long as it remains pleasurable. With time, you can even begin to narrow your focus. For example, if you decide you really like good Beaujolais, maybe you'll get an entire case of Beaujolais, from different producers, so you can compare the subtle nuances of one sort of wine through a microscope rather

than looking through a telescope at the entire diverse universe of all wines. This process of approaching a particular wine close up, from all sides and angles, is the beginning of connoisseurship. In the writer Matt Kramer's alliterative phrase, it's pursuing palate perfection, though I think of it more as simply satisfying the need to know.

Perhaps that's getting too far ahead of ourselves. In the initial phase of this home-schooling, you will get a sense of which sorts of wines you like best. If you get to the point where you are narrowing the focus, you will have long since been motivated to find out even more than you can learn just by drinking. That's the time to start buying books, and maybe even to take a class, because now you have a context for organizing, understanding, and digesting a blizzard of information. You might not be dancing the tango like an expert, or be able yet to tell the difference between a Pomerol and a Pommard. But to be honest, few people can, even with years of experience.

This, of course, is a more rigorous, systematic version of the way I fell in love with wine, and the way many people do. Some of my best friends, with no relation at all to the wine or food trades, have taught themselves about wine through this process of experimentation and discovery. My friend Michelle, for example, doesn't trouble herself with the more arcane points of wine knowledge. But she fell in love with riesling a few years ago and continues to find enormous pleasure in it. My wife, Deborah, loves wine, though she likewise is not so concerned with the details. But I have found that simply through her exposure to many different wines over the years, she has developed an uncanny ability to

describe exactly what she likes or doesn't like. In a sense she used an attenuated version of the home wine school to cultivate her own taste, even if she was not sufficiently interested to pursue it beyond that.

If you are interested, though, the more you repeat the exercise, and the longer you keep at it, the more you will learn. More important, the more you learn, the more questions you will ask. You will also come to understand what place wine will have in your life, whether you are interested enough to put in the necessary time and effort to answer those questions, or not. If your curiosity is sufficiently piqued, then you may find yourself falling in love with wine, which is what the whole exercise was about in the first place.

An Expression of Culture

I began writing about wine full-time in 2004, fifteen years after I had prophesized to Frank Prial that I might one day take over his job. Strangely, I had not the slightest inkling in 2004 that the wine job would actually come my way. In the fall of 2003, William Grimes, the restaurant critic for the *Times,* announced that he was going to step down. Having spent most of 2002 filling in for Grimes during an illness, I felt as if I was well equipped to take over as the next restaurant critic, even if it meant setting aside $25 and Under—my baby—and my wine writing. The *Times* seemed to have a different idea.

As I pieced it together later on, the top editors at the *Times* wanted a restaurant critic with a fresh eye, someone who had not been immersed in the dining culture of New York City. I had been writing $25 and Under for twelve years, which I felt gave me the background and context to make excellent sense of New York's restaurant culture. It

never occurred to me that this experience might be considered a drawback.

I knew I was being considered for the job, though, and one day I was summoned to have lunch with Bill Keller, the executive editor, to discuss it. I considered it a great sign that he was willing to hazard a little Indonesian joint on Ninth Avenue, the kind of place that I loved but that perhaps an older generation of *Times* editors might have found déclassé.

Well, lunch was fine, and perhaps it was a sign of age and maturity that I could speak to Bill Keller as a peer rather than as a halting, intimidated kid, as I sheepishly recalled feeling after earlier encounters with legendary bosses like Abe Rosenthal. But apparently I spent much of that meal discussing not what I would do if I were given the restaurant beat, but an upcoming trip I was taking to the Champagne region, where I was going to write a story on the increasingly interesting and important phenomenon of small grower-producers, who were reinterpreting the meaning of Champagne.

As much as I felt I had a broad and well-grounded understanding of New York restaurants, and the ability to write about them, I apparently conveyed to Bill Keller and the other editors who would decide my future a depth of passion about wine that outweighed what I was feeling for the restaurant beat. I credit them with knowing better than I did what path would be best for me.

So it came to be that, after a painfully prolonged process, the *Times* made the brilliantly unorthodox choice of Frank Bruni as the next restaurant critic, and, to my astonishment, named me the wine critic. Astonishment? Well, I had no

clue that a full-time wine-writing job was even available. Frank Prial had been ill the previous year, and I had filled in for him, just as I had for Grimes. But he had given me no indication that he was ready to step back, much less retire.

I did an internal double-take when my boss, Barbara Graustark, pitched the job to me as we walked around the block to grab a burger on West 44th Street. But after a few disconcerting minutes in which I grappled with shifting my thinking from restaurants to wine, I accepted. I was not to be merely the wine columnist, or a wine writer, but the Chief Wine Critic of the *Times,* an ominously highfalutin title, especially considering the fact that the *Times* had no other wine critics, then or now.

The overcaffeinated brains of the wine world, as if trying to stave off tossing and turning through a tormented night, are obsessed with dissecting issues that seem amazingly trivial. Who knows which of the world's problems might have been solved if the energy wasted, for instance, debating the differences between wine writers and wine critics had been put toward a more useful goal? Yet this is often what occupies the wine-obsessed. The writer, it is said, covers wine from a distance, reporting stories, and presenting issues, personalities, and conflicts while largely refraining from the nitty-gritty details of tasting and evaluating numerous individual wines. Gerald Asher and Hugh Johnson are the classic examples, and I would add Matt Kramer to that honor roll. The microscopic, clinical evaluations of individual bottles are left for the critic, who knows how to keep the nose in

the glass and whose writing skills might largely be confined to constructing tasting notes.

My job would encompass both of these roles, and I embraced the title Critic. But my reasoning had nothing to do with what the title announced about my function, or how it might be interpreted by readers. Instead, I was pleased and proud of what it said about the esteem in which the *Times* and the country now held wine. At the *Times,* Critic is an exalted job title reserved for matters of culture. For decades the *Times* had a roster of critics—music, film, and theater, naturally, along with art and dance, books and television, photography and restaurants, fashion and architecture. But not wine.

When Frank Prial began writing regularly about wine in 1972, it was considered an experiment. Nobody knew if the subject could sustain a regular column, or whether the public was even interested. Wine was hardly a consuming topic back then, which happened to be the year of my fateful teenage trip to Paris, my embarkation point on a life obsessed.

But interest in wine grew enormously. You might even say that the United States and I were on parallel paths toward fascination, as wine came to take on unexpected meaning in the country's life and in my own. So, when I was given the title Wine Critic, I took it not so much as an acknowledgment from the *Times* of my own work as the recognition of wine's growing importance in American life. Not only did the subject of wine require somebody to cover it as a news beat; now, the newspaper reckoned, wine was just as surely an expression of culture. Writing about it would require the

same sort of critical eye used to analyze, evaluate, and explain other forms of cultural expression. Prial never received the critic's title, and if my cheeks burned a little bit when he teased me about the "chief critic" business, I felt it was at least a ratification of all he had done as a wine writer, reporter, and critic in all but title to propel the growth of American interest in wine.

Though an expression of culture, wine differs significantly from those fields we consider as the arts. First, it must be distinguished from those arts that are paramount examples of self-expression—painting and sculpture, for example, composing and writing. The art of producing wine, if we can call it that for a moment, is much more of an interpretive performance, and so the *vigneron*—the French term, which has no English counterpart, for one who oversees both growing grapes and making wine—has more in common with an orchestra conductor, or a classical musician, say, than those who create or perform their own works.

David Chan, the concertmaster for the Metropolitan Opera Orchestra and an avid Burgundy lover, once likened making Burgundy to interpreting great classical works. Both require a particular sort of selflessness, on the part of the vigneron and the musician, to bring them to life.

"If you seek to only be yourself, that's what you get, but if you seek to faithfully bring the composer to life, that will happen, and your personality will enter the picture because you're performing the task," he told me. "I think the same thing happens in wine. If you try to faithfully capture the

terroir, inevitably you enter the picture, whereas if you're not careful, it results in a house style."

By house style, he meant a human-contrived wine rather than one indebted to terroir and abetted by humans. Even allowing for individual expression, as Chan suggests, the terroir of Vosne-Romanée or La Morra, Monte Bello, or Wehlener Sonnenuhr, is an entirely different thing than, say, a Mahler symphony. Where Mahler sought to convey the tormented suffering and grand passions of his life through his music, which must then be understood and interpreted by the performers, the vigneron is simply transmitting the qualities of a particular piece of earth through the wine. It's difficult to compare the two in terms of complexity or intellectual achievement.

Writers have often used music as a metaphor for describing certain wines, likening a subtly expressive bottle to a string quartet, for example, or a bolder, louder bottle to a brass band. But when asking where or whether wine fits in as an art, let's consider whether the orchestra analogy works, with the vigneron in the role of the conductor. The conductor must nurture the musicians, encourage and prepare them to convey the music with maximum expression, just as the vigneron must prepare and cultivate the vineyard to produce the best possible grapes. In this sense, the written music, as Chan says, is the terroir. The orchestra can perform beautifully, but it is limited by the quality of the composition. The conductor and players may be able to find new expressions in minor works, producing performances that are quite enjoyable. Occasionally, they may even be able to demonstrate greatness where nobody saw it before, in which

case the conductor may be lauded as a genius. But in general different musical works have different limits of potential. A Chopin piano concerto may offer heartbreaking beauty and delicacy while a Beethoven concerto will convey drama, intensity, and grandeur. Both works may move you, but for different reasons.

Encompassing both the vineyard and the cellar, the vigneron's job may be a little more fragmented than the conductor's. Forgive me, then, if I overstretch the analogy. In the cellar, the vigneron must decide how to coax out from the raw materials the best possible expression for that particular vintage. This indeed is partly technical work, but it also requires imagination. Just as the conductor must conjure up a sense of an ideal performance, the vigneron must measure and envision the potential of the vintage, and act accordingly. Such visions can be heavy-handed or clumsy, particularly if they go against the imperatives of the vintage. Or they can be beautiful reflections of the vintage, though perhaps not to everybody's taste.

While the vigneron may have a lot in common theoretically with the conductor, the final product is very different. Whatever can be said about the quality of the performance or the conducting, the musical composition is art. Wine itself is not art, at least not in the same way as music or paintings. It cannot offer new and different ways to understand life and the human condition, as great art does. It is consumed, an experience that can never be duplicated precisely. In a way, that's like a concert, a one-off performance. But great performances can be recorded, freezing the experience for multiple presentations, while great wines, even of a single

vintage, are subject to the variations of bottles and context.

Yet wine does have the capacity to move us. In addition to its functional role as a food or beverage, wine can display great beauty. I believe that when wine is made as a true expression of a terroir, it transcends its nature as a mere product or as simply a hedonistic pleasure. It then has something of a story to tell, about where it came from, both geologically and culturally, and about the people who shepherded the transformation of grapes to wine and that year in history.

A few years ago I had the privilege of drinking a Montrachet, perhaps the world's greatest white wine, from the 1939 vintage, a sad, ominous point in world history. That year, just as Burgundy might have been thinking about the harvest, the French army was mobilizing with the beginning of World War II. As I sipped the dark, amber-gold wine in 2006, it seemed to offer a strange amalgamation of aromas and flavors, an odd juxtaposition of effects rather than the usual smooth progression. It smelled sweet but tasted dry, with flavors of caramel and sherry as if it had been slightly oxidized. Yet it also offered a radiant, shimmering minerality that triumphed over the oxidative notes, and made drinking the wine an experience I will never forget. And it told a story: Because of the disruptions caused by the army's mobilization that summer, as farmers and field workers went off to war, the ordinarily orderly harvest was confused. It began late and rather than the usual matter of days, it stretched to weeks. The women and children who were left behind picked grapes when they could, resulting in uneven degrees of ripeness that produced the unusual spectrum of flavors and aromas.

It was all evident in the wine, history suspended in a glass. Yes, perhaps knowing the history was required to interpret the emotion in the wine, but it was there to be felt. The beauty and character of the wine reflected and transmitted that history. Maybe that is not art, but it is most certainly an expression of culture—more precisely, an expression of French culture in the Côte de Beaune at a significant point in history.

This is an extreme example, an extraordinary wine from a historic year. Yet ordinary wines also have the ability to convey the conditions and character of their time and place. Good Muscadet—can there be any mistaking this singular wine? It's made of the humble melon grape, and rarely sells for more than $20 a bottle, yet good ones, from producers like André-Michel Brégeon, Pierre Luneau-Papin, Marc Ollivier, Guy Bossard, and a handful of others, easily convey the qualities of the different terrains in which they are grown. They offer captivating textures, and a sort of bleak, stony, saline minerality that speaks of the western, Atlantic end of the Loire Valley.

Head east along the Loire to the Touraine, the land of regal châteaux and chenin blanc, and the wine is completely different. Vouvray when made well can be transparent, showing the particular character of the place in which the grapes are grown. Yet the attributes of the chenin blanc grape are paramount—the honeyed edge of flavor, along with aromas and flavors that draw comparisons to citrus, flowers, minerals, and herbs; the texture, satisfyingly thick yet not heavy or overly powerful, and the acidity and lively freshness, which gives chenin blanc the versatility, matched only by riesling,

of making wines that can be bone dry, unctuously sweet, and myriad shades in between. In fact, a good case can be made that demi-sec Vouvray, in which a fair amount of residual sugar in the wine is balanced by acidity, is the ultimate expression of wine in this part of the Loire Valley. The demi-secs from Huet, perhaps the apogee of Vouvray, could not possibly come from anywhere else, and given the integral role of the legendary Gaston Huet in preserving the Vouvray appellation after World War II, one can argue that a glass of Huet represents the history and culture of the region.

As important and expressive as those wines are, the meaning is fragile, completely dependent on a human willingness to care about its importance. Just as the symphony will not be played unless people dedicate themselves to mastering their instruments and learning the music, so the wine will have no cultural meaning unless humans absorb the nature and meaning of the wine and the region, and then devote themselves to transmitting it. In the case of Huet, this has been a delicate issue, though seemingly negotiated successfully, first by Noël Pinguet, the son-in-law of Gaston Huet, who took over Huet when Gaston's son was not interested in carrying on, and then by Anthony Hwang, a businessman who bought a majority share in Huet after Pinguet's children expressed no interest in living the wine-producing life. Now, after some years of working in apparent harmony with Hwang, Pinguet has left Huet, though a protégé whom he trained has stayed on to take over the leadership role. Will Huet remain on its game? One can only hope.

Continue east along the Loire to sauvignon blanc territory, and to two important appellations, Sancerre and Pouilly-Fumé. Sauvignon blanc is far better known and more popular than either chenin blanc or melon. In the last twenty-five years it's become a true international grape, grown around the world in virtually all winemaking countries. Yet very few sauvignon blanc wines made anywhere else are as tied to their origins as the best Sancerres and Pouilly-Fumés, and very few wines made in Sancerre and Pouilly-Fumé approach the sauvignon blancs of Didier Dagueneau.

Dagueneau was an iconoclastic vigneron, an outsize personality and a rebel who looked the part in dreadlocks and a beard. He was a risk-taker who raced motocross, ran sled dogs, and did not shy away from criticizing neighbors who he thought did not live up to his standards of grape growing or winemaking. This of course did not make him a popular figure in his region, yet the quality of his wines was undeniable, as were the high prices he fetched for them, so he was greatly admired as well.

Tasting a Dagueneau wine for the first time can be a revelation. His sauvignon blancs offer an unexpected purity and clarity, the flavors intense but nuanced. It isn't the fruit that is piercing, as in so many sauvignon blancs, but the freshness and the focus. As powerful a personality as Dagueneau was, his wines did not exalt the stature of the winemaker so much as the beauty of the terroir.

Dagueneau died in 2008 when the ultralight plane he was piloting crashed on takeoff. In one respect he was lucky: His son, Louis-Benjamin, was prepared to step in to continue work at the domaine. From all reports, he has car-

ried on admirably, producing wines that, like Didier's, are both dynamic and respectful, expressive of the terroir and the vintage, and always full of character.

Generational transitions are the most delicate links in the fragile chain that ties wine to its particular culture. The Huet and Dagueneau estates were lucky to have dedicated individuals ready to step in when necessary, but sadly that is not always the case. The history of wine is replete with wonderfully distinctive estates that have disappeared, leaving behind only ghostly bottles to give expression to the worlds of their creators. I think of the wonderful Barbarescos of Giovannini Moresco, the unmatched Côte-Rôties of Marius Gentaz-Dervieux, the incomparable St.-Josephs of Raymond Trollat, the delicate Burgundies of Jacky Truchot, and the complex, textured Cornas of Noël Verset, who, along with Auguste Clape, pretty much kept the appellation alive in the dark days of the mid-twentieth century until it was rediscovered in the late 1980s.

I think of the extraordinary Fiorano wines of Alberico Boncompagni Ludovisi, the Prince of Venosa, who made great reds and whites on his estate on the outskirts of Rome. When the prince inherited the estate in 1946, it was planted with the local grapes of the area, which made largely nondescript wines. He replanted the vineyard with cabernet sauvignon and merlot, long before these Bordeaux grapes became fashionable in Italy, and with malvasia and sémillon. Few people knew of the wines, and the superb reds were better known than the whites. But even the whites were

profound. The prince was somewhat eccentric, and was difficult to do business with. Eventually, he stopped selling his wines, and then, in 1995, without explanation, he pulled out all his vines.

To be honest, the prince's wines are a lot more revealing of his own eccentricities than they are expressions of the local culture. Only through his idiosyncratic determination, his resources, and his ambition were such wonderful wines realized. Perhaps (for he was not one to discuss his reasoning) he understood the singular nature of his wines and his estate, and that was the reason he pulled out his vines rather than hand over the estate to his son-in-law, who happened to be Piero Antinori, patriarch of the eminent Tuscan winemaking family. Antinori himself suggested that the prince was unable to bear the thought of anybody else making wines when he could no longer do it himself.

"He is so in love with this estate, and when you are very much in love you are also a bit jealous," Antinori told me a few years ago, when the prince was still alive but infirm. "When he was not able to do it himself in the old way, probably he preferred to give up."

That seemed to be the end of the wines. The prince died in 2005, and years of legal wrangling passed afterward, bogging down the disposition of the estate. Now, though, the three daughters of Piero Antinori and his wife, Francesca, the prince's daughter, are collaborating on a project to replant the estate and make Fiorano wines again. I will be fascinated to see what they can do, though the prince was so peculiar in his methods that no one should expect the same sorts of singular wines that he made. Still, Fiorano may speak again.

I'm not so sure similar hope exists for the future of one of my favorite Bordeaux producers, the microscopic Domaine du Jaugaret in St.-Julien. In this era of corporate Bordeaux, Jaugaret is an anachronism. The critics don't score its wines; it doesn't play the futures game. Even hard-core Bordeaux lovers don't know about it. In fact, even the Bordelais are hardly aware of its existence.

I had never heard of Jaugaret until a few years ago, while discussing honey, of all things, with Neal Rosenthal, the wine importer, who not only brings in honey as well, but tends hives on his farm in upstate New York. Somehow the discussion came around to Bordeaux. I mentioned that I was planning a trip there, and he said he hoped I would have time to visit Jaugaret, whose wine he imports. How tiny is it? Well, it only has about 3.25 acres of vines, the equivalent of a thimbleful of wine. It's a size that was more typical of Burgundy than Bordeaux, which was maybe, I thought, why Neal liked it so much, being more of a Burgundy guy himself.

I filed it away in the back of my mind, and some time passed before I finally tracked down a bottle of the 2002 vintage in New York. After pouring myself a glass I knew from the first sniff that I was going to love this wine. It offered all the complex aromas one might expect from a really good St.-Julien, but more important was the impression of grace it conveyed, despite its youthful density, and the way its entrancing aromas and texture kept drawing me back to the glass. This was a wine in its truest form, unmediated by

the polish and pretense of marketing or, indeed, even by the calculating hand of a winemaker. It was perhaps the most direct expression of St.-Julien terroir that I've ever had, the epitome of an honest wine unshaped by any desire other than to transmit the history of a place and a people through the medium of the wine.

That wine haunted me, and I resolved, on my next visit to Bordeaux, to walk the land where the grapes were grown and to meet the man who made that wine, Jean-François Fillastre, whose family had overseen Jaugaret for more than 350 years. In fact, the Jaugaret label is unusual itself. The most prominent lettering is reserved for "St.-Julien," emphasizing the primacy of terroir. In lighter tones is the name of the estate. ("It's a domaine, not a château," a neighbor to Jaugaret said to me when I went to visit, underscoring the difference in scale and intent between a big commercial enterprise and a vigneron.) Least conspicuous of all, underneath the vintage indication, the label simply states: "Fillastre, propriétaire," without even mentioning which Fillastre, connoting a timeless association between family, land, and wine.

My visit to Jaugaret turned out to be one of the most rewarding, illuminating, and enjoyable I've ever made to a producer. Yet who would ever guess the beauty and importance of Jaugaret simply by looking at the facility, no more than a series of stone sheds with floors of dirt and gravel and walls covered in a mushroomlike mold? Jaugaret occupies a different universe than the grand châteaux that make up the global image of Bordeaux. Yet Jaugaret brims with the quality that so much of Bordeaux lacks—soul.

"I use the methods of my father—natural, no manipula-

tion, no chemicals," Fillastre told me, as we stood in a room where three vintages sat aging in old oak barrels, illuminated by lamps wreathed in cobwebs. Using a tapered pipette made of glass that he had blown himself, he pulled samples from the barrels, wines that were fresh, alive, and aromatic. "I'm not making wines for consumers," he said. "I'm making wines for my own pleasure."

These words might well have been spoken elsewhere by other idiosyncratic winemakers who have gone their own way, stubborn idealists like Gianfranco Soldera of Brunello di Montalcino, Bartolo Mascarello of Barolo, Anselme Selosse of Champagne, or Henri Bonneau of Châteauneuf-du-Pape. While those winemakers have been celebrated for their very personal expressions, Fillastre is lost within a region that many younger American wine lovers perceive as stodgy, dull, and lacking authenticity. In a good year he only makes 6,000 bottles, while a great château like Mouton-Rothschild might produce 170,000 bottles.

"I don't demand of the wine, it demands of me," he said, dismissing the culture of enologists and consultants who employ the latest in technology to achieve the wines they desire. "People are always following styles. I don't disagree with evolution in winemaking, but I don't know anybody who's trying to preserve the old ways."

Over lunch with him I had an opportunity to taste some older vintages. A 1990 was pure, round, and full, absolutely delicious, but a 1982, the last vintage produced by his father, Jean-Emmanuel, was something else entirely, rich and concentrated yet light and precise with grace and finesse. But perhaps the most extraordinary wine I tried was after lunch,

after touring his vineyards, back at his winemaking facility. He opened an unlabeled bottle that was clearly older than the ones we had consumed. Through the glass of the bottle, the wine looked to be a pale ruby color. After managing to pry out the crumbling cork, he poured out a few glasses of this wine, which was luminous and pure, delicate but not fragile. It turned out to be a 1943, his birth year, in fact, and no doubt made under trying conditions during the German occupation of France.

"I make wines to hold up the family tradition, not to make money," he said.

How long that tradition can continue is a question mark. Fillastre was sixty-seven when I visited him in the summer of 2010, and he had no heirs. His younger brother, Pierre, has two daughters, but Fillastre said they are not inclined to be vignerons. The future is a concern.

"If I'm sick, I could lose everything," he said. "I worry about that."

Luckily, his father made wine until he was ninety, so perhaps Fillastre has more than a few years remaining. Still, it's sad to imagine a world without a Domaine du Jaugaret, and without the collected wisdom, tradition, and experience that Fillastre embodies. It's even sadder to imagine the Jaugarets and Fillastres that we've already lost without realizing it.

Not all wine, of course, is an expression of culture. Most of the wine made in the world today, and throughout wine-making history, is product—a commodity created to fill a demand with the primary goal of making a profit. That was

true centuries ago, when farmers brought their grape harvest to the local winemaking cooperative and viewed their profit in terms of sustenance. And it is true today with multinational corporations that push their brand-name beverages with little regard for where the grapes came from or how the wine was made.

Nothing is wrong with that. I have nothing against people who buy and enjoy those sorts of wines, just as I don't argue with people who dine at Olive Garden and Red Lobster. I will say, though, that I personally have little interest in these sorts of wines. They offer no real pleasure to me, and incite no more curiosity than a Coca-Cola, a Budweiser, a fast-food hamburger, scripted reality television, or formulaic producer-rendered pop music. If I'm on an airplane where they serve a meal—a pretty rare thing nowadays—and the only wine available is from one of those little mass-produced bottles, I might drink it, or I might have an industrial beer, or water. I have no more interest in one than the other.

Similarly, I have no real critical interest in products like Two-Buck Chuck or Yellow Tail, or any confected, manufactured wines, whether cheap or expensive. People in the wine industry, and those who parrot them, often talk optimistically about these as stepping-stone wines; that is, as first steps for non–wine drinkers who will eventually turn to better and more expensive wines. Personally, I've found that's more coincidence than anything else. Such a small percentage of the people who enjoy Yellow Tail work their way up to falling in love with wine that you might as well make the argument that people who start on orange juice will one day be wine lovers. It's more an industry rationalization

for selling homogenous products than anything else. These products may be interesting as business phenomena, but for serious wine writers to treat them on the same level as they would real wines is simply pandering and false populism. Can one of these wines be better than another? Of course. But rarely is one more interesting or surprising than another.

As I have learned more about wine, and about my own tastes and inclinations, I've found what moved me, grabbed me, and held my attention were the wines that expressed themselves as a part of a larger culture. I fell in love with the Jaugarets and the Mascarellos, the Biondi-Santis and the Selosses, the López de Heredias and the Pierre Chermettes, the Joh. Jos. Prüms and the Willi Schaefers, wines from people who were passionate not just about making great wines but about exploring the depths of their cultures, which gave their wines even greater meaning. Many of these are famous names, and expensive wines, but by no means is this true of all of them.

You can find dolcetto di Dogliani from Anna Maria Abbona, for instance, for under $20 in many different stores, but chances are you will not find a more interesting dolcetto. Dolcetto wines, after all, are just a daily drink from northwestern Italy, nothing prestigious about them. But the Abbona family has worked hard to preserve the tradition of cultivating dolcetto on the hills of Dogliani, steep slopes that are arduous to farm. It would be far easier if the Abbonas, like many other producers, relocated their vineyards to flat lands, where the work could be automated, and they might have made more money if they had replaced the dolcetto

vines with other, better-known grapes that would have been easier to sell in the international marketplace. But dolcetto has been grown on those hills for centuries, and Anna Maria Abbona and her family believe strongly in the local traditions.

Frankly, you can taste it in the wines. They have a depth and character that I've rarely seen in dolcetto, and they give me great pleasure to drink, much more than I would feel with a glass of one of the lesser dolcettos.

Similarly, I love the plain Beaujolais from producers like Jean-Paul Brun, Pierre-Marie Chermette, or Domaine Dupeuble, which are cheap and, even in Beaujolais, come from unheralded sites. Yet these are serious wines, not in the sense that they demand ponderous contemplation, but that they are made with serious purpose, and they reflect centuries of effort and discovery. These are not wines made by shortcut. They are delicious in their own right, and more so because they could come from nowhere else. There is simply no comparison between serious Beaujolais—which nonetheless is joyful by definition—and mass-market Beaujolais, which is not joyful but sad.

What all of these wines have in common is that they celebrate perseverance rather than lifestyle, history rather than mythology, and rewards other than monetary. Many of these producers could have made other, more lucrative choices. They might have sold their land for profit or tried to follow fads. But each chose the harder path, or at least the path that was more difficult financially and more laborious, because they believed that their wines and their vineyards were part of a tradition, and that the tradition had cultural value. In the

twenty-first century, a time of great discontinuity with our collective past, many of these people live lives that indeed would be recognizable to their ancestors.

As wines of cultural expression came to be my overriding interest, it appeared as if Old World wines had a decided advantage. I found myself at odds with some prominent American writers, who accused me of having an Old World palate and misjudging the efforts of American winemakers, particularly in California. I considered the criticism, but in the end felt that the accusations were silly. Nobody is watching over wine writers with a giant abacus, keeping track of where their favorite wines come from, except a defensive industry and, perhaps, other wine writers, who like almost nothing better than to discuss and criticize their competitors.

Well, as it happens, the Old World does have a decided advantage. Wine has been part of the culture in Europe for centuries. Its place is firm, if not exactly secure. Most American wineries are no more than a couple of decades old, and many of the most famous names—Robert Mondavi, for example—were less interested in developing the traditions of a particular place than they were in becoming big, even global, enterprises. I've often wondered what might have happened if Mondavi had stayed focused on making Napa cabernets, and if it had stayed a family company. But that's idle fantasy. Instead, it expanded to multiple continents, overreached, went public, and was snapped up by a big corporation. I've loved many old Mondavi cabernets, but I don't find the current wines nearly so interesting.

Yet California absolutely has some wonderful producers who make wines that without a doubt express their terroirs. If they are not exactly the products of a culture, it may be because by the middle of the twentieth century wine was strictly a commercial enterprise. Farmers were no longer growing grapes among many other subsistence crops, for their own use or for local consumption. While it is true that the roots of the California wine industry grew from seeds planted by immigrants who simply wanted to make wine for themselves, its swift recent ascent into big business bypassed the development of local wine cultures.

Nonetheless, consider the historical California producers who are still making wines that are instantly identifiable to aficionados. Mayacamas and Ridge Monte Bello are two of California's greatest cabernets. They don't always get the credit they deserve, but both of them have proven over decades that their respective vineyards are unusual and distinctive. They are both secluded in the hills, their vineyards difficult to get to and tough to farm, but the wines have demonstrated they are both worth the intense effort. Would I consider these wines cultural expressions? Absolutely, though I would identify them more with forceful individual personalities—Paul Draper of Ridge and Bob Travers of Mayacamas—rather than with communities.

The American wines in this category—I would add others like Stony Hill, Mount Eden, and perhaps Heitz and Hanzell—almost all reflect the efforts and personalities of individual pioneers rather than the collective culture of communities. That's a function of history and culture, too. Creating a wine estate in the twentieth century, in the

United States, required acts of individual willpower, vision, and determination. In most of Europe, commercial wine enterprises generally grew organically out of collective endeavors, whether on a village level or through the church. Of course, wine took off in the United States in the twentieth century, not the twelfth, by which time local cultures were vestiges. What's new is global, and so an American wine culture has developed in concert with many other parts of the world, as familiar in Melbourne as it is in Hong Kong.

As is so often the case, Bordeaux was a significant exception. It was never confined to its villages, developing instead as an enterprise largely to fill the needs of international clients. While vineyards in the region had originally been planted by the Romans, Bordeaux really took off as a wine region to slake the commercial thirsts of the English and the Dutch. The leading estates, many of which still exist today, were founded by wealthy merchants rather than farmers, and I suppose their legacy today can be seen in the fact that so many Bordeaux wines are constructed to meet commercial expectations rather than reflecting communities or individuals.

Even among start-ups, some nascent American producers are making such distinctive wines that I can't help viewing them already as something much deeper than delicious beverages. Producers like Rhys in the Santa Cruz Mountains, Peay and Failla on the Sonoma Coast, La Clarine Farm in the Sierra Foothills, Tablas Creek in Paso Robles, Ravines in the Finger Lakes, and Shinn Estate on the North Fork of

Long Island are probing deeply the possibilities of their sites. You most definitely can taste their efforts in the wines.

As in so many of the world's top wine regions, land in the best-known California areas is now rarely available except to those with means—a great deal of means. This leaves start-ups without a fortune two methods for getting into the business. One might be to buy land in less-exalted areas, like the Sierra Foothills, or somewhere along the Central Coast. The alternative, instead of buying land and tending a vineyard, is to buy grapes. That is, become a négociant. This approach offers the advantage of access to grapes from excellent sites without requiring the bank account of an Internet tycoon. The downside is that the négociant may have little input into the farming process and may not consistently be able to assure access to those grapes.

Still, some young négociants are making exciting wines, which indeed convey passion, vision, determination, and hard work. I'm thinking of producers like Arnot-Roberts, which make superb syrahs from a variety of sites in Sonoma and Mendocino counties, along with some very unusual whites, and Copain Cellars, which makes excellent pinot noirs and syrahs, also primarily from Mendocino and Sonoma. I could also name Rivers Marie and Wind Gap, and quite a few others.

One of the most interesting California producers is also one of the most unusual, and, alas, microscopically small. It is Matthiasson Family Vineyards. Just as it sounds, it's a family operation, set unexpectedly in the heart of Napa Valley. And yet the Matthiassons go against everything one might take for granted about Napa—its wealth, the way its

denizens do business, the grapes they grow, and the sorts of wines they make. In a Napa world of lock-step assumptions, the Matthiassons are free-thinking, passionate individualists. They go their own way in how they live their lives, and in how they make their wines.

Steve Matthiasson is a vineyard consultant. Unlike many in Napa he is not wealthy, and he did not inherit land. In fact, it's surprising to find Steve, his wife, Jill Klein Matthiasson, and their two sons in Napa at all. But Napa is not populated only by wealthy winery owners. Plenty of people work in those wineries, and they have to live somewhere. One of those places is a subdivision just north of the city of Napa, rows of neat houses on tidy streets. Oddly enough, on one of those streets, a driveway snakes between two houses, seemingly leading to nowhere. Stay on that driveway, take a sharp turn, and another agricultural world opens up behind those neat houses, including a rambling old house with a tumble-down barn and a small vineyard, all invisible from the street.

This is chez Matthiasson, a kind of modern-day ode to the sort of community subsistence farming that defined how generations of Europeans lived their lives. The Matthiassons are not only grape growers and winemakers. They have two small fruit orchards. They raise and kill their own animals for meat. Jill puts up fruit and vegetables, and sells a lot at local farmers' markets.

Unlike so many producers in Napa, who either inherited vineyards or can afford to buy them, the Matthiassons have had to acquire grapes by other means. As a vineyard consultant, Steve works with vines all over Napa, both small family-owned plots and huge tracts. He's learned to recog-

nize the rows that have the potential to be spectacular and those that do not, and so he gets a few grapes here, a few more there, or he leases an acre and a half of merlot in the middle of a corporate vineyard.

"You have to find the little spots, and if you do it's awesome," he told me a few years ago. "Unless you have a whole pile of money, you have to barter your way through stuff."

Barter. What could be more ancient, and more emblematic of the Matthiassons' archaic aims and methods? Steve acquires odd lots of unusual grapes that one might never imagine could be found in Napa Valley: ribolla gialla and tocai friulano—white grapes found primarily in Friuli-Venezia Giulia—and old stands of sémillon, farmed without irrigation and head-trained, an old method of pruning the vines found primarily in vineyards planted before World War II. He blends these grapes with sauvignon blanc to make a lithe, agile, energetic white wine, lean yet textured, delicious and unexpected from the heart of cabernet country. Yes, cabernet does well in Napa, but other grapes might do well, too. If Napa is indeed cabernet country, it's not because years of trial and error have proved it so. It's simply an understandable economic imperative—people will pay far more for Napa cabernet grapes and wines than they will for any other Napa grapes and wines. It's hard for any but the most stubborn or determined growers to argue with that logic.

Not that Steve disdains red wines. He makes reds as well, oddballs like a ripe yet lively refosco—another Friulian grape—and also more conventional Napa reds, like a blend of cabernet sauvignon, cabernet franc, merlot, and malbec. These wines are big, as most reds are from Napa, but none-

theless retain their freshness. Most of all, they are alive—not denatured products but living, breathing wines that perhaps achieve this quality by sacrificing predictability.

"The whites get a lot more attention, but it could be the red is more our baby," Steve said. "The red tastes really good to us. Every time we open a red, it's a different wine. I love that!"

It's an almost magical feeling to be sitting with the Matthiasson family around their big, wooden dining table at the center of their residence. Platters of vegetables pickled and jarred by Jill—cauliflower, okra, green beans, green tomatoes—whet the appetite, to be followed by lamb raised and now cooked by the family. Alongside, we drink the wines, both white and red.

It's a do-it-yourself American ethos that we venerate freely in mythology but rarely in real life, and, apart from the electricity, the kids on computers, and the comfort of this suburban residence, the evening tableau might not be all that different from a farmhouse in Europe several centuries ago, where wine was just one of the many staples, products of a community of families, consumed at the table.

If you feel I'm offering an overly rosy view of the past, perhaps you are right. I would never want to trade my world today for a life in the age before anesthesia. Centuries ago, one might find lamb on the table only for a significant celebration, certainly not for an ordinary meal. No doubt, the wine we drink today is in general far superior. We have many, many reasons to be thankful we are living in the twenty-first

century and not the eighteenth. And, of course, dinner in the Matthiasson household is a rare exception in twenty-first-century America. It represents a dream, an ideal, no more than that. Certainly, the Matthiassons augur no incipient back-to-the-land movement or herald the return of an old European wine culture in the heart of Napa Valley. But they do represent where wine came from and where wine at its best belongs, as well as indicating how alienated we are today from wine's original place in the spectrum of life.

Naturally, wine's role needed to evolve, and it has. As with most food staples nowadays, wine comes from somewhere else. Few among us grow our own food, prepare our own bread, raise our own crops and meat, or make our own wine. In the twenty-first century, it's not necessary that we do. Still, it's important to remember where things came from, and to retain at least an understanding of the past and semblance of continuity to it, just as the greatest wines evoke history and tradition.

The commonplace notion today that all that matters is what's in the glass signifies a severing of wine from culture. To isolate wine in this manner serves to make it a fetishistic object of desire for some, an intimidating, anxiety-producing sore point for others, an emblem of pretentious snobbery, and, sadly, too often a bore. When the score of a wine is more important than what a wine represents, yes, that wine is a bore. It is divorced from culture, assessed in a vacuum, judged without context, and prized for its monetary value rather than its cultural content. It's a little like judging the paint-by-numbers reproduction of the *Mona Lisa* as more worthy than an original but gentle watercolor.

The old wine cultures of Europe are largely receding and certainly cannot be reproduced in the United States or elsewhere. But what they offer is another way of understanding the pleasures and emotions of wine, of recognizing wine's role as a staple grocery and occasional star, and of developing an ease of coexistence. It's not connoisseurship that leads to loving wine, but familiarity and sharing, which eventually lead to insights and understanding.

The Greatest Time
to Love Wine

Here we are nearing the end of this book, and I've provided few definitive answers to some of the knotty questions I posed back at the beginning. Well, let me rephrase that—very few easy answers. I'm sorry, but that's the way it goes. I'm not going to try to assert something that I know is not true because it makes people feel more comfortable. Wine is not an easy subject to master, and anybody who insists otherwise is simply after your hard-earned money. Luckily, mastery is not the goal; ease is what we're after.

If you do indeed experience some form of wine anxiety, it should feel liberating to understand that no handy magical key will unlock the mysteries of wine. It means you've done nothing wrong, you lack no physical gifts and no specialized vocabulary. It's not your fault!

Yet the mainstream American wine culture has led many people to believe that they themselves are somehow responsible for the anxiety they feel. No, I don't mean that wine

educators or wine writers are out there intent on making
you feel guilty. But the underlying suggestion that wine can
be demystified and made simple eventually leads people to
blame themselves when they find they still don't get it. They
believe they haven't studied hard enough, or have not suffi-
ciently developed their olfactory senses, or simply don't pos-
sess the proper equipment.

By now you can see the inherent contradictions in these
dual notions. On the one hand wine can be demystified and
made simple. On the other, wine requires one to behave
like a professional, with a specialized vocabulary, an inten-
sive education, and possibly the sorts of physical attributes
that can be measured statistically on athletes and porn stars
but with wine lovers depends solely on how insistently one
pushes a point of view.

These twisted, contradictory thoughts about wine can't
help but cause anxiety. It's a double bind that, either way, re-
sults in consumers feeling they are wrong. By turning wine
into a specialized field, requiring critical omniscience and
demanding pronouncements at every turn, American wine
culture ignores the simple emotional relationship with wine
that is the basis for a lifelong attachment.

Drinking wine is an elemental, natural pleasure that for too
many people has been gilded with nonsense. My friend Jim's
father was a Sicilian immigrant who drank wine with dinner
every night when he returned home from work. In his for-
mative adult years in the 1960s and '70s, American wine
culture as we know it now did not exist. Glossy consumer

publications did not publish hundreds of scores and notes on wines from around the world, and indeed, Jim's father would not have been interested if they had. The idea that he would try to parse out the aromas and flavors in his glass to the assembled audience would have been ludicrous. He kept a gallon jug of red wine in his refrigerator and poured himself a glass or two the way other people might pour water or orange juice. Nothing complicated about it. It was habit, born of the culture in which he grew up back in Sicily.

Frankly, I would never want to drink the wine that Jim's father so enjoyed. It was a cheap bulk red that, because I care about these things, I would have found repellent. But I would never have dreamed of interfering with his pleasure, and I admired his complete lack of self-consciousness about the wine.

He did not see wine as an element of style, transmitting to the world a coded indication of his personality. Of course, he didn't feel that way about his shoes, either. In any case, his chosen beverage neither disturbed nor offended me. Honestly, what could possibly be wrong with enjoying this sort of wine straight from the fridge in juice glasses, the way Jim's father did?

Back when Jim was a kid in the 1960s, the bulk wine his father bought was probably the nearest equivalent to the sort of village cooperative wines that his family used to drink back in Sicily. Those wines in the old country had the benefit of being local produce. In Connecticut, Jim's father had to take his wine where he could find it.

What would Jim's father drink today if he were still alive? Probably the same big gallon jug, the sort of bulk-

production wines that, believe it or not, continue to make up a high percentage of American wine sales. Or maybe he would drink the equivalent of Two-Buck Chuck or Yellow Tail. I'd like to imagine he would select one of the excellent French or Italian country wines that you can now find in bag-in-a-box packaging, the sort that will stay fresh in your refrigerator for weeks as you draw your nightly glass or two from the tap. But I doubt it, because, frankly, Jim's father did not care all that much about the quality of what he was drinking. He was mostly interested in the price.

The point is that throughout history, the act of consuming wine has essentially been one of uncritical enjoyment. It's a simple pleasure, first and foremost, the beverage equivalent of bread on the table. This, of course, ought to be the fundamental basis for any continuing interest in wine. Do you like to drink it? Not *If I'm facile with a wine list it will improve my job prospects* or *I'm going to collect bottles like sports cars or pieces of valuable crystal.*

You might ask, with good reason, who am I to pass judgment on anybody's rationale for pursuing an interest in wine? Truly, that's not at all my intention. People can do whatever they want. I'm simply saying that if you really want to experience the pleasure of wine it's best to be honest about your motives. Clearing out the extraneous rationalizations is the best way to tap into a direct emotional relationship with wine. Once you can establish to your own satisfaction that you enjoy wine for what it is rather than what it represents, then it becomes a question of how much

time, energy, and money you want to devote to enhancing that pleasure.

Not long after I began as wine critic, I stated in a column, "If you don't love Beaujolais, you don't love wine." I rightly took some criticism for that, because I was trying to convey a truth with a statement that was too easy to take only literally. The idea was that Beaujolais, probably more than any other wine, connotes the sheer, elemental, joyous pleasure of wine for wine's sake, rather than any of the other reasons people buy wine, whether for status, religious observance, as an investment, as an intellectual exercise, as a social lubricant, or simply to get drunk. The truth is, it didn't have to be Beaujolais. Substitute any juicy, straightforward wine, and you get the idea.

This is the fundamental idea I want to convey, the answer, even if it doesn't seem like an answer. If you love wine, all the sense of fulfillment, pleasure, and satisfaction that you hope to get out of wine can follow. But you need to answer that essential question. And to answer that question, it's especially helpful to understand that many of the so-called truths about wine that we accept blindly are in fact no such thing. Instead, they are assumptions that, like the conventional wisdom about politics, crumble when examined closely.

Some people seem to understand these things intuitively. Joe Dressner was a wine importer who died too young, at sixty years old in 2011, after battling brain cancer for three years. I would not say we were friends. In fact, he was an irascible

sort who once made a good friend of mine cry through sheer orneriness. We had a good business relationship, though, and I liked him because he was such a singular character: blunt, acerbic, uncompromising, and provocative, and not necessarily in control of his ridicule, but also principled, honest, articulate, funny, and wise about wine.

His import company, Louis/Dressner Selections, which he ran with his wife, Denyse Louis, and a partner, Kevin McKenna, offered a wonderful array of producers from some of the least heralded regions of France and Italy. Cour-Cheverny, Gaillac, Saumur, Jasnières, and Coteaux du Loir are just some of the oddball appellations in France where Louis/Dressner found great vignerons and which Joe Dressner helped put back on the mental map of wine lovers. How did he do this?

Joe never went to a class to learn how to deconstruct a wine into esoteric aromas and flavors. I never saw him try to identify a wine blind, as if that were ever a sign of useful knowledge. He had no formal training. He simply drank a lot of wine. With time he learned to distinguish between what he liked and what he didn't, and he was sufficiently curious and resolute to work out the reasons for those differences. It turned out that the wines he liked had much in common. They were generally made by small producers who worked their own plots, who did not use chemicals in the vineyard and kept their yields small, who harvested by hand rather than by machine, and who used no additives in the cellar but merely shepherded the grape juice along its journey into wine.

These were the wines he grew to love and sell, made

by people whose personal histories often involved genera-
tions of dedicated grape growing. Even as these wines came
to be known as natural wines (a term he occasionally used
and often disdained), and wines like these came to be a hot-
button topic among the wine lovers of the world, Joe would
scorn the notion that he was involved in some sort of move-
ment. In fact, while he certainly had his core beliefs he was
not dogmatic about them. One of the principles of Louis/
Dressner was that wines should be made with indigenous
yeasts that were present on the grapes and in the winery,
rather than inoculated with yeasts selected by the winemaker.
Yet the wines of Didier Dagueneau from Pouilly-Fumé, one
of the shining domains in his portfolio, are inoculated with
yeast. Joe couldn't argue with the wines.

"It's a taste and sensory preference," he once told me. "It's
not being purist, or that we follow this guru or that guru,
but that we feel the wines taste better."

Joe would regularly bring a crew of his vignerons from
France to the United States, where they would meet mem-
bers of the trade, offer consumer tastings, and raise hell
after hours. These visits were important to him. The per-
sonal contact with consumers and the trade helped sell wine,
of course, and Joe was a salesman. In fact, one of the most
endearing qualities about Joe was that he did not sell wine
to make himself or his family rich. His priority was to sell
enough wine, at a high enough price, to make it possible for
his vignerons to keep doing their job without unremitting
financial anxiety.

Remember, most of his producers were not from glori-
fied regions. Outside of the exalted golden circle, making

and selling wine for a living can be like any other agricul-
tural pursuit: difficult and uncertain. Along with other great
importers I've known, like Kermit Lynch and Neal Rosen-
thal, Joe cared tremendously about the producers with whom
he worked. He believed that it was crucial for the public and
the trade to see for themselves that wine—good wine—was
made by people who had a vision and a philosophy as well as
warts and flaws.

Regardless, the men and women who traveled with Joe,
and their wines, represented a culture that was a far cry from
the way most Americans have come to think of wine. They
were not there to glorify wine into something overly com-
plicated or turn it into a fetishistic object. Their wines could
not be reduced to scores and tasting notes, nor did they strain
to demystify wine for their audience. Wine was a mysterious
pleasure and a joy. It belonged on the table, to be shared with
friends and family along with great food. But Joe was not a
holier-than-thou preacher. His attitude was, if you want to
drink wine he regarded as wretched along with awful food,
well, that was your business.

Joe didn't mind living in his own, marginalized world.
He had no interest in proselytizing, beyond creating the
markets he needed to sustain his growers. In fact, he feared
growth. "The Natural Wine Movement," he once wrote sa-
tirically, "does not expect the Wine Industrial Complex to
be won over to natural fermentation, low sulfur and what-
have-you. Even if it were, it would still be making unfath-
omable, undrinkable stuff."

He did not spare those who would proselytize, either.
"The Natural Wine Movement abhors earnestness," he con-

tinued. "Humorless activism to promote wine is an oxymoron. Getting smashed, eating well, and laughing with good friends are key to our movement."

There you have it, indelicately.

Clearly, Joe Dressner and my friend Jim's father lived in different worlds, and in different times. Though Jim's father was a Sicilian immigrant he never in a million years would have shelled out $40 for a bottle of Arianna Occhipinti's fresh, striking, complex Sicilian wines, which happened to be imported by Louis/Dressner. Nonetheless, even though these two men would have found each other completely alien, they did share an important quality. They were at ease with wine. They each got what they wanted from it without fussing or, if I really need to say it, feeling inadequate.

Part of me would like to think I could have introduced some better wine to Jim's father and that he would have enjoyed it. Since the mid-twentieth century, we have come to understand that good food depends on good ingredients, and if you care about food, why wouldn't you care as much about wine? Not in the sense of connoisseurship, but simply in wanting the wine, like the food, to be made from good, wholesome ingredients rather than from processed junk. But the formula isn't always cut and dried. Jim's father loved to eat—his wife was a wonderful cook—but my guess is that he would not have wanted to pay a premium for great ingredients or for great wine. Just as people his age grew up smoking cigarettes, they valued the convenience and cheapness of mass-produced foods.

———

Even today, most people choose not to spend the extra money or the time necessary to gather local or organic ingredients. Food and wine are simply not important enough for them to pay the price. People like Michael Pollan, Eric Schlosser, Alice Waters, Mark Bittman, and Ruth Reichl have all made the argument that one's choices in food are political acts. I happen to believe this, too. But one's choices in food, and wine, also clearly express a cultural divide as well.

On one side is a mainstream, mass-market world in which the salient issues are not the methods of production, the wholesomeness, or the nutritional value. They are cost and convenience. It may be cheaper to go to the grocery store to buy a three-pack of tomatoes or ground chuck in a plastic-and-foam wrap than to find a farmers' market or to grind some locally produced beef yourself. It may seem easier and cheaper to get dinner at Mickey D's than to think about where all that meat comes from and what's done to it. Or it may be that food is not so much of a pleasure for some people, but simply fuel.

The fact that we even have a divide over food demonstrates our cultural resilience. By the 1970s the industrialization of the food industry was well on its way to wiping out small farms and regional distinctiveness. But from the last two decades of the twentieth century on, the battle was rejoined. Writers like Calvin Trillin and Jane and Michael Stern paid tribute to the last vestiges of regional cuisine in the United States, inspiring new generations to seek out those foods, giving incentive, small as it might have been, to businesses

that could cater to the meager but growing demand. Localized farmers' market movements across the United States created ways for small farmers to survive, and for people to obtain top-quality, seasonal ingredients. Greater awareness of what good ingredients could taste like, along with rising political consciousness, helped to create an economic and cultural network for supporting the small, local production of ingredients, whether from coffee roasters, farmers, butchers, cheesemakers, bakers, urban gardeners, or those engaging in other small-scale efforts.

You can see a parallel in the American craft-beer revolution. By the 1970s, huge mass-market breweries made virtually all the beer consumed in the United States. Most of it was homogenized, denatured, pilsner-style beer. Yet a cultural awareness that something greater once did exist inspired a very small number of people to seek out what had been lost. With no other means for satisfying their yearning, they were compelled to brew their own beer. Thus were the seeds of the craft-beer revolution planted as over the next few decades many of these home brewers went on to start small breweries, making the sorts of beers that, in their imaginations or in their travels, they discovered they loved. Nowadays, the United States has the most vibrant beer culture in the world, even as the consumption of craft beers still only amounts to a small fraction of all the beer consumed by Americans. For the most part, beer drinkers live in one of these two worlds, the mass-market or the craft, even if occasional crossover occurs.

———

Wine is in a very different place than food or beer. Centuries-old traditions in wine, embodied by small, family estates, never completely died out to the extent that they did in beer and food, for which I am profoundly grateful. Because of the slow cycle of viticulture, it might have been far more agonizing to revive dormant or faded wines.

Not that these sorts of revivals haven't happened. Across Spain, from Priorat to Ribeira Sacra, as I've said, ancient vineyards that were consigned to nature have been successfully reborn, and new markets created. It's happened in France, in Italy, across Eastern Europe. It's even happened in the United States.

But for the most part, the raw material for making great wines has always been there. All that's been missing is the market, and now the market has been revived, too. Wines that for so many decades and centuries expressed local cultures are now available for a global audience.

That is why I believe we are now living in the greatest time in history to love wine. Though I've said this many times, it bears repeating: More people around the world have more access to more great wines from more places than ever before. It is indeed the Era of More, and if more is not always better when used in the sense of bigger or more powerful, more is indeed a good thing when it comes to variety.

Paradoxically, it has also been a time of dire warnings about the future of wine and this wonderful variety that I treasure. Fear of a monotonous, monochrome future for wine has fueled such good-versus-evil efforts as Jonathan Nossiter's polemical documentary film *Mondovino,* and Alice Feiring's *The Battle for Wine and Love, or How I Saved the*

World from Parkerization. Both works raised the specter that the soulless forces of homogenization—Robert M. Parker Jr., *Wine Spectator,* and so on—were turning wine, an authentic emblem of individuality, community, and culture, into a bland, indistinct commodity.

While I believe this threat has been overstated, I do believe it exists. But it's not so much a question of good versus evil as it is an overlapping of cultures. The solution is not to condemn people or institutions. They after all are advocating what they think is right. They believe that the soul of wine may be best expressed in scores and tasting notes. They have elevated wine into an obscure field, suggesting it requires years of training in order to enjoy. They have cast wine adrift from its cultural moorings and treated it like a laboratory specimen. Their beliefs may even be rooted in their own interests, because they've built businesses founded on these beliefs.

Fine. I have my own interests, too. I want continued access to the wines that I love and to wines that I don't even know I love yet but am sure I will discover in the future. I believe that I can maintain access to these wines by encouraging a demand for the sorts of wines that I love. And I believe that demand will rise from a growing audience of people who can see beyond the points and the notes and the blind tastings. These people instead see wine as the expression of culture that it has been for centuries.

That doesn't mean that taste aligns with understanding. People who view wine from a similar perspective may prefer decidedly different styles. That's to be expected and encouraged. All producers who rise organically from centuries of

tradition may not necessarily be to my taste. The point is not to insist on one style of wine. It's simply to encourage a more relaxed relationship with wine, one of ease and pleasure, free of anxiety, in which one can explore one's tastes without fear of being wrong or of lacking some crucial skill or equipment. Wine does not need to be simplified, demystified, appreciated, or elevated. It does need to be loved, though, for without love what's the point of learning any more about it?

I am not proselytizing, however. I'm not out to convert everybody to my point of view. I believe we can all exist quite comfortably in our own worlds, where our attitudes and beliefs can be very different except for small, overlapping segments. I do believe, however, that another point of view must be stated, that American wine culture cannot be passed down as an assemblage of assumptions and conventional wisdom. The rest I leave to you, because nobody is obliged to love wine. If you want it, though, a beautiful world awaits.

Acknowledgments

Every day brings fresh reminders of the many people on whom I rely and to whom I'm profoundly grateful.

I start with the two women to whom I've dedicated this book: my mother, Ruth Asimov, whose early gift of a trip to France turned out in ways she never imagined, and Deborah Asimov, my wife, who inspires me with her faith and love, her tolerance, and for holding me accountable with her acute analysis and critical thinking.

Among the many great pleasures of being a father, I've enjoyed introducing my two sons, Jack Asimov and Peter Asimov, to food and wine. Their embrace has been gratifying, though they can be a tough audience. I have the good fortune of a supportive and sensitive family. Thank you especially Nanette Asimov and Hugh Byrne, Robyn Asimov, Kathy Henschel, and Greg Henschel and Francey Youngberg. Jackie Lee shared many formative experiences with me, and an important collaboration. I wish I could share this book with my father, Stanley Asimov, my brother-in-law Peter Henschel, and my mother-in-law and Champagne buddy, Annerose Henschel.

I am among those lucky writers whose agent is David Black. David, thank you for your patience and confidence in me despite long bouts of indecision.

Robert Miller, whose inspiration, Harper Studio, was alas short-lived, encouraged me, for which I'll always be thankful. Cassie Jones took over in midstream and proved, with a strong yet subtle hand, that careful, intelligent editing is still possible despite the pressures of this difficult era for publishing.

The entire team at William Morrow has been tremendously helpful to me, particularly Andy Dodds and Tavia Kowalchuk. Thank you!

It's been my privilege to work at the *New York Times* for many years now, and as long as I've been there I still look with awe at each day's newspaper. It's an achievement that is easy to take for granted. Only by stepping behind the curtain can you see the hard work and collaborative energy of the fiercely intelligent, passionately dedicated, consummately skilled, honorable people who put it together daily from scratch. In my corner of the newsroom, I've been made to look good by superb editors and colleagues. I particularly want to thank Pete Wells and Nick Fox; my inspiring pod-mates past and present: Kim Severson, Julia Moskin, Florence Fabricant, Sam Sifton, Frank Bruni, Jeff Gordinier, and Glenn Collins; and the editors who so many times have saved me from careless or foolish errors, especially Pat Gurosky, Alison MacFarlane, Emily Weinstein, and Joe Siano. Thanks also to Susan Edgerley and Patrick Farrell. Howard G. Goldberg has done many kind things for me over the years, for which I'm grateful.

Frank J. Prial set dauntingly high standards for reporting, writing, wit, and common sense; I've tried to live up to his example.

Bernard Kirsch has been a great friend and colleague. By the quirkiest of chances he was present at that lunch many years ago at Allard in Paris. He was also present at the first wine panel tasting and hasn't missed one since. Bernie, we couldn't do it without you!

Everywhere I've traveled throughout the wine-producing world I've been privileged to meet men and women, too numerous to name individually, who've inspired me with their intelligence, their wit, their understanding, and their passion. Thank you all.

I'm similarly grateful to the many skilled and devoted sommeliers and members of the wine trade in New York who have so selflessly contributed their knowledge and curiosity to our wine panels. I've learned something from every one of you, but I don't think I've learned more from anybody than I have from Daniel Johnnes. Nobody has done more to teach Americans about the pleasures and intricacies of Burgundy. I've been fortunate to have had more than twenty years' worth of conversations with him about Burgundy and wine in general, all of them illuminating.

I'd like to thank Jordan Mackay for help and encouragement that came in ways he may not recall; Melissa Totten remembers Texas even better than I do, thank you!

Here in New York, I've been blessed with close friends. We've shared many meals and countless bottles, and while I appreciate their interest in wine and food, that's merely a small facet of the pleasure of their company. Many, many thanks to Jason Smith, ace coffee, cheese, and cocktail maestro, and Lisa Berte, superb Italian cook; to Dr. S and Dr. Y, ministers of wine storage, excellent cooks of savories and

sweets, and scintillating, empathetic conversationalists; to Rafael Mateo, my road warrior buddy, with whom I've shared so much, always a fount of wisdom, among many other things; and Michelle Willoughby, who knows good music of every sort.

Finally, I'd like to thank Sensei Nobuyoshi Higashi and the entire Kokushi Budo Institute community for mental, physical, spiritual, and psychological sustenance. Seii, kinro, kenshiki, kihaku.

Index